American Prints

FIRST EDITION

This book was published on the occasion of an exhibition at the Whitney Museum
of American Art, November 25, 1981–January 24, 1982, supported by grants from
Manufacturers Hanover Trust and the National Endowment for the Arts.

Library of Congress Cataloging in Publication Data

Goldman, Judith
 American prints: process & proofs

 Catalog of an exhibition held at the Whitney Museum of American Art, New York,
Nov. 25, 1981–Jan. 24, 1982.
 Bibliography: p. 172
 1. Prints, American—Exhibitions. I. Whitney Museum of American Art.
II. Title.
NE505.G6 769.973′074′01471 81-47244
ISBN 0-87427-036-7 (WMAA) AACR2
 0-06-433261-6 (H&R) 81 82 83 84 10 9 8 7 6 5 4 3 2 1
 0-06-430116-8 (H&R pbk) 81 82 83 84 10 9 8 7 6 5 4 3 2 1

Designer: Marcus Ratliff

Composition: Columbia Publishing Company, Inc. Frenchtown, New Jersey

American Prints: Process & Proofs

Judith Goldman

Whitney Museum of American Art

Icon Editions
Harper & Row, Publishers

Sponsor's Message

MANUFACTURERS HANOVER is pleased once again to sponsor an outstanding program at the Whitney Museum, this time as it spotlights American printmaking. The artists represented bring to life the diversity of culture and heritage that is one of our country's great strengths. Sharing the riches of American art is a long-standing Whitney tradition. We are proud to play a small part in keeping that tradition alive.

JOHN F. MCGILLICUDDY
Chairman and President
Manufacturers Hanover Trust

Contents

Foreword

IT is only in recent years that American artists have begun to consider printmaking as a medium in which the opportunities for aesthetic expression equal those in painting and sculpture. With the growth of print workshops in this country during the past twenty years, fine art printers have developed techniques that permit artists to experiment with a wide variety of styles and effects.

"American Prints: Process & Proofs," organized by Judith Goldman, Advisor on Prints to the Whitney Museum, offers the public a rare chance to study the creative process of printmaking in the work of fourteen contemporary artists. Although their subjects and approaches vary, these artists all show great respect for the medium and share a desire to explore its unique technical possibilities to the fullest. Printmaking is the only medium in which revisions are recorded as an inherent part of the process. The evolution of color, line, shape, and texture—visible in the successive proofs of each print—dramatically illustrate the aesthetic decisions each artist must make before the final image emerges. The exhibition also includes an introduction which briefly surveys the history of American prints from the late seventeenth century to the mid-twentieth century.

We are grateful to Manufacturers Hanover Trust and the National Endowment for the Arts for their enthusiastic support of this unusual project, and to the lenders we extend sincere thanks for sharing their works of art with a wide audience.

TOM ARMSTRONG
Director
Whitney Museum of American Art

Preface and Acknowledgments

THE inherent variables of the graphic arts distinguish them from other media. Prints are made in progressive stages; and once an image is fixed on a matrix of stone, wood, metal, cloth or any other material capable of yielding an exactly repeatable image it is inked and proofed on a press. On rare occasions, the first proof yields the desired effect; far more often proofs are guides for alterations to come. Proofs show commercial printers the percentages of yellow, red, blue and black which when combined yield a full spectrum of colors. For artists, proofs become working materials—images they study and rework which lead to decisions, revisions and the eventual final print. Proofs represent the steps along the way; viewed as a group, they show the evolution of a printed picture.

How prints are made—the procedures followed—can reflect the print's function, the taste and technology of the times and, in the case of prints created by artists, aesthetic choices. Viewed in terms of process, early American prints indicate the rudimentary state of native graphics, while those produced by English-trained colonial printers show the reproductive techniques which characterized seventeenth-century English prints. Nineteenth-century printed pictures, created to purvey information and provide decoration, were produced by the most expedient means. Journalists preferred lithography's speed and wood engraving's portability; and until photography modified print technology, copyists favored metal engraving, the most mechanical and exacting of the intaglio techniques.

The craftsman, working to meet journalistic or reproductive goals, follows set procedures. He meticulously works a plate, deletes mistakes and makes proofs to test lines and tones. In the hands of artists, the graphic processes cease to be predetermined or governed by technology. Artist-printmakers follow no set procedures, but discover images in the proofing process.

For artists, mistakes become triumphs; the inky surface of a lithographic stone yields discoveries. The print's intrinsic capacity for change leads to unknown possibilities. In proofs, artists can see what is and what was simultaneously; using a snakeslip or scraper, they erase marks or lighten tones; discarding a plate or reversing its printing sequence, they alter an image entirely and,

if displeased with the result, they restate the printing element and begin over again.

"American Prints: Process & Proofs" focuses on what American prints have been and what in the last twenty-odd years they have become. To demonstrate the properties of each graphic medium and how artists use them, whenever possible prints are shown in stages and proofs. The exhibition begins with a survey of prints made in America from 1670 to 1960, which traces the evolution of the print from an illustrative, reportorial form to a fine art medium. This survey is not meant to be comprehensive, but to provide a historical context for the prints American painters have made since 1960, prints which are inextricably connected to their process. Those prints—their size, scale, ambition—represent a radical break with the graphics that preceded them; and as a group, may finally constitute the full flowering of an American fine art print tradition.

The exhibition presents working, trial, and final proofs of fourteen contemporary American painters. But its concern is not with the technique of printmaking, its recipe aspects, or with the refinements of connoisseurship; it views working and trial proofs to demonstrate how the contemporary painter uses inherent graphic properties and procedures to create printed art.

"American Prints: Process & Proofs" looks at graphics by painters; it excludes printmakers, not because they have not made important graphic statements, but because historically painters have brought the major innovations to the graphic arts. The fourteen painters include realists, abstractionists and artists who have been labeled Pop and Minimalist and Photo-Realist. They are among the best artists working in prints today.

For the purpose of this exhibition, process has been defined to include everything from a line drawing or sketch and its translation into print to the addition and subtraction of lines and tones to alterations in color or printing sequence. Process obviously includes mechanical alterations, particularly changes in color which yield serial images. But because the process of such changes often cannot be seen—only the results—they have not been included in this exhibition. The decision to exclude solely mechanical changes meant the omission of Roy Lichtenstein and Andy Warhol. The exhibition's concept also meant the exclusion of artists who do not work in proof, most notably, Robert Rauschenberg. These artists have all made major contributions to American graphics; their omission indicates only the liability of any concept or definition when applied to art.

This exhibition was a collaborative effort and would not have been possible without the cooperation and talents of many people. I am especially grateful to Susan Bracaglia, who assisted me in every aspect of this exhibition, for her tenacity and intelligence, and to Cass Canfield, Jr., for his encouragement and interest in this project from the start. Their contributions helped shape the scope

and concept of this exhibition, as did the critical suggestions offered by Paul Cummings and Bill Goldston at every step along the way.

I also wish to thank Talia K. Gross, who researched the initial stages of this exhibition; Robert Rainwater of The New York Public Library, for his generosity in providing information and for meeting sometimes quixotic requests with unfailing good humor. In preparing the manuscript I was assisted by the editorial suggestions of Susan Bracaglia, Cass Canfield, Jr., and Joan Simon. I am particularly indebted to Sylvia Hochfield for her intelligent reading of the manuscript; to Jane Freeman for her perceptive comments and patience in typing and retyping the manuscript; to Wendy Persson-Monk who provided research and read galleys; to Anne Grant and Tony Mascatello at Bark Frameworks; and to Marcus Ratliff for the care he brought to the design of this catalogue.

This exhibition reflects the generosity and cooperation of artists, private collectors, publishers and institutions who have lent their work and allowed me access to their collections and archives. I appreciate the assistance provided by the print rooms of The Art Institute of Chicago, The Metropolitan Museum of Art, The Museum of Modern Art, The New-York Historical Society, and The New York Public Library, and the courtesies extended by the publishers Crown Point Press, Oakland; Gemini G.E.L., Los Angeles; Landfall Press, Chicago; Multiples, New York; Tyler Graphics, Bedford, New York; and Universal Limited Art Editions, West Islip, New York.

Others who provided invaluable information include: Brooke Alexander, James Angell, Amy Baker, Joan Banach, Toddy Belknap, John Berggruen, Pat Branstead, Keith Brintzenhofe, Kathan Brown, Georgia Bumgardner, Riva Castleman, Joseph A. Chubb, Sylvan Cole, Jr., Charles Cowles, Susan Crile, Jean G. Crocker, Gloria Gilda Deák, Anita Duquette, Robert Feldman, Sid Felsen, Robert Getscher, Marian Goodman, Lindsay Green, Tatyana Grosman, John Hutcheson, Louis LoMonaco, Colta Feller Ives, Diane Kelder, David Kiehl, Mark Lancaster, Margo Leavin, Mary LeCroy, Kathy Jordan Lochman, Susan Lorence, Karen McCready, Nancy Mozur, Robert Miller, Tony Norton, George Page, Peggy Patrick, Dorothy Pearlstein, Francis A. Penn, K. Martin Pierce, Bruce Porter, Rachel Rome, Elizabeth Roth, Lawrence Rubin, Maurice Sanchez, Richard Schneiderrman, Jonathan Silver, Richard Soloman, Maureen St. Onge, Susan Teller, Stephanie Terenzio, Tony Towle, Kenneth Tyler, Nicholas Weber, Joan Weyl and David Whitney.

I would particularly like to thank Tom Armstrong for his enthusiastic support and for permitting me to undertake this project; and the staff of the Whitney Museum for their assistance in putting together this exhibition.

JUDITH GOLDMAN

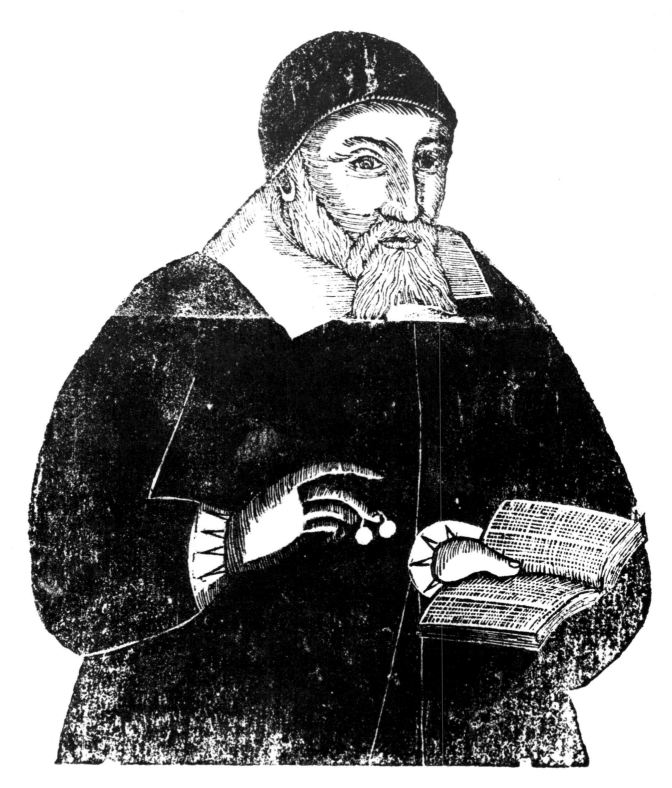

Mr, Richard Mather.

American Prints 1670–1960

Artists, Artisans & the Graphic Arts

I

THE climate of the New World was not conducive to picture-making. Art fostered divisions of class that colonists thought they had left behind. "The fine arts," Adams told Jefferson, "have been subservient to priests and kings.... [They] promote virtue when virtue is in fashion. After that, they promote luxury, effeminacy, corruption and prostitution."[1] In colonial America, art and artists aroused complex feelings. Art was simultaneously scorned and feared. Colonists who had come from rural areas had no exposure to or interest in art. To gentry Puritan emigrés, aware of Charles I's insatiable taste for art, it had connotations of a wasteful, extravagant Crown. Art was antithetical to Puritan ideals, potentially disruptive to the business of the new Republic.

The fine artist had a hard time in America. To find "example and instruction," Benjamin West traveled to England; other painters followed. Having learned all he could in Boston, John Singleton Copley wrote West that he had nothing to study except "a few prints indifferently executed from which it will not be possible to learn much."[2] There was a demand for portraiture in early America, but the craft status of portraiture, conferred by the medieval guilds, further complicated art's position. Regarded as an artisan, the typical portrait painter was an itinerant, a jack-of-all-trades, who worked with his hands and painted whatever needed painting: houses, signs, and portraits.

Painting was not considered a gentleman's profession. John Trumbull's father, the governor of Connecticut, did not want his well-bred son to become a painter. When Trumbull explained to his father that art had been the glory of Greece, his father replied, "You appear to forget, sir, that Connecticut is not Athens."[3] Attitudes like the governor's caused Copley to complain in another letter, "The people generally regard it [painting] as no more than any other useful trade... like that of a carpenter, tailor or shoemaker...."[4] Colonial painters went to England not only to study great art, but to escape the confines of an artisan class. In England or the Continent, painters might become the confidants of kings.

Opposite:
Fig. 1
JOHN FOSTER
Mr. Richard Mather, 1670
Woodcut
American Antiquarian Society, Worcester, Massachusetts

Without a climate for high art, there could be no fine art print tradition. Didactically conceived and rudimentarily made, America's first prints conveyed information. Images of necessity — maps, state seals, broadsides, and portraits of clerics — they marked boundaries and authority, announced power, called for town meetings and revolution.

Early European prints had also transmitted information. Fifteenth-century religious woodcuts, bought for pennies, circulated pictures of the faith; herbals offered lessons in botany. Wherever tourists traveled, European print publishers appeared flogging Roman ruins and Venetian perspectives. But the European print's reportorial, commercial functions did not preclude its role as art. In contrast, several centuries passed before America had an established fine art print tradition.

In Europe, prints carried both artists' reputations and innovations. By the seventeenth century, Andrea Mantegna, Albrecht Dürer, and Titian had all made lasting contributions to graphic arts and the status of prints as a fine art was secure. A decree issued by Louis XIV in May 1660 proclaimed prints a fine art "which depend upon the imagination of their authors and cannot be subjected to any laws other than those of their genius; this art has nothing in common with the crafts and manufactures; none of its products being among the necessities which serve the subsistence of civil society, but only among those which minister to delight, or pleasure, and to curiosity."[5]

North American graphic arts occupied an entirely different position. Europe's great painter-printmakers created prints as original inventions, after paintings and on commission from publishers. The European illustrated book tradition dated back to medieval illuminated manuscripts. But America had no fine art book tradition, no paintings to copy, no established visual iconography. Early America's first printmakers were largely self-taught men, who printed whatever needed printing; artisans, not artists. The distinction would wield an influence over American prints into the twentieth century.

English censorship undermined the development of North American printing arts. Holland, not England, produced the first English-language newspaper. In 1625, Charles I had suppressed newssheets, and until the Declaration of Rights of 1689, restrictive laws governed the English press. America's first letterpress, established in 1638 by Stephen Day in Cambridge, Massachusetts, printed mainly religious tracts; and the colonists' first newspaper, *Publick Occurences both Foreign and Domestic*, printed in 1690, lasted only one issue before the Council of Massachusetts suppressed it with a warning that all further printing required licensing. The danger seen in the press was expressed *in extremis* by Sir William Berkeley, colonial governor of Virginia, in 1671 when he wrote: "But I thank God we have not free schools nor printing; and I hope we shall not have these three hundred years. For learning has brought disobedience and heresy and sects into

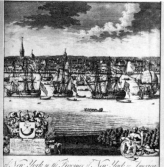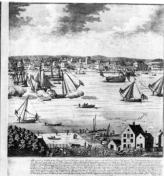

A South Prospect of y.º Flourishing City of New York in y.º Province of New York in America

the world, and printing has divulged them and libels against the government."[6]

The history of America's printed pictures is intertwined with the history of its press. Printers arrived in the Colonies before presses did. William Burgis, an Englishman, drew his large view of Manhattan Island in 1716 (Fig. 2), shortly after his arrival, but had to return to England in 1719 to have his copperplates engraved and printed. Francis Dewing, another Englishman, brought the first copperplate to Boston in 1717, but after five years he too returned to England. Printers who came to seek New World fortunes had a hard time; colonial America had a need only for the most basic kind of printed information, and most printers supplemented their incomes by printing calicoes and engraving silver; even the accomplished Peter Pelham, in order to make ends meet, taught needlepoint, sold prints, and ran a dancing school on the side. As late as 1750, America had only four or five copperplate presses.[7]

But it wasn't that colonists didn't have a taste for printed pictures. Boston, New York, and Philadelphia printsellers did a brisk business in Hogarth's moral tales, English mezzotints, and New World views produced by Londoners who had never been there. Nor was it that colonists preferred imported pictures; it was that comparable prints, images which provided decoration or piqued curiosity, weren't produced in America. Native printers lacked the skill and technology to create them. The prints colonists bought to decorate their homes influenced a direction American prints would take. Reflecting the reproductive standard that governed seventeenth- and eighteenth-century English graphics, they were the prints John Singleton Copley used as his source, the ones he complained about to Benjamin West as being "indifferently executed."

America's first prints — maps and portraits, broadsides, currency, trade cards, death notices, bookplates, and decorative tailpieces — were made by self-taught printers, such as John Foster and Amos Doolittle; silversmith-engravers like Paul Revere and Nathaniel Hurd; and English-trained engravers like Peter Pelham,

Fig. 2
WILLIAM BURGIS
A South Prospect of New York, State I, 1719–21
Engraving
Print Collection, The New York Public Library, Astor, Lenox and Tilden Foundations

Overleaf:
Fig. 3
HENRY PELHAM
The Fruits of Arbitrary Power, or the Bloody Massacre, 1770
Engraving with hand-coloring
American Antiquarian Society, Worcester, Massachusetts

Fig. 4
PAUL REVERE
The Bloody Massacre, 1770
Engraving with hand-coloring
American Antiquarian Society, Worcester, Massachusetts

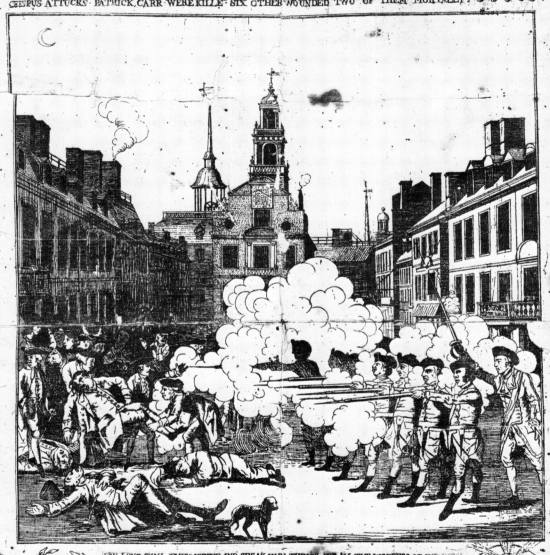

THE FRUITS OF ARBITRARY POWER, OR THE BLOODY MASSACRE,

PERPETRATED IN KING STREET BOSTON ON MARCH 5 1770, IN WHICH MESSr SAMl GRAY. SAMl MAVERICK. JAMES CALDWELL.

CRISPUS ATTUCKS, PATRICK CARR WERE KILLd SIX OTHER WOUNDED TWO OF THEM MORTALLY:

HOW LONG SHALL THEY UTTER AND SPEAK HARD THINGS AND ALL THE WORKERS OF INIQUITY
BOAST THEMSELVES : THEY BREAK IN PEICES THY PEOPLE O LORD AND AFFLICT
THINE HERITAGE : THEY SLAY THE WIDOW AND THE STRANGER AND MUR-
-DER THE FATHERLESS - YET THEY SAY THE LORD SHALL NOT SEE NEI-
THER SHALL THE GOD OF IACOB REGARD IT. PSALM XCIV.

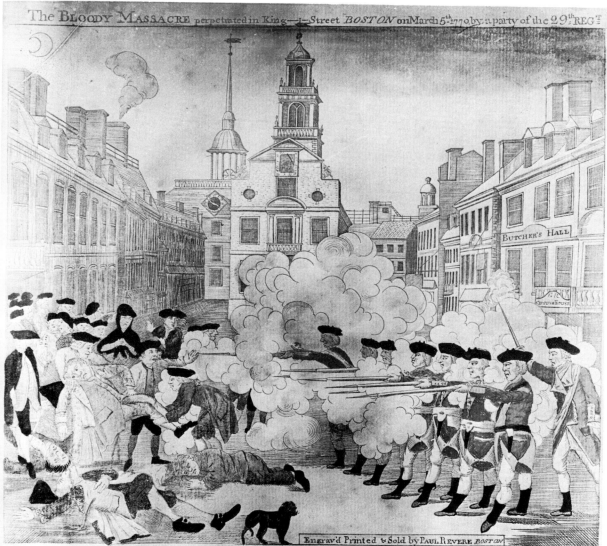

The BLOODY MASSACRE perpetrated in King——ſ——Street BOSTON on March 5th 1770 by a party of the 29th REGt

Engrav'd Printed & Sold by PAUL REVERE BOSTON

Unhappy Boston! ſee thy Sons deplore,
Thy hallow'd Walks beſmear'd with guiltleſs Gore.
While faithleſs P——n and his ſavage Bands,
With murd'rous Rancour ſtretch their bloody Hands;
Like fierce Barbarians grinning o'er their Prey,
Approve the Carnage, and enjoy the Day.

If ſcalding drops from Rage from Anguiſh Wrung,
If ſpeechleſs Sorrows lab'ring for a Tongue,
Or if a weeping World can ought appeaſe
The plaintive Ghoſts of Victims ſuch as theſe;
The Patriot's copious Tears for each are ſhed,
A glorious Tribute which embalms the Dead.

But know, FATE ſummons to that awful Goal,
Where JUSTICE ſtrips the Murd'rer of his Soul:
Should venal C——ts the ſcandal of the Land.
Snatch the relentleſs Villain from her Hand,
Keen Execrations on this Plate inſcrib'd,
Shall reach a JUDGE who never can be brib'd.

The unhappy Sufferers were Meſſrs SAMl GRAY, SAMl MAVERICK, JAMs CALDWELL, CRISPUS ATTUCKS & PATk CARR
Killed. Six wounded; two of them (CHRISTr MONK & JOHN CLARK) Mortally

a merchant portraitist and Copley's stepfather. John Foster's 1670 portrait of the Rev. Richard Mather is America's earliest extant print (Fig. 1). Made posthumously as a commemorative portrait, it is a primitive picture. The too-small head, hands, the teeny eyeglasses and book appear as if grafted on from another picture; and the large robe recalls the painted sets stocked by amusement-park photographers. On a break from reading Scriptures, Mather appears simultaneously awesome and accessible. A kind eye meets the viewer's, and conveys intimacy, while the bulk of the engulfing robe creates distance. Direct but unreachable, open but guarded, the portrait depicts attributes that remain typical of the American character.

John Foster was a naif who brought his own language to wood. Born in 1648, the son of a brewer and captain in the militia, he graduated from Harvard in 1667, where he was ranked third socially in a class of seven. A well-connected Puritan, a friend of Increase Mather and John Eliot, he did not join the clergy, the expected vocation for a Harvard man. Instead, he taught Latin and English and cut the country's first known map, portrait, and scientific illustration. It is not known when Foster became interested in printing or where he learned his craft. It has been suggested that he saw opportunity in an open field. But Richard Holman, whose essays on Foster reveal these facts, finds it odd that "a member of the intelligentsia came to take up one of the mechanic trades." "It was," Holman says, "an unusual step in the seventeenth century."[8]

There appears to have been a need to elevate artisan-craftsmen. A 1681 announcement of Foster's death from tuberculosis at age thirty-three describes him as a schoolmaster, not a printer; and a later description by a contemporary of Foster's has the sound of defensive aggrandizement: "After a while I came to look on Foster as one of the great men of that great age...a man worthy of the love, friendship and admiration of the Mathers. Had Foster lived to the age that Franklin reached, Franklin might have been called a second Foster."[9] There is a touch of boosterism in the Benjamin Franklin comparison, a suggestion that respect for Foster may have been belated.

Peter Pelham represents the non-native printer, and one of the few English-trained printers who remained in colonial America. A portrait painter and professional engraver, Pelham apprenticed to John Simon, a leading London engraver, and by the time he settled in Boston in 1727 he had experience and skill. A reproductive engraver, Pelham made mezzotints after his own portraits, until John Smibert's arrival; after that, he produced mezzotints after Smibert's portraits. Of the fourteen mezzotint portraits he created, only his Mather portrait was financially successful. None of his other portraits of worthies did as well, but in February of 1728, Mather died; within a month Pelham had published and sold out his portrait; Mather's death created ingredients essential to printed pictures—demand and an audience.

The first mezzotint produced in North America, Pelham's professional, uninspired rendering of Cotton Mather is a stock portrait revealing less about Cotton Mather than about the taste for mezzotints in Restoration England (Fig. 5). (The popularity of the technique caused it to be called the *manière anglaise*.) Pelham, an Englishman, rendered Cotton Mather, a second-generation American, as an Englishman. His sly, knowing eyes, disdaining lips, and overly defined features give Mather the air of a fop, not a New England divine; and his about-to-double chin suggests a variety of vices Massachusetts clerics discouraged: lust, gluttony and greed. The workaday face has the aura of reproductive art; the nose and mouth have appeared before, and will appear again, fattened up a bit, in the face of Timothy Cutler, another cleric engraved by Pelham (Fig. 6).

Paul Revere (1735–1818) was a gifted silversmith and popular if workaday engraver who seldom created his own designs, but borrowed freely from available sources. He printed whatever needed printing — pamphlets, almanacs, calendars, trade cards, currency for the Massachusetts Bay Colony, political caricatures and propaganda. A merchant who understood supply and demand, he was the most popular and prolific silversmith in colonial America and one of the best-known printers. He was also a Revolutionary who understood the power of the press, and on March 5, 1770, when British soldiers shot into an unruly Boston crowd killing five colonists and injuring others, Revere saw an opportunity to incite feelings against the Crown and turn a profit. *The Bloody Massacre*, Revere's most famous and effective print (Fig. 4), taken from a drawing by Henry Pelham (1749–1806), was the first important print one colonist swiped from another.

In effect and intent, the Pelham and Revere engravings differ radically. Almost identical schematically, Pelham's black-and-white *Massacre* (Fig. 3), inscribed with a passage from the Ninety-fourth Psalm, is decorated with a circle holding a spectral cloud and two broken swords, an allusion to another biblical quote: "They shall beat their swords into ploughshares." Pelham was a Loyalist who returned to England before the Revolution. Pelham's *Massacre*, showing power's deadly, divisive effects, is a plea against violence and vengeance, not the Crown.[10] Revere was a member of the Sons of Liberty. Printed in violent oranges and inciting reds, his *Massacre* encouraged Revolutionary fervor. Zealous couplets in the accompanying legend refer to British soldiers as grinning barbarians, as "savage bands" with "bloody hands." Revere's Redcoats appear as gleeful sadists. Pelham's soldiers look only bedraggled.

It is not known how Pelham's print fared. Revere's speed at issuing his engraving may have cut Pelham out of the market. Revere sold 200 copies of his *Massacre* and demand for the print was great enough for Jonathan Mulliken, a Newburyport clockmaker, to issue his only known print, a version of the massacre after Revere's. Over one percent of Boston's population of 15,000

Overleaf:
Fig. 5
PETER PELHAM
Cottonus Matherus, 1728
Mezzotint
The Metropolitan Museum of Art, New York; Bequest of Charles Allen Munn

Fig. 6
PETER PELHAM
The Reverend Timothy Cutler, D.D., 1750
Mezzotint
American Antiquarian Society, Worcester, Massachusetts

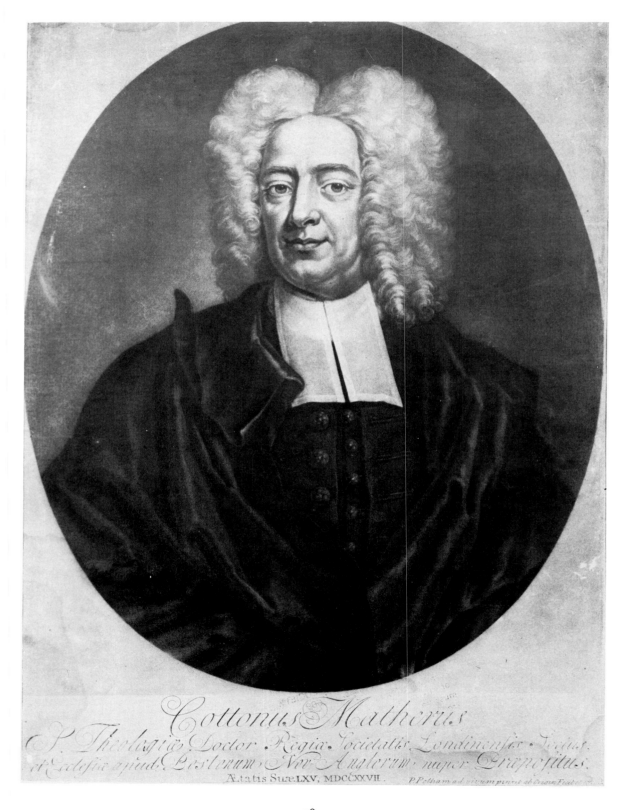

Cottonus Matherus

S. Theologiæ Doctor. Regiæ Societatis Londinensis Socius.
et Ecclesiæ apud Bostonum Nov Anglorum nuper Præpositus.

Ætatis Suæ LXV. MDCCXXVII. P. Pelham ad vivum pinxit et Quasi Fecit.

18

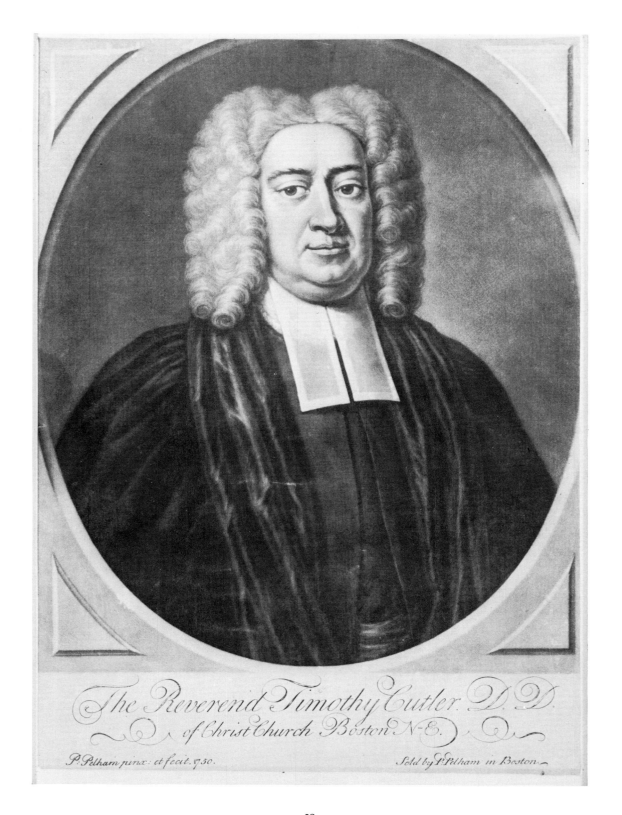

The Reverend Timothy Cutler. D.D.
of Christ Church Boston N-E.

P: Pelham pinx: et fecit. 1750. Sold by P. Pelham in Boston.

owned the Revere print and many more saw it. It was like watching a murder on live-action news. The image circulated so pervasively—and many felt so misrepresented the facts—that at the trial of the British soldiers, John Quincy warned the jury of being unduly influenced: "The prints exhibited in our houses have added wings to fancy; and in the fervor of our zeal, reason is in hazard of being lost."[11]

Budding nationalism brought factional passions, focus and, as evidenced by the 200 owners of the Revere print, an audience for graphic art. As national purpose altered, so did prints' subject matter. In the years directly following the Revolution, commemorative prints of historic events and the Founding Fathers would replace utilitarian maps and portraits of clerics. The Revolution meant the beginning of a national mythology, battles and heroes that graphic artists could depict for centuries. By the second half of the eighteenth century America had newspapers, printers and presses, but the quality and production of American graphic art did not improve.

In April of 1775, shortly after Paul Revere had made his famous ride, Amos Doolittle (1754–1832), a fifth-generation American and a Revolutionary, traveled with his friend the portrait painter Ralph Earl to the battle sites of Lexington and Concord, or so the story goes. Motivated by patriotism and profit, Earl and Doolittle created, rendered, and re-rendered the news. Earl painted the battle sites as flat, primitive landscapes, punctuated by Redcoats, fires, gravestones, farmhouses and trees. Doolittle reportedly posed for Earl's naive history painting.[12] For *A View of the Town of Concord* (Fig. 7), he assumed the position of the two foreground figures. In Earl's painting and Doolittle's engraving after it, Redcoats appear lined up like the guards at Buckingham Palace; precisely placed gravestones create a perfect balance.

Doolittle had an earnest, clumsily emphatic, primitive line. He was without a knack for verisimilitude, but during his long printmaking career, he engraved, printed and published maps, church music, a Prodigal Son series, patriotic portraits, and regularly issued engravings of each incoming president. With more competition, Doolittle might not have had a career at all. But at the end of the eighteenth century, America still had few skilled printers.

In contrast, London had a profitable print trade and a highly skilled work force of engravers, who regularly turned out reproductive engravings after paintings. Before the French Revolution halted continental sales, English print publishers earned over 200,000 pounds a year. One print alone, Woolett's engraving after Benjamin West's *Death of General Wolfe*, earned its publisher 15,000 pounds.[13] Aware of the immense sums painters and publishers earned across the Atlantic, in the years following the Revolution, American printers produced prints, hoping to repeat West's great successes.

In 1787, broke and overextended, Charles Willson Peale (1741–

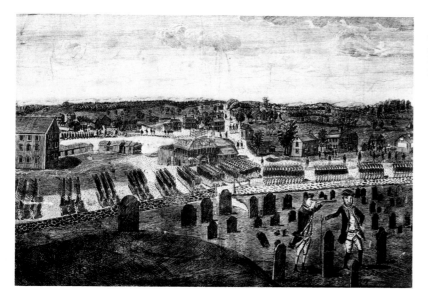

Fig. 7
Amos Doolittle
A View of the Town of Concord, 1775
Engraving with hand-coloring
Print Collection, The New York Public Library, Astor, Lenox and Tilden Foundations

1827) engraved, printed and published a series of mezzotints after his portraits of, among others, Lafayette and Benjamin Franklin. But even after he had reduced the price of his mezzotint of Lafayette from one dollar to "two-thirds of a dollar," Peale found no takers.

John Trumbull (1756–1843) told George Washington that the success of his prints would gauge the American attitude toward art. His effort began promisingly. To his first offer of two engravings after his paintings *The Death of General Montgomery in the Attack on Quebec* and *The Death of General Warren at the Battle of Bunker's Hill*, at three guineas, his 300 subscribers included the president of the United States, seventeen senators, and twenty-seven members of the House of Representatives. *The Death of General Montgomery* was issued in 1792, seventeen years after the event it depicted. Unable to find competent craftsmen, Trumbull contracted his work out to European engravers; but by the time they'd finished, his subscribers had lost interest. "Wherever I went I offered my subscription book," Trumbull wrote. "And rapidly decreasing was the enthusiasm for my national work. The progress of the French Revolution blasted my hopes."[14] Trumbull had taken too long. His conservative subscribers found pictures glorifying the battles of America's first civil war dangerous.

Historically, interest in prints increases when there is a prosperous middle class. Post-Revolutionary conditions in America were unfavorable to the buying, selling and making of prints. A decade-long depression followed the Revolutionary War. The country's population was primarily rural, isolated and poor; and until the Constitutional Convention, the states were barely united at all; fighting over boundaries and trade, they had lost sight of their national purpose.

II

ANOTHER country entirely, nineteenth-century America was anything but image poor. English-trained printers continued to immigrate, only in the nineteenth century they prospered. Lithographers printed sheet music, trade cards and theatrical posters. The rise of the illustrated press provided a forum for illustrators. Winslow Homer was the star reporter for *Harper's Weekly*, which regularly ran wood engravings by English illustrators and the cartoons of Thomas Nast. Every kind of graphic art was produced in nineteenth-century America—except fine art prints.

The less than successful War of 1812 had fostered nationalism and a desire for a historical past. America had become a nation before she had a history, and there was a need for national definition and a sense of continuity. Printed pictures helped satisfy that need. Depictions of Revolutionary battles, proscriptions of moral conduct, definitions of national character spread and reinforced cultural and political mythologies. Every political and moral issue from Jacksonian democracy to temperance appeared in printed pictures. They documented the War of 1812, the Civil War, the expansion of the frontier, the growth of railroads.

Popular lithographs restated history, altered facts. In John H. Bufford's 1857 *Boston Massacre* (Fig. 8), Redcoats remain aggressive, but the British captain crawls and cowers. The Bostonians do not flee as they did in Revere's print. One lone, brave colonist, embodying ideal attributes of the American character, holds off the British, while a Redcoat kills a black Bostonian, the print's

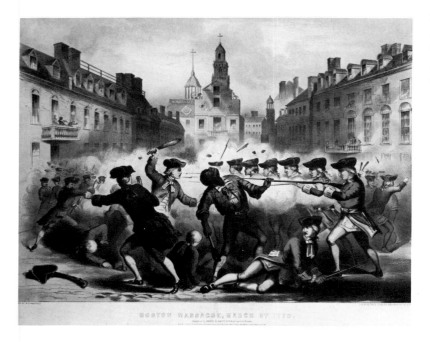

Fig. 8
JOHN H. BUFFORD
Boston Massacre, March 5th. 1700,
 1856, drawn by William L. Champney
Chromolithograph
The Bostonian Society, Boston

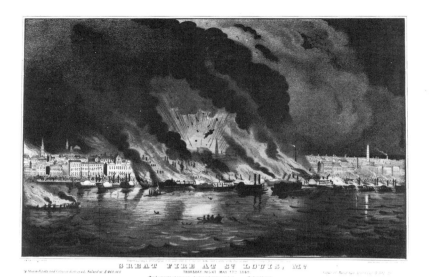

Fig. 9
NATHANIEL CURRIER
Great Fire at St. Louis, Mo., 1849
Lithograph with hand-coloring
The Old Print Shop Inc., New York

central figure. A black was indeed killed at Boston, but Bufford's massacre is a Northerner's view of pre-Civil War America.

Industrialization and technological developments also created a demand for printed pictures. As industry grew and transportation systems expanded, wider distribution of goods became possible and mass production became the American way. Increase in commerce brought a new demand for printing—calling cards, placards, advertisements, and financial notes.

By the 1830s America had a taste-conscious middle class, who cared about what they wore and how they lived. They read *Godey's Lady's Book* to find out how others lived, and acquired the Philadelphia *Atlantic Souvenir*, New York's *The Talisman*, and *The Hyacinth*—gift books whose articles were illustrated with engravings after paintings by Washington Allston and Thomas Cole.

The age was as graphic as our own, only the technology was different. From 1825 through the 1890s, flourishing lithography shops produced harbor views and still lifes, portraits and moral warnings that met every taste (Fig. 15). The first, the Pendleton Shop in Boston, founded in 1825, issued prints after paintings by Gilbert Stuart, Samuel F. B. Morse, and Thomas Sully, and hired artists Fitz Hugh Lane, David Claypoole Johnston, Rembrandt Peale and William Rimmer to create original lithographs. More respectful of the artist's role than other litho shops, Pendleton's was also less successful. The public taste for lithographs was not a taste for art, but a taste for information and decoration. Buyers of lithographs, who responded to advertisements, like those of Currier & Ives billing lithos as "cheap engravings for the people," preferred pictures of firemen to pictures of art. Those who were art-conscious joined the American Art-Union and received engravings after paintings as part of their membership premium.

Overleaf:
Fig. 10
CURRIER & IVES
The American Fireman, Prompt to the Rescue, 1858
Lithograph with hand-coloring
The Old Print Shop Inc., New York

Fig. 11
NATHANIEL CURRIER
Awful Conflagration of the Steam Boat Lexington in Long Island Sound, 1840, drawn by N. Sarony and W. K. Hewitt for the New York *Sun*
Lithograph
Museum of the City of New York; Harry T. Peters Collection

L. Maurer.

THE AMERICAN FIREMAN,
Prompt to the Rescue.

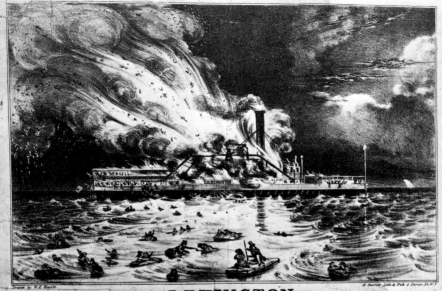

Awful Conflagration of the Steam Boat **LEXINGTON** In Long Island Sound on Monday Eve^g. Jan^y 13^th 1840. by which melancholy occurrence, over **100 PERSONS PERISHED.**

THE LEXINGTON

Fig. 12
NATHANIEL CURRIER
*Washington Taking Leave of the Officers
of His Army...Dec. 4th, 1783*, 1848
Lithograph with hand-coloring
Museum of the City of New York; Harry
T. Peters Collection

Advertising their prints as "suitable for framing or the ornamenting of walls...the backs of bird cages, clock fronts or any other place where elegant tasteful decoration is required," Currier & Ives were not in the art business. As their catalogue stated, they sold "the best, cheapest and most popular pictures in the world," and from 1857 to 1907, they lithographed over 7,000 subjects, in large and small folio sizes that ranged in price from eight cents to three dollars. No other firm equaled their production or marketing techniques.

An assembly line produced their collaborative efforts. Staff artists drew the picture or copied the drawing of freelancers. The lithographer modified it, and once printed, a line of young immigrant girls, seated at a long table, colored the prints by hand. There was a girl for each color, and a specialist who handled difficult passages and added finishing touches.

In January of 1840, five years after the firm was formed, the steamship *Lexington* burned and sank in Long Island Sound. Over 120 passengers perished. The tragedy did wonders for Nathaniel Currier's business. Within days, his lithographers had drawn the tragedy and Currier had convinced Benjamin Day, editor of the New York *Sun*, to run the litho in an extra edition (Fig. 11), which became the country's first illustrated news extra. Demand for the print was unprecedented. Within a short time, fires became one of the company's stock items and a house specialty. But Currier did not stay in the illustrated news business, which wood-engravers were about to take over. Understanding the public taste for violence, he mass-produced fire pictures. Voracious flames raced across prairies and consumed buildings. For almost every city that burned in nineteenth-century America, there was a Currier & Ives lithograph to commemorate it. Not only a pop-

ular stock item, the fire prints, compositionally strong, were far more interesting than the honeyed optimism the average print conveyed.

Currier & Ives lithographed any subject or opinion with a market. Categories among their catalogue listings included "Love Scenes, Kittens and Puppies, Ladies' Heads, Landscapes, Vessels, Flowers and Fruits." Apolitical and non-partisan, they purveyed patriotism and prejudice. In Civil War scenes, the North is always winning; in the popular *Darktown* series (advertised as comic prints), blacks are burlesqued as Uncle Toms, unable to meet the white world's standards. Lithographs poked fun at recent Irish immigrants and were sometimes altered to meet prevailing tastes. When the temperance movement brought a brisk business in printing moral warnings (Fig. 16), the firm's heavy-drinking chief lithographer deleted the wineglasses and decanters from the 1848 lithograph of Washington at Fraunces Tavern (Figs. 12, 13).

Currier & Ives was one of many thriving firms. William Sharp (1803–1875), an Englishman, introduced chromolithography to America in 1839 and produced elegant botanical prints after English engravings. (In chromolithography, impressions are not hand-colored but printed, by running separate stones for each color through the press.) In Boston, the more saccharinely inclined lithographer Louis Prang (1824–1909) designed lithographs for specific rooms in the house. Pictures with titles like *Cherries in a Basket* were made to hang in Victorian dining rooms. "Our fruit and flower pieces," Prang's catalogue read, "are admirably adopted for the decoration of dining rooms and parlors."

Son of a Prussian calico printer, Louis Prang was after the

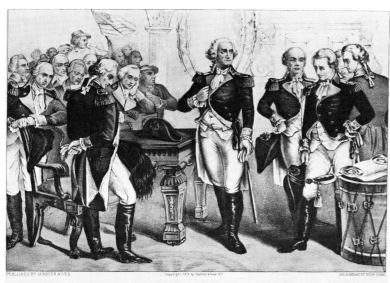

Fig. 13
CURRIER & IVES
Washington's Farewell to the Officers of His Army, 1876
Lithograph with hand-coloring
Museum of the City of New York; Harry T. Peters Collection

Fig. 14
L. PRANG & COMPANY
Lawn-Tennis, 1887, after painting by
 Henry Sandham
Chromolithograph
Hallmark Historical Collection, Kansas
 City, Missouri

same market as Currier, but he aimed at both its high and low ends. He printed greeting cards and cards of monarch butterflies, blue jays and Hudson River waterfalls, and sold 40,000 copies at twenty-five cents each of a map detailing a Civil War battle. For the high end, he reproduced paintings in chromolithography (Fig. 14). Eastman Johnson's *Boyhood of Lincoln* sold for twelve dollars, four times the price of Currier & Ives' most expensive print.

Technically more sophisticated than Currier & Ives, whose lithographs were hand-colored, Prang produced exactly registered color prints such as those for *Oriental Ceramic Art* (D. Appleton & Company, 1897). He used as many as forty-five stones for one image, which he printed on a steam press that could produce 5,000 impressions a day. In 1885, Prang employed thirty-two artists; like Currier & Ives, Prang did a booming business in printed pictures. But unlike his New York colleagues, Prang stayed abreast of technological developments. The widespread use of photography eventually put the Currier & Ives firm out of business; far more modern in his outlook, in 1897 Prang merged his firm with the Taber Art Company in Springfield, Massachusetts, whose specialty was creating photographic reproductions on gelatin plates.

The painters Thomas Sully, Rembrandt Peale, Thomas Doughty and the architect Alexander Jackson Davis earned a living working for the lithographic firms. And a few painters, among them George Inness, William Sidney Mount and Rembrandt Peale, tried to create original images in lithography. But the results, as seen in Rembrandt Peale's lithographs, were ordinary, and showed no particular understanding of the medium's process or potential. The American artist did not regard lithography as an artist's medium as Géricault had in France or Goya had in Spain. The average nineteenth-century lithograph was not fine but popular art.

Opposite:
Fig. 15
HASKELL & ALLEN
The Old, Old, Story, c. 1871–75
Lithograph
The Old Print Shop Inc., New York

PUBLISHED BY HASKELL & ALLEN, 61 HANOVER ST BOSTON, MASS.

THE OLD, OLD, STORY.

WOMANS HOLY WAR.

Grand Charge on the Enemy's Works.

In Europe the woodcut, the simplest, least costly reproductive medium, had been the poor man's pleasure; engravings, requiring more time, expertise, and expensive materials, had been bought by the middle class. (Dürer's engraved *Passion* cost four and a half times more than his smaller woodcut *Passion*.) In England and America, similar distinctions existed between lithography and engraving. Lithography, a fast, cheap commercial form, provoked Ruskin's 1857 pronouncement "Let no lithographic work come into your house if you can help it."

Changing taste did not put the lithographers out of business; new technologies did. As lithography's speed had modified the function of copperplate engraving, the wood engraving's portability —which allowed artists to draw on the spot—had taken over the lithograph's illustrative and reportorial functions, and the camera's ability to reflect reality assumed lithography's reproductive functions. Who needed to buy a lithograph of a fire when you could see the real thing in a photo?

In America, lithography's commercial functions affected the medium well into the twentieth century. In 1917, George Bellows, already creating his successful and popular lithographs out of build-ups of inky tones, wrote: "I am doing what I can to rehabilitate the medium from the stigma of commercialism that has attached itself to it so strongly.... The mechanics are such as to drive away the artist who would contemplate its use."[15]

Engraving served different functions from those of lithography. Considered a more refined medium, it played an important role in the mid-nineteenth-century New York art world. The new nationalism that demanded history also created a need for an American culture, for American literature and American art. In 1826, hoping to make art known to an "art concerned" public, Samuel F. B. Morse and Asher B. Durand helped found the National Academy of Design. In 1838, William Dunlap published his still important, three-volume encyclopedic chronicle, *A History of the Rise and Progress of the Arts of Design in the United States*. That same year, James Herring, a portrait painter, opened New York's first public exhibition space, the Apollo Gallery at 410 Broadway, with ambitious plans. Charging twenty-five cents admission and one dollar for a season ticket, Herring hoped to promote the fine arts in the United States. The venture failed. In 1839 the Apollo Gallery became the Apollo Association for the Advancement of Fine Arts in the United States. Its goals, like Herring's, were "to cultivate artistic talent and promote popular taste."

For a five-dollar membership fee, subscribers received "a large and costly Original Engraving from an American Painting"—along with a ticket to the annual lottery of original paintings. The association, which in 1844 became the American Art-Union, was the first venture in the mass distribution of art. By 1846, the Art-Union's 4,457 members, who had paid a total of 22,293 dollars, received an engraving after George Caleb Bingham's *The Jolly Flat-Boat Men*. By 1849, the Union had distributed over 50,000

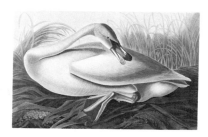

Fig. 17
JOHN JAMES AUDUBON
Trumpeter Swan, 1837, engraved by
 Robert Havell
Engraving with aquatint and hand-
 coloring
Associated American Artists, Inc.,
 New York

Opposite:
Fig. 16
CURRIER & IVES
Woman's Holy War, 1874
Lithograph
The Old Print Shop Inc., New York

reproductive engravings after paintings by, among others, Asher B. Durand, Thomas Cole, Emanuel Leutze and William Sidney Mount. The selection committee chose prints that would match the popular taste. They had a predilection for moralistic genre scenes of minor aesthetic merit and naturalistic images that conveyed a mannered sentimentality equaled only by the lithographs of Currier & Ives. With the exception of a series illustrating Washington Irving's *Rip Van Winkle*, the prints issued by the Art-Union were, like many prints published in nineteenth-century America, reproductive, rather than attempts to create original art.

Until the advent of the lithographic firms, prints reflected reproductive vision and foreign skills. English emigrés continued to produce many of the best nineteenth-century prints. As they had a century before, printers came in search of opportunity. John Hill, who engraved for Turner, Rowlandson, and Colnaghi & Son in London, settled in Philadelphia in 1816. The best aquatint engraver in America, his *Hudson River Portfolio* (1820–28), which he engraved after watercolors by William Guy Wall, sold in the thousands. Hill's engravings set the standard for nineteenth-century landscapes and views, and he had virtually no competition until the arrival of another Englishman, the equally skilled engraver William James Bennett. On occasion Bennett drew his own designs, but most of his engravings were after paintings.

Being reproductive does not lessen the quality of graphic art; it only alters the standard that measures the work. Skill, truthfulness and the indefinable means by which an artist captures the aura of an original work mark great reproductive prints. John James Audubon (1785–1851), half-French, half-Creole, raised in Louisiana and Nantes, considered himself a natural scientist, not a fine artist. But his brilliantly colored, monumentally scaled, sometimes screeching, sometimes airborne acrobatic birds, made after watercolors, are among the best nineteenth-century American prints (Fig. 17). Only, they aren't quite American. Engraved, printed and hand-colored in London by Robert Havell and his son Robert Havell, Jr., they too reflect English skill.

Audubon couldn't find a printer in North America who could engrave and etch his plates, but not because by then one did not exist. He approached Alexander Lawson, who a few years earlier had engraved Alexander Wilson's drawings for *American Ornithology, Or the Natural History of the Birds of the United States* (1808–14). But Lawson, who probably regarded Audubon as unwanted competition for his friend Wilson, refused, claiming that Audubon's birds were badly drawn and anatomically incorrect, that he made feathers too large and gave turkeys flat feet. In 1826, Audubon left for England in search of a printer.

Only one American engraver could equal the work of English-trained printers. Asher Brown Durand (1796–1886) was in his mid-twenties when he began work on an engraving after John Trumbull's *The Declaration of Independence of the United States of America* (Fig. 18). Like Trumbull's other print ventures, the engraving was

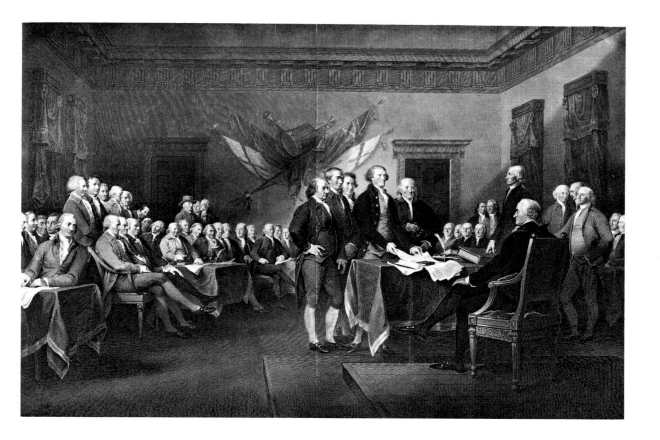

Fig. 18
ASHER BROWN DURAND
The Declaration of Independence of the United States of America, 1820, after painting by John Trumbull
Engraving
Print Collection, The New York Public Library, Astor, Lenox and Tilden Foundations

financially unsuccessful; and despite his own personal solicitation, Trumbull had to mortgage the plate while Durand was working on it. But the results pleased Trumbull and established Durand as one of the country's preeminent engravers. The largest engraving ever finished in America at that time, it was so large that a printer could not be found to handle it and eventually an English printer was imported for the job.

A superb craftsman who only occasionally worked from life, Durand was a reproductive engraver in the printed picture business. He had a sure touch and the ability to achieve with a linear syntax the most delicate modeling. Changing tones and rounding contours, he made alterations to meld the old image into the new medium. His most famous engraving, *Ariadne* (Fig. 19), after the painting by Vanderlyn, humanizes the sentimental neoclassical nude. Durand loved *Ariadne* and, being a romantic, was probably equally taken with the myth. With an almost imperceptible network of airy lines, Durand connected the floating nude to her sylvan background, and with the same lines, he imbued expectation into every contour of her body.

Durand's engraved work showed the talent that would lead him to painting the *plein air* of the Hudson River Valley and the confidence that would elect him president of the National Acad-

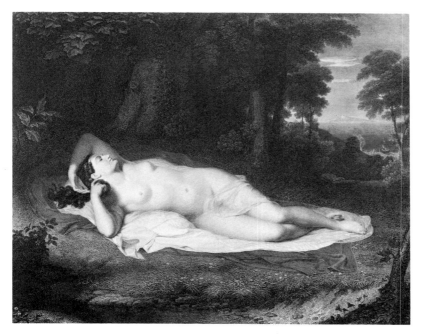

emy of Design. But once he began to paint full-time, Durand
stopped printing. "As successful as he had been," John Durand
wrote in his biography of his father, "it must be said that he
was not fond of it [engraving]." But Durand engraved *Ariadne*
for his own pleasure, and the energy reflected in the mythic
nude suggests that the son was, perhaps, only making a case for
the father's higher aspirations.

To many nineteenth-century artists, printing and painting
were separate and unequal endeavors. Graphic arts were a prac-
tical means for the artistically inclined to earn a living, but
were not considered either an artist's medium or profession.
Making prints carried connotations of labor. Artist and artisan,
painter and illustrator, occupied separate worlds whose bounda-
ries would remain intact even after expatriate James McNeill
Whistler's influence made its way across the Atlantic.

Winslow Homer (1836–1910) was an exception. For thirteen
years, he worked simultaneously as a painter and wood-engraver,
and ten years after he stopped engraving, he learned to etch. He
began as a lithographer, working at the Bufford Shop in Boston.
When only twenty he produced exacting lithographic portraits of
forty-two members of the Massachusetts Senate. But he hated
the work. It was his first and last nine-to-five job.

With the rise of illustrated newspapers came a demand for
wood-engravers. Faster than lithography, wood engraving involved
no heavy stones. Artists drew sketches, which copyists transferred
to the whitened end-grain of boxwood which, when cut by en-
gravers, left black lines in relief; or, as in Homer's case, the artist
drew directly on the boxwood. To support himself and maintain

his independence, Homer taught himself wood engraving.

For ten years before he started to paint, Homer worked as a "special reporter" for *Harper's Weekly*. Although known as a reportorial engraver, Homer only occasionally rendered the news. Born and raised in Boston, he idealized country life. His engravings reflect a bucolic world of girls in hammocks and boys in trees, a place inhabited by John Greenleaf Whittier's "Barefoot Boy"—only Homer avoided Whittier's sentimentality. He drew metropolitan as well as country life. Homer's city bears no resemblance to the one American illustrators, such as Reginald Marsh, drew a century later. As innocent and safe as the country where his farm boys make hay, it is a city without a grim side, where children play in Boston Common and couples skate. A sleigh turns over, but carriages do not crash, and buildings do not burn. Instead, the skirts of winsome women billow in breezes and men lose top hats to the wind.

When Homer did render the news, he didn't do it well. His Civil War engravings, his major journalistic assignment, are unconvincing. He couldn't catch the action on a battlefield that he could on a skating pond. *The War for the Union 1862—A·Cavalry Charge* (1862) looks like a copy of a bad history painting; in *The Army of the Potomac—A Sharp-Shooter on Picket Duty* (Fig. 20), one of Homer's strongest graphic compositions, a ready soldier perches in a tree, his leg dangling over a limb against a feathery background of pine needles, looking like a boy in the woods, playing war. But Homer was a great illustrator. Positioning his subjects in the foreground, he created immediacy; and by stopping the action—showing a dancer dancing—he gave viewers access to the events he depicted. The etchings he produced after paintings lack the compositional originality of his wood engravings; except for background changes, they follow his paintings almost exactly.

Fig. 20
Winslow Homer
The Army of the Potomac—A Sharp-Shooter on Picket Duty, 1862
Wood engraving
Whitney Museum of American Art, New York; Purchase

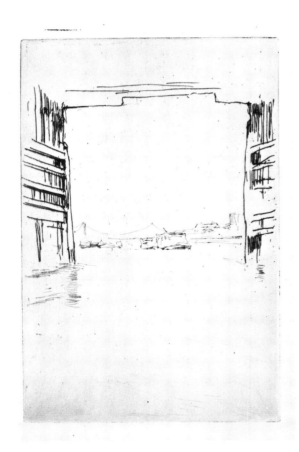 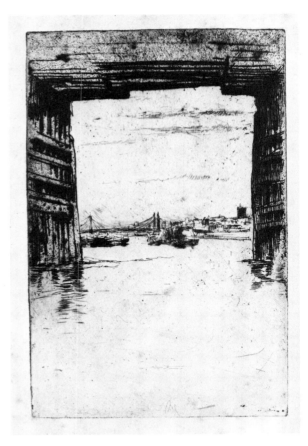

The first Americans to create important bodies of printed art—James McNeill Whistler and Mary Cassatt—were both expatriates. Whistler etched plates in London, Paris and Venice; Cassatt worked in France. In effect, both belong to a European fine art print tradition, not an American one. When James McNeill Whistler (1834–1903) arrived in Paris in 1855, a renewed interest in Rembrandt's etchings had swept across Europe and settled in France. Barbizon artists etched from nature; their printer, Auguste Delâtre, experimented with the wiping and inking of etchings. Enamored by the freedom they believed etching allowed, French critics described the medium's properties, proclaimed its ability to catch essences, and argued pros and cons of expressive printing.

In one of many short stints of gainful employment, Whistler etched topographical maps for the United States Coast Geodetic Survey, and when he arrived in France he was already an able draftsman—on the eve of the etching revival. *The French Set* (1858), his first etchings, reflects a young journeyman's abilities. Dependent on crosshatching for contrast and tone, *The French Set* reveals a debt to Charles Méryon and an overexposure to British etching. Although his etchings of the Thames, of docks, longshoremen and the dangled riggings of sailing ships are sometimes too busy,

Left:
Fig. 21
JAMES MCNEILL WHISTLER
Under Old Battersea Bridge, State I, 1879
Etching
S. P. Avery Collection, The New York Public Library, Astor, Lenox and Tilden Foundations

Right:
Fig. 22
JAMES MCNEILL WHISTLER
Under Old Battersea Bridge, State III (final state), 1879
Etching
Hunterian Art Gallery, University of Glasgow, Scotland

they show the compositional devices to come. The dark doorways and long passageways, centered in the Venetian views, maintaining flatness and creating depth, are seen in the earlier *Limeburner*; and Whistler's major graphic innovation—expanses of blank space that carry content—appear in *Under Old Battersea Bridge* (Figs. 21, 22).

Whistler made his greatest prints in Venice. With a sparseness as improbable as Venetian opulence, he caught her Byzantine grandeur. He sketched distant palazzos in jagged outlines, leaving nothing to fill in. Regarding the etching needle as an extension of his hand, to work on plates he warmed up like a baseball player, circling his arm in the air, gaining momentum before he swooped down on the plate and left a mark.

The more he worked at etching the more involved he became in its process. Reworking the Venetian plates in as many as eleven states, he added and deleted lines; printing himself, he varied tones. Leaving layers of filmy ink across the plate, he created dusk in *Nocturne*; in another impression, he altered the ink ever so slightly, changing time and climate.

Aware of the equation between a medium and its means, Whistler worked with the essentials of etching: line, plate, ink and tone. Copperplates were his sketch pad; he used them like paper. Taking into account the plate size, he positioned compositions to fill the whole space. The plate edge was as important a consideration as inking. Buildings and ships' masts extend beyond the plate mark; bridges extend outside the margins; windows continue upward out of sight; the plate edge framed Whistler's view. In the Venice etchings he reversed the technique. Centering compositions, he left the border areas empty, except for tone (Fig. 22). Compositions stretch out like a horizon line, creating a massive scale.

Whistler's interest in prints was not purely aesthetic. With his brother-in-law Francis Seymour Haden, he is responsible for the modern practice of limited editions and hand signing. For the prints he signed by drawing a butterfly on a little tab, Whistler charged double.

Whistler had his own line, which has been constantly imitated and never matched. He was America's first great fine art painter-printmaker, but nothing particularly American distinguishes his etchings. The flat space and distant perspectives of his Grand Canals reflect the influence of Japonisme; light breaking through inky tones shows an awareness of Impressionism. The view itself, casual, everyday sorts of sketches of gilded palaces and labyrinthine monuments to power, is not an American one. The spare, offhand view of opulence is one Whistler formed as a young boy visiting Russia's royal court, where he grew accustomed to grandeur.

For decades, Whistler's influence hung over American etching like a thick fog. But the innovations he had brought to etching— the spare, active line, centered compositions, blank spaces that

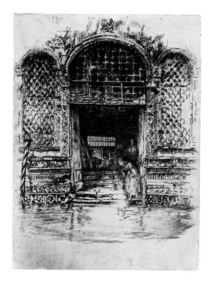

Fig. 23
JAMES McNEILL WHISTLER
The Doorway, State III, 1880
Etching
S. P. Avery Collection, The New York
 Public Library, Astor, Lenox and
 Tilden Foundations

suggest an expansive scale, variations in ink and printing—became, in the hands of lesser graphic artists, a mannered poetry of decay.

Nothing particularly American characterizes Mary Cassatt's (1844–1926) etchings either. Her prints show Degas' influence and the fascination for Japanese prints she shared with him and other French Impressionists. Cassatt created over 200 prints. Many reflect too much discipline. Her often tight, overly determined line lacks suppleness. Cassatt's babies have static, overly rounded bodies, like Ideal toys, and Kewpie-doll faces. In *By the Pond* and *The Tramway* women hold children uncomfortably. Except in *Maternal Caress*, Cassatt's women and children do not look as though they belong together.

Still, Cassatt's 1891 color aquatints remain unequaled. Upon seeing them, Degas said that he could not believe that a woman drew so well. With line, brilliant colors, and patterns, she created interiors where women bathe, drink tea, and caress babies. Having studied Japanese prints, Cassatt began the aquatint project with plans to imitate *ukiyo-e* woodcuts. The prints' boudoir atmosphere is French, but through a rigorous handling of process, she transposed the flat surfaces and deep perspective of *ukiyo-e* woodcuts into etching. Building domestic scenes out of angles, patterns, and reflecting mirrors, Cassatt created complicated interiors and spaces within spaces.

As involved with process as Whistler, Cassatt worked slowly, building aquatints like paintings. She started with line to block out compositions (Fig. 24), added colors and patterns, revising and refining until the image was resolved. In *The Letter*, State II (1891), lines have been covered with colors, but the picture's space is undefined; the lady's skirt merges into the desk, and it is unclear whether she is sitting, kneeling or standing. In its final state (Fig. 25), additions of color, pattern and perspective resolve the images. The placement of the letter directs the eye back into space. The lady's position echoes that of the letter. Patterning creates the compositional drama. The flowered background, which meets the patterned blue dress, offsets the foreground composition; at the same time, the two patterns merge, forming a disjunctive flatness.

In 1881, Sir Francis Seymour Haden, surgeon and etcher, confidant of James McNeill Whistler and a devoted proponent of the art of etching, toured the United States, delivering lectures and giving demonstrations of etching in New York, Boston, Baltimore and throughout the Midwest. Espousing the beliefs of the French etching revival, Haden spoke of etching's superiority over engraving. The etcher worked from nature; the engraver relied on drawings. Etching thus permitted artists freedom, while engravers were slaves to their tools. Audiences listened attentively to the man who had said: "I believe the etching needle is as good as the pencil, just as the brush is as good as the chisel, but we ought to use it as poets, not as artisans." It was the perfect moment. An interest in etching had swept the country. Etchings had been shown at the Philadelphia Centennial Exhibition of 1876. By then, Bos-

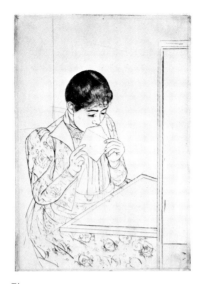

Fig. 24
MARY CASSATT
The Letter, State I, c. 1891
Etching with drypoint
The Metropolitan Museum of Art, New
 York; Gift of Arthur Sachs

ton, Philadelphia, New York and Cincinnati had organized etching clubs, and the following year Brooklyn formed the aptly named Scratchers' Club.

"To use it as poets, not as artisans," that was the hard part for American artists. Painters were poets; printers were artisans. The freedom Haden espoused and believed essential to etching was antithetical to everything American artists thought about printed art. The new interest in etching as a *peintre-graveur* medium produced dismal results.

James Smillie, an engraver and son of the man who produced the Art-Union prints, fittingly became the first president of the New York Etching Club. His description of the club's first meeting set the tone of late nineteenth-century etching: "Then, an elegant brother, who had dined out early in the evening, laid aside his broadcloth, rolled up the spotless linen of his sleeves and became for the time an enthusiastic etcher." An earnest dilettantism characterized the American etching clubs. Their members included the talented Moran family—but had no Millets, Whistlers or Hadens. Hobbyists, the men in broadcloth suits and linen shirts, were enthusiastic gentleman printers. At the end of the century, America barely had a fine art print tradition at all.

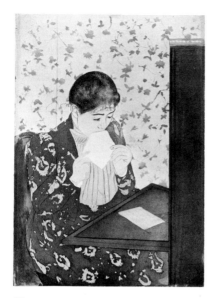

Fig. 25
MARY CASSATT
The Letter, State III (final state), 1891
Etching with aquatint, soft-ground, and
 drypoint
The Metropolitan Museum of Art, New
 York; Gift of Paul J. Sachs

III

AMERICA produced few graphic artists as original as Whistler or Cassatt. Although Thomas Moran and Impressionists J. Alden Weir and John Twachtman each produced a few interesting prints, nineteenth-century America fostered no important *peintre-graveur*. Winslow Homer's wood engravings, Thomas Nast's political cartoons, and the technical quality of reproductive lithographs and engravings represent the nineteenth century's contributions to graphic arts.

The commercial, reportorial images, which characterized nineteenth-century graphics, tainted twentieth-century printmaking. The old bias, stemming from the print's craft status, remained. Printmakers were regarded as hobbyists, commercial artists, and amateurs. The meaning of amateur had changed from "a lover" to "a non-professional," but the distinction between printmaker and painter was the old one first formed in colonial America; it separated artisan from artist, craft from inspiration and work from art.

Still, during the first decades of the twentieth-century printmaking flourished. Through the 1920s, amateur etchers continued their Whistlerian charade. Realists George Bellows, Edward Hopper and John Sloan printed the city. America had print dealers and collectors. In 1910, the Grolier Club published its catalogue raisonné of Whistler's etchings; a decade earlier, the firm of M. Knoedler & Co. had exhibited English mezzotints from J. P. Morgan's collection. Until 1929, the country had a healthy print market, and collectors bought prints on grand tours, acquiring works

by Whistler, the Old Masters, and D. Y. Cameron, a fashionable journeyman English etcher.

By 1935, John Marin, George Bellows, Milton Avery, and Stuart Davis had made lasting contributions to American print-making. The print had teachers and spokesmen. Joseph Pennell, at the Art Students League, tried to give lithography a good name. Kenneth Hayes Miller, a painter, printmaker, and pivotal force in the Fourteenth Street School, taught Reginald Marsh and Isabel Bishop to etch. In the 1930s, the Works Progress Administration introduced artists to woodcut, a medium which until then had been disdained and only used successfully by European emigrés; and George Macy founded the Limited Editions Club, commissioning artists as disparate as Fritz Eichenberg and Reginald Marsh to illustrate literary classics ranging from Dostoevsky to Dreiser.

Throughout the decade artists conveyed hard times in dark lithographic tones. William Gropper protested non-union labor practices. Rockwell Kent cut curves in wood that promised hope, purveying the earnest message that given the right politics man could prevail. In the 1940s artists banded together to form publishing programs, but their efforts were short-lived.

For all the activity, one development in printed art rarely influenced or led to another. Seldom critically discussed, writing on prints usually appeared in catalogues raisonnés and carried the eulogistic tones that characterized seventeenth-century descriptions of John Foster's career. According to the literature of American prints, everyone is a would-be Ben Franklin.

The graphic tradition that evolved was fragmented. Regionalists, Social Realists, and an occasional abstractionist each approached the medium differently. Some artists, such as Charles Sheeler, made a few inventive prints and then curtailed print-making activities. More typical were artists like John Sloan, whose late work deteriorates into heavy-handed craft, or painters, such as Childe Hassam, who despite the reputation his graphics still enjoy, created few exceptional prints. The only characteristic uniting the graphic art produced between 1900 and 1950 is its illustrative quality: images are more appropriately discussed in terms of their subject matter than their art.

Twentieth-century printsellers followed their nineteenth-century predecessors. Fine art print publishers appropriated the techniques established by merchandisers of popular prints. Associated American Artists, which began its still existent publishing program in the 1930s, advertised five-dollar lithographs as "cheap lithographs for the people," and published prints that met popular taste—Regionalist views of wheat fields and folk heroes by Grant Wood (1891–1942) and Thomas Hart Benton (1889–1975) offered an optimistic antidote to the breadlines of the 1930s. Both Wood and Benton exploited the lithograph's potential for tonal range, but seldom used graphics to create original images; although not literal reproductions, the majority of their lithographs were made after preexisting paintings and drawings. Copyists no longer translated

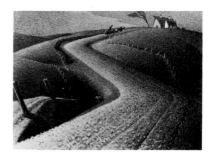

Fig. 26
GRANT WOOD
March, 1941
Charcoal and chalk
Davenport Art Gallery, Davenport, Iowa; Gift of Nan Wood Graham

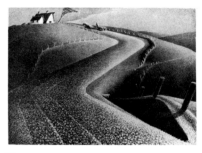

Fig. 27
GRANT WOOD
March, 1941
Lithograph
Associated American Artists, Inc., New York

paintings into prints; the artists did it themselves. Aside from slight differences in tonal range and surface handling, Grant Wood's *March* mirrors the drawing almost exactly (Figs. 26, 27). Thomas Hart Benton made more alterations for the lithograph of *Rainy Day*, transposing a linear composition into tone.

Although twentieth-century prints were seldom made on assignment as Homer's had been, the men who made them, such as Edward Hopper, Reginald Marsh, and John Sloan, had all worked on assignment; and as their predecessors had, they depicted the city. The early English engraver William Burgis had etched New York from a distance, as an outsider looking in; Winslow Homer and Currier & Ives rendered a closer metropolitan view, idealizing the urban landscape.

The twentieth-century city has crime, beggars, crowds, buildings instead of grass; realism replaces optimism, and as the city grows larger the artist's view becomes more abstract. A self-taught etcher and experienced illustrator, John Sloan (1871–1951) had an unindignant eye and a spry, satiric line. His city is transitional. Like Homer, he focused on urban pastimes, but rendered more sophisticated subjects in intimate views: people in bedrooms, asleep on tenement roofs, at a gallery vernissage. Sloan used etching to sketch everyday life (Figs. 31, 32). Devoted to printmaking, involved in its process, he regularly reworked images to change the slightest detail. But Sloan couldn't find a market for his New York City prints. His quotidian scenes were considered too explicit; in 1906, his total income from prints was $81.25.

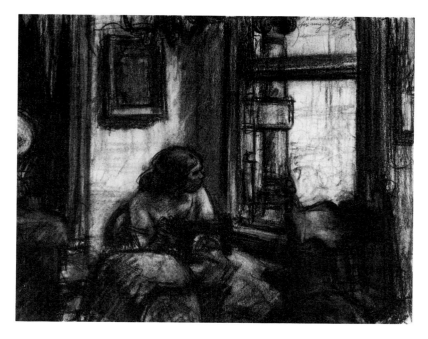

Fig. 28
EDWARD HOPPER
Study for *East Side Interior*, 1922
Conté and charcoal
Whitney Museum of American Art,
 New York; Bequest of Josephine
 N. Hopper 70.342

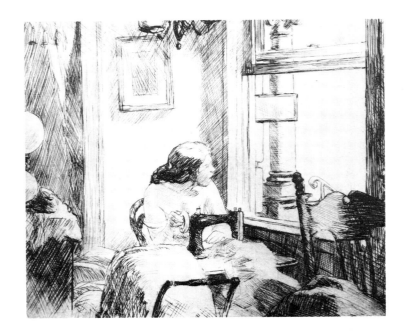

Fig. 29
EDWARD HOPPER
East Side Interior, State I, 1922
Etching
Philadelphia Museum of Art; Thomas
 Skelton Harrison Fund

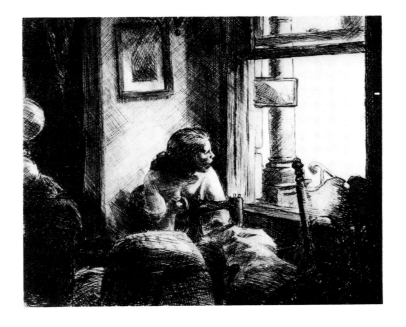

Fig. 30
EDWARD HOPPER
East Side Interior, State V (final state),
 1922
Etching
Whitney Museum of American Art,
 New York; Bequest of Josephine N.
 Hopper 70.1020

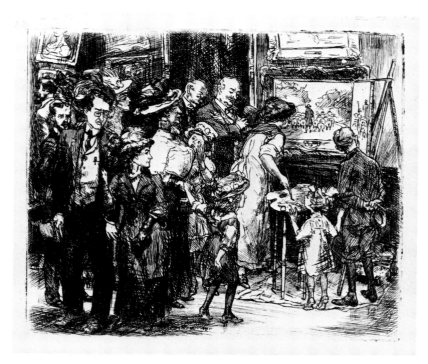

Fig. 31
JOHN SLOAN
*The Copyist at the Metropolitan
 Museum*, State II, 1908
Etching
National Museum of American Art,
 Smithsonian Institution, Washing-
 ton, D.C.; Gift of Mr. and Mrs.
 Harry Baum in memory of Edith
 Gregor Halpert

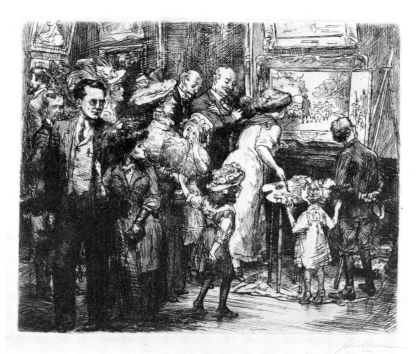

Fig. 32
JOHN SLOAN
*The Copyist at the Metropolitan Mu-
 seum*, State VII, 1908
Etching
National Gallery of Art, Washington,
 D.C.; Rosenwald Collection

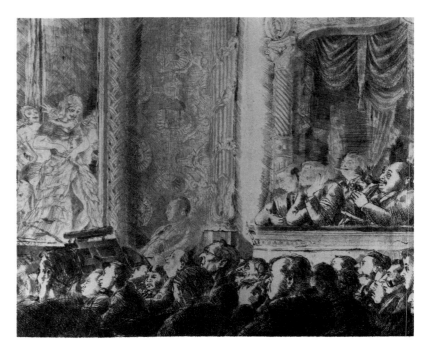

Fig. 33
REGINALD MARSH
Etching
Irving Place Burlesk, State III, 1930
The William Benton Museum of Art,
 University of Connecticut, Storrs;
 Anonymous gift

Edward Hopper (1882–1967), an uneven printmaker, etched lasting impressions of urban solitude. In *Night in the Park* (1921), *Night Shadows* (1921), *East Side Interior* (Figs. 28–30), and *Evening Wind* (1922), he etched solitary lives, showing an excruciating loneliness in the looming shadows cast by streetlights, and silent expectation in the light of open windows. Hopper worked from resonant charcoal drawings which he translated into crosshatched lines, building images up with additional crosshatching. But he often overworked his plates, particularly when he didn't have a story to tell.

Reginald Marsh (1898–1954) etched a far busier place than Sloan or Hopper. He presented a romantic's view of low life—a city of burlesques and breadlines. Drawing studies for prints in easy outlines, Marsh filled them with crosshatching, producing up to twelve states of one image (Figs. 33, 34), but, like Hopper, he tended to work lines until he turned action into static dramas. Sloan fell into the same trap. In early etchings his line is easy and immediate, but in the later prints, which became more self-consciously "artistic," he turned images lifeless with leaden crosshatching. For artists who had first worked as commercial illustrators, printmaking posed problems; Sloan, Hopper and Marsh had all been workaday illustrators and as artist-printmakers they sometimes lapsed into a commercial graphic syntax or—in attempts to escape it—they tried too hard to make art.

Other artists etched the city. With dappled, crosshatched lines, Childe Hassam transposed the feathery light of Impressionism into print (Fig. 35). Charles Sheeler depicted New York's ambition in the slant of the Delmonico Building. Jan Matulka's *New*

York Evening conveyed energy in a network of squares. Louis Lozowick's curvilinear city, a view from abroad, was based on a drawing made before he ever saw New York (Fig. 36). In continuous tones reminiscent of black-and-white film, Martin Lewis told now nostalgic stories of chance encounters, in which romance, not muggers, is just around the corner. Lewis' optimistic landscape recalls E. B. White's description that "no one should come to New York to live unless they are willing to be lucky."

John Marin (1870–1953) drew a Cubist-inspired city. The only modernist to create important prints, like Whistler and Cassatt he learned to print abroad. An out-of-work architect sent to Paris by his family to find himself, Marin taught himself to etch as a means of support. He had read *Traité de la gravure à l'eau-forte* by Maxime Lalanne, a nineteenth-century French landscape etcher; had studied Rembrandt's etchings; and greatly admired Méryon. His first etchings depict the sights of grand tours—bridges in Amsterdam, the tower of Saint-Germain-des-Prés—and show a debt to Whistler in their centered composition and close-up view. At times, in the sureness of a line, as seen in *Notre-Dame, Paris* (1908), the architect seems to be in control. But a slight agitation signals Marin's future direction: little birds flap in the sky, reckless clouds dance over Saint-Sulpice.

Marin made his best prints after his return to New York in 1911. He came back to a city of jagged, newly built towers like the Woolworth Building, and he condensed the new city into a mark, as Whistler had distilled Venice. In *Brooklyn Bridge and Lower New York*, Marin's city simultaneously expands and caves in on

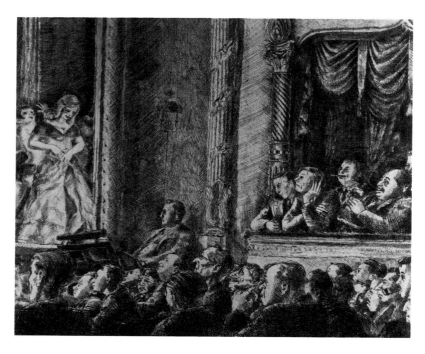

Fig. 34
REGINALD MARSH
Irving Place Burlesk, State VIII (final state), 1930
Etching and engraving
Print Collection, The New York Public Library, Astor, Lenox and Tilden Foundations

Fig. 35
CHILDE HASSAM
Fifth Ave., Noon, State I, 1916
Etching
Hirschl & Adler Galleries, New York

itself. His *Woolworth Building* sways on the brink of collapse in a sky crowded with staccato markings (Fig. 37). Marin described the prints he made exactly. "Do you want to know what I think about etching?" he wrote. "Well, little letters of places. You don't want to write a volume, to give tersely, clearly, with a few lines."

Marin's early, traditional prints of European villages and landmarks of Dutch and Venetian canals sold well. But like John Sloan, he found no audience for his later, far better prints of New York City — even among the modernists surrounding his dealer Alfred Stieglitz. At An American Place, Stieglitz's gallery, Marin's prints were kept in a drawer. Stieglitz had no qualms about his own reproductive medium, photography, but he didn't like to show prints at the gallery.

Even if Stieglitz had promoted Marin's *Woolworth Building*, it wouldn't have had many takers. Joseph Pennell's 1915 etching of

the Woolworth Building (Fig. 38), pin-straight, rendered in a soft, tasteful line, surrounded by a dappled sky, typified the preferred taste. The difference between Marin's and Pennell's Woolworth Building is that between an original graphic view and a competent illustrative rendering, but it was Pennell's vision that characterized American printmaking. Joseph Pennell (1859–1926), a student and biographer of Whistler, made significant contributions to graphic art as a teacher and print connoisseur. He created interesting large-scale lithographs of the Panama Canal. But his own etchings were journeyman prints.

Artists like Pennell and John Taylor Arms (1887–1953) dominated American printmaking. In 1913, the year Marin etched his Woolworth Building, John Taylor Arms' wife gave him an etching set: three years later Arms retired from his career as an architect and devoted his life to etching. A meticulous craftsman, Arms built his etchings out of thousands of microscopic lines, and kept an account of the hours he put into each print, specifying how much time he spent on each procedure. Etching was Arms' lifework, and when he was not building a print of Chartres, Notre-Dame, or a Gothic detail, he followed Seymour Haden's example, lecturing and demonstrating etching techniques. He believed etching and engraving to be the superior graphic media and, as president of the Society of American Etchers, was largely responsible for the exclusion of woodcutters and lithographers.

Arms etched with dazzling mechanical skill. In the nineteenth century, he would have equaled Durand as a reproductive engraver; in the twentieth century, he outdistanced the Super Realists who followed him. As a figure in American printmaking, he represents the conservative aesthetic that dominated the graphic arts. The powerful Society of American Etchers ran the exhibitions, influenced print clubs—and in their concern with craft, they isolated the print from the world of painting and sculpture.

The position of the graphic arts is revealed by the artists who did not make prints. Georgia O'Keeffe did not. Neither did Arthur Dove or Clyfford Still. Printmaking attracted few modernist painters, who regarded it as a medium for illustrators, craftsmen and hobbyists; and the few modernists who experimented in the graphic arts produced insignificant results. Jackson Pollock's graphic forays, lithographs made in 1935–38 and drypoints made in 1944–45 and printed posthumously in 1967, are noteworthy only because they are by Pollock. The same is true for Marsden Hartley's lithographs. Early in his career Adolph Gottlieb successfully experimented with woodcuts (Fig. 42), but the prints he made after he had an established market translate his paintings without considering the properties of the new medium. Willem de Kooning's and Franz Kline's etchings for the 1960 Laurel portfolio (Figs. 40, 41), look remarkably similar; blacks are etched to the same density; large-scale gestures are constrained by small formats. Both prints look like student work. Apart from Robert Motherwell, Barnett Newman was the only New York School painter to pro-

Fig. 36
LOUIS LOZOWICK
New York, 1925
Lithograph
Whitney Museum of American Art, New York; John I. H. Baur Purchase Fund 77.12

Overleaf:
Fig. 37
JOHN MARIN
Woolworth Building (The Dance), State II (final state), 1913
Etching with drypoint
The Metropolitan Museum of Art, New York; Alfred Stieglitz Collection

Fig. 38
JOSEPH PENNELL
The Woolworth Building, 1915
Etching
Associated American Artists, Inc., New York

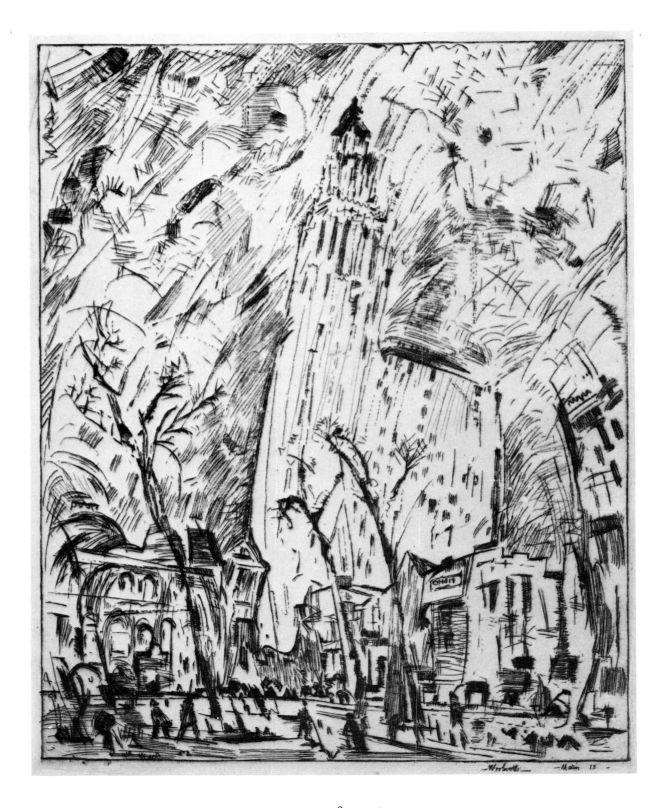

Woolworth — Malin 13

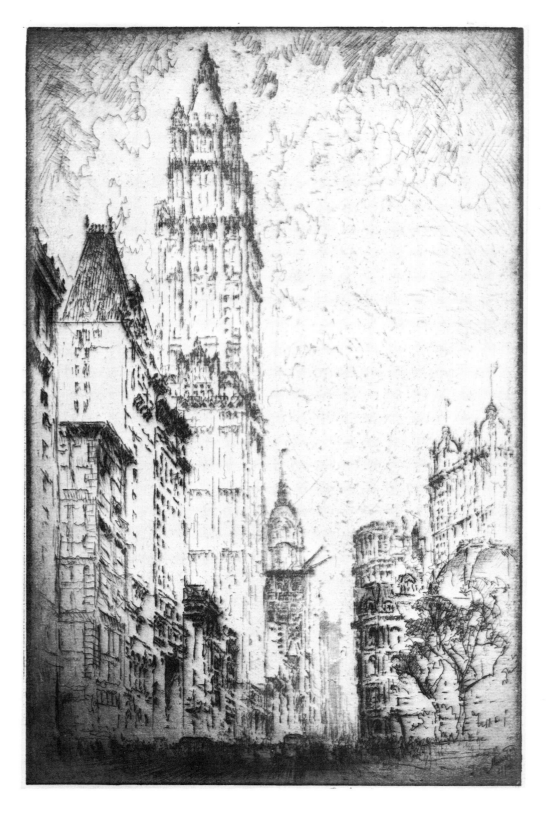

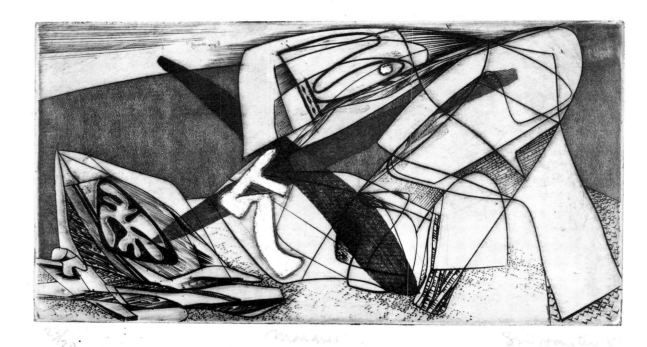

duce important prints, and like Motherwell he only began making prints when he received an invitation from a publisher.

Small in format, black and white, linear, a basically narrative form, prints did not suit modernist aesthetics; restrictions in procedure and format make it a difficult medium in which to convey abstraction. The major artists who created successful abstract prints — Josef Albers, Lyonel Feininger and Max Weber — were all European-trained; interestingly, not one had an influence on American printmaking.

The establishment of Stanley William Hayter's Paris-originated Atelier 17 in New York in 1944 should have helped dissolve the distinction between printmakers and painters. Hayter was a generous, charismatic teacher, as devoted to engraving as John Taylor Arms had been to etching. But Hayter was a sophisticate compared to Arms, and at his New York Atelier 17, American painters met exiled Europeans who did not share the Americans' prejudice against printmaking. Hayter transmitted his ideas about engraving to an impressive group that included Louise Bourgeois, Le Corbusier, Salvador Dali, Anne Ryan, Kurt Schwitters, Robert Motherwell, Jackson Pollock, Mark Rothko, and Joan Miró.

Hayter viewed printmaking as the Abstract Expressionists viewed painting. Focusing on the action of the tool, he saw the plate as an arena. Concerned with the potential of burins and metal plates, he believed as much in the act of making a line as in the line itself. "It is preferable," he said, "to work with uncon-

I will always love you
though I never loved you

a boy smelling faintly of heather
looking up at your window

the passion that enlightens
and stills and cultivates, gone

while I sought your face
to be familiar in the likeness

or to follow your sleep whistle
around a corner into my light

that was love growing fainter
each time you failed to appear

I spent my whole life searching
love which I thought was you

it was mine so very briefly
and I never knew it, or you went

I thought it was outside disappearing
but it is disappearing in my heart

like snow blown in a window
to be gone from the world

I will always love you

Frank O'Hara

Poem !

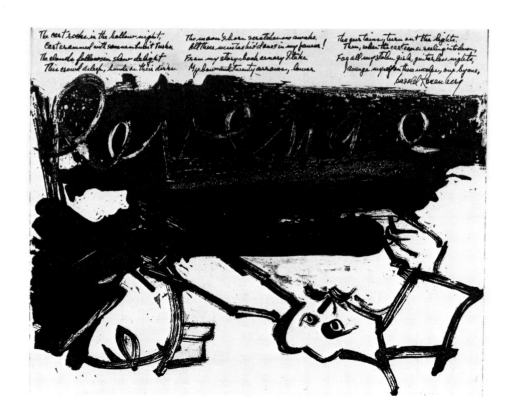

The cat rocks in the hollow night,
Caterammed with somnambulist Turks.
The clouds fall over in slow delight
This crowd asleep, hands in their dirke.

The moon & horn scratches us awake.
All these mustachio'd ones in my power!
From my storybook armory I take
My bow and twenty arrows, lower

The curtains, turn out the lights.
Then, when the cats come reeling into town,
For all my stolen girls, guitarless nights,
I avenge myself on these mustaches, one by one,

Harold Rosenberg

51

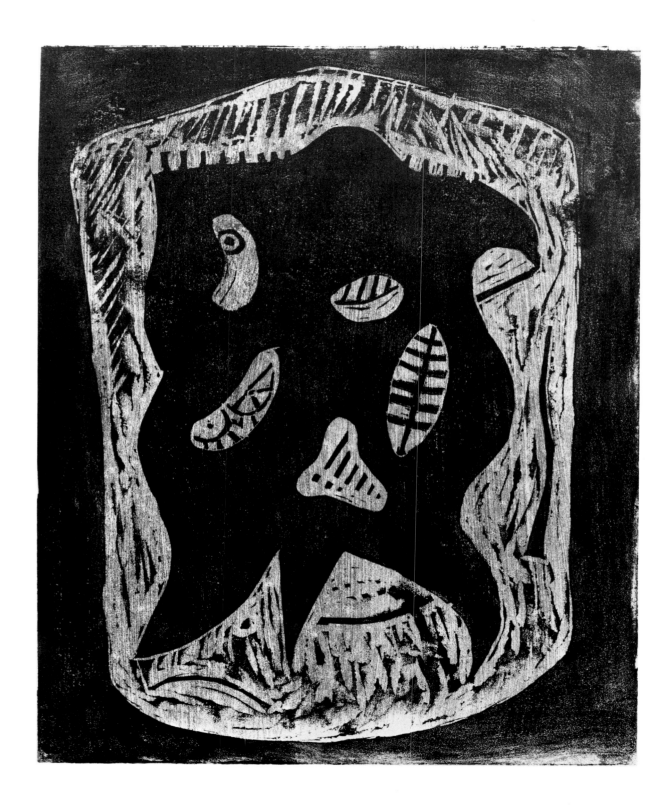

centrated eyes, the direction and depth of the line being controlled by the touch alone, a far more sensitive and accurate control than that of vision."[16] To Hayter, the act of engraving, the interplay between burin and plate, created the essential dynamic energy.

In the decades following Hayter's New York Atelier 17, a printmaking revival occurred. Artists who had worked at Hayter's went on to set up graphic studios: Gabor Peterdi taught at Yale; Mauricio Lasansky created a graphic workshop at the University of Iowa. Painter Karl Schrag ran Atelier 17 after Hayter returned to Paris. In 1947, the Brooklyn Museum initiated important biennial print exhibitions under the direction of Una Johnson, which gave printmakers their first important forum. Prints attracted a new, enthusiastic audience. In 1952, an article in *Life* magazine heralded prints as "Art Bargains in Color Lithographs — Originals at Low Prices." But few American painters became involved with graphics; with the exception of Karl Schrag and Gabor Peterdi, both painters, the artists who dominated American graphics in the 1950s were primarily printmakers.

Hayter's effect on American printmaking was not unlike that of John Taylor Arms. Hayter felt that "if a plate develops beauty in itself, the print also will probably be satisfying." By equating the plate with the image it carried, Hayter inadvertently emphasized technique over content, a message which artists continue to misapply and misrepresent.

Opposite
Fig. 42
ADOLPH GOTTLIEB
Untitled, c. 1945
Woodcut
Print Collection, The New York Public Library, Astor, Lenox and Tilden Foundations

1. Quoted in Neil Harris, *The Artist in American Society: The Formative Years, 1790–1860* (New York: George Braziller, 1966), p. 36.

2. Guernsey Jones, ed. *Letters and Papers of John Singleton Copley and Henry Pelham, 1739–1776,* reprint edition (New York: Kennedy Graphics and Da Capo Press, 1970), p. 51.

3. Quoted in James Thomas Flexner, *History of American Painting, Volume Two: The Light of Distant Skies (1760–1835)* (New York: Dover Publications, Inc., 1969), p. 94.

4. *Letters and Papers of John Singleton Copley and Henry Pelham, 1739–1776,* pp. 65–66.

5. Quoted in William W. Robinson, "This Passion for Prints: Collecting and Connoisseurship in Northern Europe during the Seventeenth Century," in Clifford Ackley, *Printmaking in the Age of Rembrandt,* exhibition catalogue (Boston: Museum of Fine Arts, 1981), p. XXVII.

6. Quoted in Warren Chappell, *A Short History of the Printed Word* (New York: Alfred A. Knopf, Inc., 1970), p. 139.

7. Sinclair Hitchings, "Graphic Arts in Colonial New England," in *Prints in and of America to 1850,* ed. John D. Morse (Charlottesville, Va.: The University Press of Virginia, 1970), p. 97.

8. Richard Holman, "Seventeenth-Century American Prints," in *Prints in and of America,* p. 25.

9. Quoted in Holman, "Seventeenth-Century American Prints," p. 43.

10. The suggestion that the Pelham engraving was a plea against violence and that Pelham was a pacifist as well as a Loyalist was made by Gloria Gilda Deák, consultant to the Print Room of The New York Public Library.

11. Quoted in Hiller B. Zobel, *The Boston Massacre* (New York: W. W. Norton & Company, 1970), p. 279.

12. In 1876, John W. Barber (1798–1885), a historian, engraver, and friend of Amos Doolittle, first reported Ralph Earl's and Amos Doolittle's trip to the battlefields of Concord and Lexington. The story of Doolittle posing for Earl has become part of the mythology of American graphics and is repeated in James Thomas Flexner's *History of American Painting, Volume Two,* p. 27. However Ian M. G. Quimby makes a convincing case that the story is probably apocryphal. Although he contends that Doolittle's prints concur almost exactly with visual reports of the battles, he finds it unlikely that Ralph Earl, a Loyalist, would have accompanied troops fighting the British or reported a battle which resulted in British defeat. See Ian M. G. Quimby, "The Doolittle Engravings of the Battle of Lexington and Concord," *Winterthur Portfolio 4,* 1968, pp. 83–108.

13. E. P. Richardson, "Charles Willson Peale's Engravings in the Year of National Crisis, 1787," *Winterthur Portfolio I,* 1964, p. 166.

14. *Autobiography, Reminiscences and Letters of John Trumbull, from 1756–1841* (New Haven, Conn.: B. L. Hamlen, 1841), p. 172. Also quoted in Flexner, *History of American Painting, Volume Two,* p. 89.

15. Lauris Mason, *The Lithographs of George Bellows* (Millwood, N.Y.: Kto Press, 1977), p. 21.

16. Quoted in Joann Moser, *Atelier 17,* exhibition catalogue (Madison, Wis.: Elvehjen Art Center, University of Wisconsin), p. 22.

American Prints 1960–1981

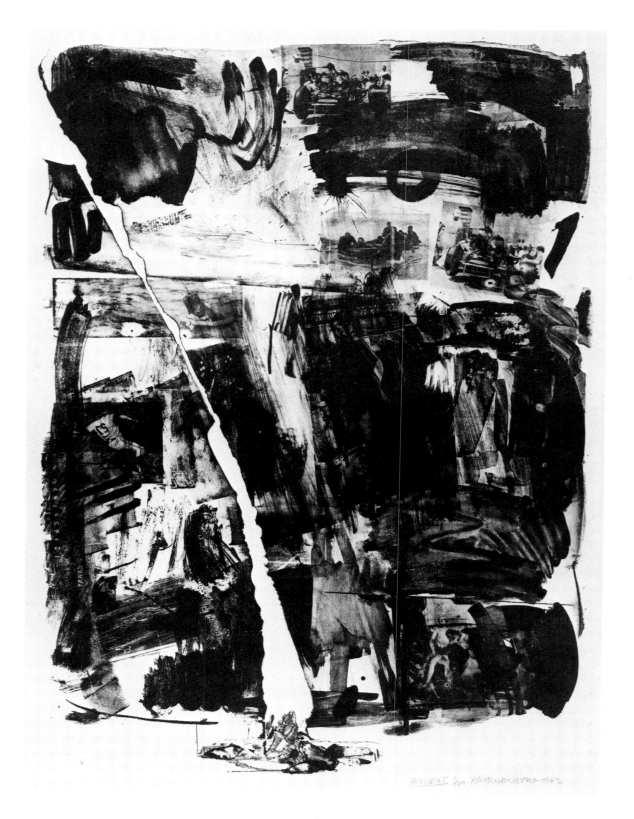

Accident 1/29 RAUSCHENBERG 1963

American Prints 1960–1981

Prints, Publishers & Graphic Workshops

"I thought the second half of the twentieth century was no time to begin writing on rocks" was Robert Rauschenberg's first reaction to lithography. Frank Stella has described printmaking as a "necessary evil," and before Larry Rivers made a lithograph he thought of printmakers as artisans who wore corduroy jackets and smoked pipes. The painters who became printmakers in the late 1950s and early 1960s shared the Abstract Expressionists' prejudice against graphics. Few were predisposed to the media, and had there not been a convergence of economic, aesthetic and technological factors favorable to multiple art, they might not have made prints at all.

The economic climate was conducive to graphics. By 1960, the dominance of Abstract Expressionism had caused the aesthetic balance of power to shift from Paris to New York. The art market followed; and as the interest and prices of paintings increased, so did the demand for more affordable printed pictures. In the fluid 1960s, culture had become a marketable commodity, and the painters whom the British critic Lawrence Alloway labeled Pop artists attracted a large public. If only briefly, artists enjoyed the celebrity Andy Warhol promised everyone, and by the decade's end, they had become part of what journalists and print publishers referred to as a graphics revival.

The phrase was a misnomer; the large, brightly colored, perfectly registered graphics American painters created did not represent a revival, but a radical break with the graphics that had preceded them. Prints utilizing mechanical and technological procedures had no antecedents. But economic conditions do not entirely explain the American painters' turn to printmaking: the graphic aesthetic which characterized their painting translated naturally into print.

In the 1960s, printed matter joined paint, charcoal, pencil and paper as raw material with which artists structured images. Before he formed paintings out of layers of fragmented images transferred from print, Robert Rauschenberg primed his canvases

Opposite:
ROBERT RAUSCHENBERG
Accident, 1963
Lithograph
Leo Castelli Gallery, New York

with newsprint. Screenprinting photogravure heroes onto canvas, Andy Warhol printed paintings which commented on the "culture-at-large." Repeating Marilyn Monroe serially in garish colors, Warhol and his staff helped create what would be known as "The Media," and worked like machines to produce art.

While Warhol used newsprint heroes to mock and emulate the effects of the press, Roy Lichtenstein employed print to comment on art. Paintings formed of enlarged comics and Ben Day dots raised questions about perceptions and expectations. Monet's *Haystacks*, updated and translated into half-tone dots, revealed neither temporal nor seasonal conditions, but demonstrated technological variables. Removing popular and artistic images from their context, Lichtenstein's paintings exemplified Walter Benjamin's "Work of Art in the Age of Mechanical Reproduction."

The capabilities of the press were equally well suited to non-Pop artists who used serial images. Mechanical and technical processes offered artists such as Josef Albers and Frank Stella a way to repeat images, vary color, and change the position of modularly formed units; the press could also yield the precise, linear edge their art required.

Favorable economic conditions, artists with graphic sensibilities, and an audience provided the essential components for the rise of printmaking. But there were missing ingredients: printers and publishers to produce, commission, and finance graphic art. Without an established fine art print tradition, it followed that there were few printers specializing in fine art prints. Until the establishment of the Tamarind Lithography Workshop in Los Angeles in 1960, George Miller, who printed the lithographs of New York artists from 1936 to the mid-1960s, was the country's only successful printer of artists' editions. In Los Angeles Lynton Kistler printed for a smaller group of artists, but few other fine art lithographers existed. Lithographers tried, as Pendleton had a century before, to establish fine art print shops, but due to lack of interest on the part of artists and their public, none succeeded.

June Wayne, a painter, printmaker and weaver, worked with Lynton Kistler from 1948 on; and when she did not work with Kistler, she had to travel to Paris to work at the French lithographic firm of Mourlot. Having to travel halfway around the world to create lithographs made Wayne acutely aware of the art's deplorable state. In 1958 she brought the problem to the attention of W. McNeil Lowry at the Ford Foundation and presented him with her plans for the Tamarind Lithography Workshop; in 1960, the Ford Foundation funded the three-part, three-million-dollar project.

Tamarind's goal was to resurrect lithography from North American obscurity by training master printers, and to expose mature artists to the lithographic art by extending them fellowships. A selection panel, which included William Lieberman, James Johnson Sweeney and Gustave von Groschwitz, recommended artists to receive Tamarind fellowships. Finding artists to

ROBERT RAUSCHENBERG
Tanya, 1974
Lithograph
Castelli Graphics, New York

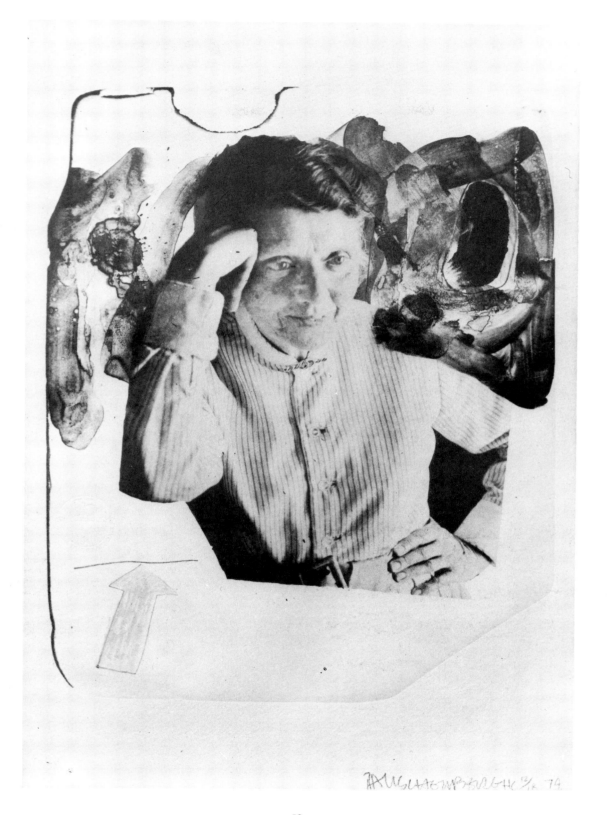

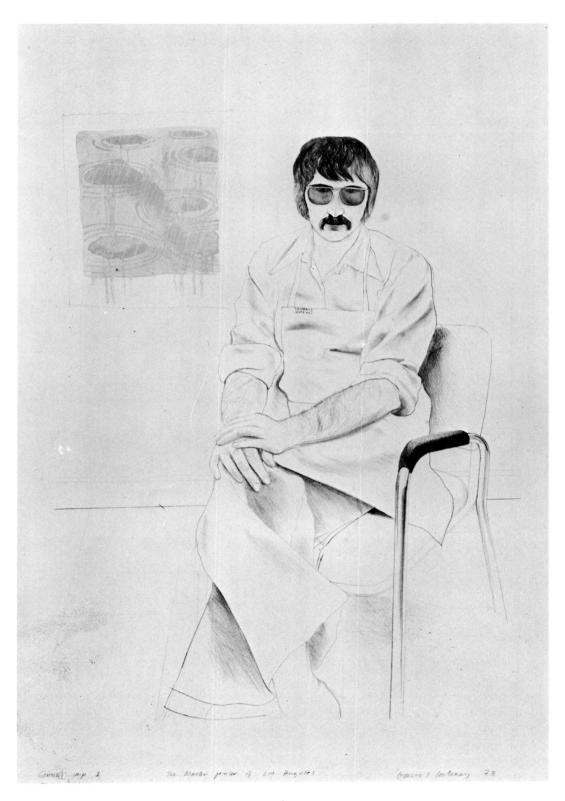

The Master printer of Los Angeles

work at Tamarind was easier than finding printer trainees. According to Clinton Adams, the current director of the Tamarind Institute in New Mexico, they had "to beat the bushes to find applicants for the master printer program." As late as 1960, Americans still had mixed feelings about the artisan crafts.

"A handful of creative people is all that is needed for a renaissance in the art, if that handful comes together at the right time, in the right place. Half a dozen master printers scattered around the United States with a cluster of artists revolving around each, could cause a resurgence and a blossoming forth of the art of the lithograph that would attract the interest of the world"— June Wayne's vision became a reality. By 1970, Tamarind had produced 2,900 lithographs, extended grants to 103 artists and graduated over 50 master printers. By then, lithographic workshops under the directorship of Tamarind-trained printers existed in almost every major American city. For the first time in the history of American prints, painters could collaborate with professionally trained printers to create graphic art.

While the work force of Tamarind-trained master printers changed the position of printmaking, publishers such as Tatyana Grosman and Kenneth Tyler made other contributions. In 1957, Tatyana Grosman, a fifty-three-year-old, Russian-born, German-educated emigré, moved a lithography press into her West Islip, Long Island, garage and established a studio—Universal Limited Art Editions (ULAE)—where she hoped to publish artists' books. She knew nothing about lithography, less about the marketplace, but she had ideas about artists and books. Though hardly well formulated, Tatyana Grosman's ideas, like the initial concepts of artists, found definition in the process and evolution of each graphic project.

Operating on instinct, both naive and impervious to popular taste, Tatyana Grosman, along with her late husband, the painter-sculptor Maurice Grosman, asked artists with no experience in lithography to draw on stones. She extended invitations to painters whose work had a strong graphic element, approaching Robert Motherwell after she saw his use of words in his *Je t'aime* series. She seduced artists with a quiet, zealous persistence, and by depositing stones in their painting studios. Speaking softly in a conglomeration of French, English, and Russian, she convinced artists of the importance of printed art. One artist led to another. Larry Rivers recommended Grace Hartigan, and the two together convinced Helen Frankenthaler to experiment on stone. Jasper Johns introduced Tatyana Grosman to Robert Rauschenberg, and also told James Rosenquist and Jim Dine about ULAE.

A concern with paper and materials, small, numbered editions, and an unerring sense of quality became the hallmark of ULAE prints. They reflected an other-worldly atmosphere where nothing cost too much or took too long, which Robert Motherwell described as "a place where it is simply assumed as seldom elsewhere nowadays that the world of the spirit exists as concretely

Opposite:
DAVID HOCKNEY
The Master Printer of Los Angeles, 1973
Lithograph
Gemini G.E.L., Los Angeles

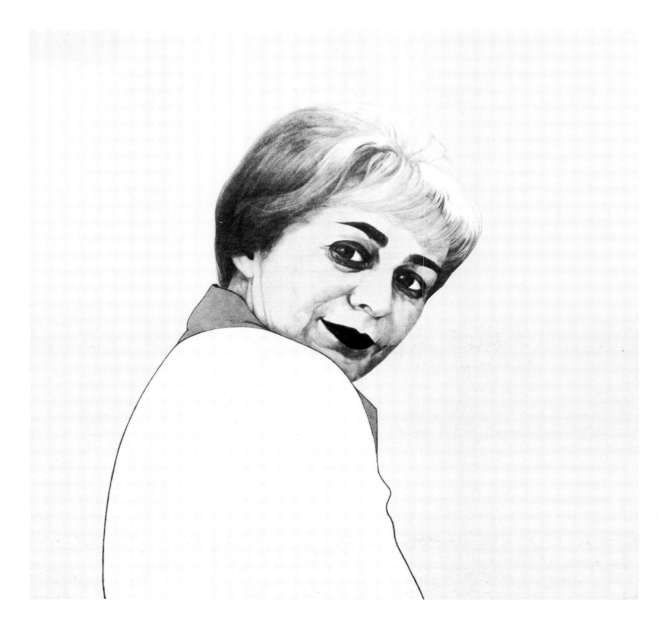

as, say, lemon yellow or woman's hair, but transcends everyday life. At West Islip, Long Island, this consciousness permeates every moment."

In comparison, an efficient, technological aesthetic characterized the prints from Gemini G.E.L., the workshop which master printer Kenneth Tyler, his wife Kay Tyler, Stanley Grinstein and Sidney Felsen formed in Los Angeles in 1967. Kenneth Tyler was raised in a town of oil refineries, bungalows and workers on the southern shore of Lake Michigan. He was trained as an artist, metallurgist, salesman, and master printer. His industrial background and need to work informed the Gemini aesthetic.

THEO WUJCIK
June Wayne, 1973
Lithograph with colored pencil
Brooke Alexander, Inc., New York

The same artists worked at both Gemini and ULAE, but the prints they created at the two studios had different looks. Kenneth Tyler printed hard, flat, perfectly registered surfaces well suited to the prints of Josef Albers, Ellsworth Kelly and Frank Stella. Technologically inclined, working in collaboration with artists such as Claes Oldenburg, Tyler created methods to combine molded polyurethane and traditional lithography, thus Americanizing, with Detroit efficiency, the way lithographs were produced.

Kenneth Tyler's career marks the path the American print has traveled since 1967. In 1973, he left Los Angeles to form Tyler Graphics Ltd. in Bedford, New York. In a pastoral setting, removed from the Hollywood aesthetic he had brought to graphics, for the last eight years he has focused attention on prints made of handmade paper and colored by hand. He has not entirely abandoned his industrial aesthetic; prints from Tyler's workshop are still distinguished by bigness and technical virtuosity; and those he has made with Frank Stella, on honeycomb-aluminum structures, perhaps best reflect the contributions Tyler has made to American painters and printmakers.

The publishers and printers who have collaborated with American painters have each brought their own standard and expertise to the American print. The art of etching predominates at Kathan Brown's Crown Point Press in Oakland, California. An Abstract Expressionist atmosphere dominated the studio Irwin Hollander, a Tamarind-trained master printer, ran in New York from 1964 through 1972. Brooke Alexander promoted and published prints by realists and images that carried a narrative content. Robert Feldman, director of Parasol Press, published the work of Minimalists and Conceptualists. The Landfall Press in Chicago, run by another Tamarind-trained master printer, Jack Lemon, continues to print and publish mainly the work of realists.

With the exception of Vincent Longo, Michael Mazur, and Nathan Oliveira, the artists included in this exhibition began their printmaking careers working in conjunction with printers and publishers. Their graphics reflect collaborative efforts. Seen as a group, the work reflects the radical changes that have taken place in American graphic art — and what finally may be the beginning of an American *peintre-graveur* tradition. Seen as individual works, the time spent, the decisions and revisions behind each graphic image represent the new involvement American painters have brought to graphics.

Chuck Close

Chuck Close paints portraits of photographs, not people. Made by the artist, the photos he paints from are snapshots of official identification; close-up, frontal views like those taken by police departments and passport agencies that render subjects the same. The people in the portraits have passive faces, glazed eyes. Looking neither happy nor sad—even when smiling—they share a bland anonymity and appear disturbingly bored. They exist in that limbo in front of the lens, frozen in a state of emotionless tranquility.

Rendered with scientific precision in monumental scale, the people in the portraits are unfamous; their faces trigger no stories or memories as Warhol's do. The faces, those of the artist's friends, are forgettable. Close starts where Warhol stopped. Warhol painted the hot portraits of a fast and violent decade; Close paints the alienated, narcissistic aftermath.

Close is Warhol's cool counterpart. Like Warhol, he makes art out of the language of mechanical reproduction, but Close does not find or salvage commonplace snapshots as Warhol did; he takes them. Then by enlarging it to gargantuan scale and rendering it with an Old Master's technical virtuosity, he imbues an ordinary photo with the look of art. Like Warhol, Close reverses our visual expectations. What you see is not what you get. The

Left:
Keith, Trial Proof, 1972
Mezzotint
44½ × 35⅛ inches (113 × 89.2 cm)
Australian National Gallery, Canberra

Right:
Keith, Trial Proof, 1972
Mezzotint
44½ × 35⅛ inches (113 × 89.2 cm)
Australian National Gallery, Canberra

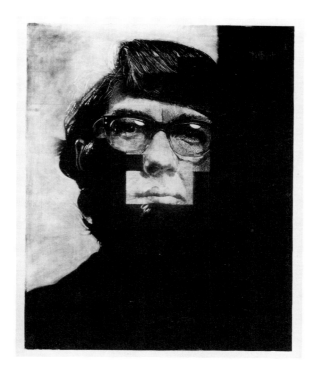

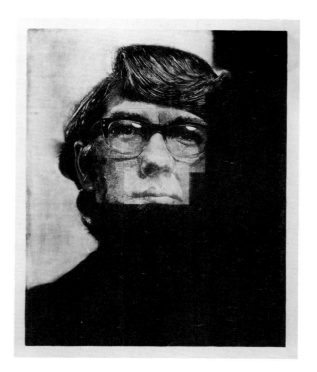

irony, crucial to Warhol, stemmed from the contradiction be-
tween past and present experience; Warhol took us slumming
in our own memories. Close shocks with sheer size and visual
data; a Close portrait relies on a physical and intellectual irony.
Devoid of feeling and narrative content, a Close portrait aggran-
dizes a system, not the events behind a face, inundating the viewer
with information.

Close recycles the same faces, painting them within rigidly
predetermined systems. From 1967 to 1970, he simulated the con-
tinuous tones of black-and-white photography. In 1970, he began
working in colors; confining himself to the reds, yellows, blues and
blacks of offset printing, he created additional colors by overlay-
ing them, meticulously emulating the commercial method of
color separation. Since 1968 he has built portraits out of a variety
of systems, filling preexisting grids with black-and-white and
color dots, hand-drawn lines and fingerprints.

The confrontation posed by a Close portrait is perceptual
and physical. Scale overwhelms the viewer; reality (or the look of
it) appears and disappears. Although they reveal every excru-
ciating detail on a face, the portraits tell us nothing about the
people portrayed. Viewed up close, the face in a continuous-tone
portrait dissolves into a map of pits and crevices, as abstract as

Left:
Keith, Trial Proof, 1972
Mezzotint
44½ × 35⅛ inches (113 × 89.2 cm)
Australian National Gallery, Canberra

Right:
Keith, Trial Proof, 1972
Mezzotint
44½ × 35⅛ inches (113 × 89.2 cm)
Australian National Gallery, Canberra

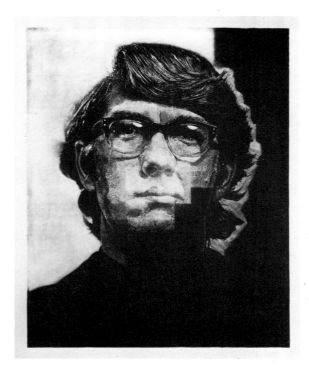

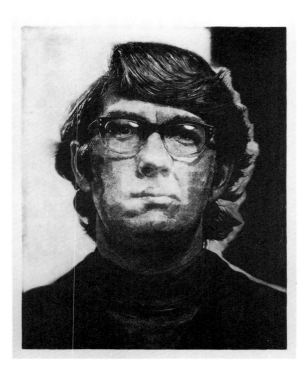

moon craters. From a distance, a dot portrait appears in sharp focus, but as one moves toward it, the face disintegrates into a confusion of signs that suggest a computer printout gone haywire.

Close's prints, like his paintings, are guided by camera vision, by the appearance of a photographic reality. Close renders forms and shapes we do not consciously see. "The enlargement of a snapshot does not simply render more precise what in any case was visible, though unclear; it reveals entirely new formations of the subject," wrote Walter Benjamin.* This is exactly what we see and ultimately confront in a Close portrait—"entirely new formations," abstract data.

Close creates a now-you-see-it-now-you-don't kind of reality. Methodically creating the illusion of a photograph, he shows it to be only that—an illusion, consisting of abstract signs: dots, lines and tones. Didactic in his conception, Close has it both ways: in the name of realism, he took a side door to abstraction. His use of the grid has suggested a connection to Minimalism; his dogged lessons in vision have branded him a Conceptualist. But he is neither, nor is he much of a realist. He simply appropriates elements of current visual syntax to find his own abstract language.

In printmaking, Close continues his examination of visual perception. But when he uses a graphic language in a graphic medium, the results are different. The prints, like the paintings, confront the viewer, but the confrontation is on a human scale, and their effect is neither disorienting nor overwhelming. Recycled

Left:
Keith, Trial Proof, 1972
Mezzotint
44½ × 35⅛ inches (113 × 89.2 cm)
Australian National Gallery, Canberra

Right:
Keith, Trial Proof, 1972
Mezzotint
44½ × 35⅛ inches (113 × 89.2 cm)
Australian National Gallery, Canberra

Opposite:
Keith, 1972
Mezzotint
44½ × 34¹⁵⁄₁₆ inches (113 × 88.7 cm)
Edition: 10
Printed by Kathan Brown
Published by Crown Point Press,
 Oakland, California
The Museum of Modern Art, New
 York; John B. Turner Fund

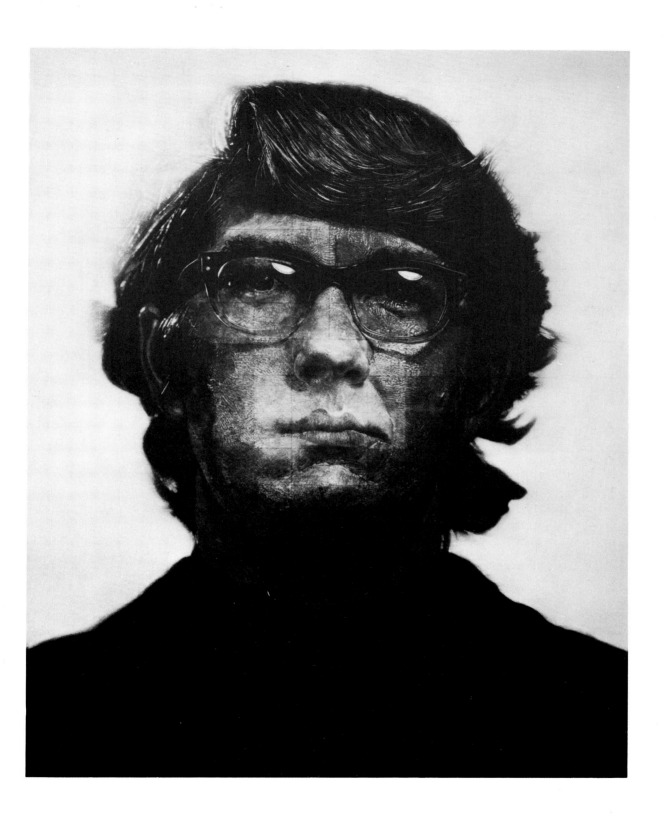

into print, reduced in scale, the faces are accessible.

But as prints go, the few Close has made are very large. The sheer size and rigorous technique of *Keith* (1972), the artist's first print, gave it a landmark status among contemporary prints. Using mezzotint, a continuous-tone technique popular in the eighteenth century before the invention of photography, Close spent three months proofing and correcting his image. He worked from black to white, forming the face by scraping and burnishing away deep pits from the photoelectrically roughed surface.

He took months to do by hand what could have been instantly done by machine. Why? Was it discipline or Calvinism? For all the technical proficiency, the effort doesn't show; even in proofs, as the face gradually grows out of the black ground, the image never appears labored. Close once refused to issue an etching photographically produced to his specifications because he hadn't made it. It is important that he do the work, equally important that the effort not show. He has the same attitude toward paintings — a single one has taken him up to a year to make. For Close, the image and its process are indivisible. His final result is determined by whatever system — photographic, dots, fingerprints — he rigorously follows.

The mezzotint *Keith*, distinguished from the painting by its warm blacks, size and the grid's appearance, was a turning point for Close. For the mezzotint as for the painted continuous-tone portraits, Close used a grid to square off work areas. In the portrait, he painted the grid away. In the mezzotint *Keith*, he left a remnant of the grid across the face; fragmenting the face, the grid casts doubt on the photographic reality. By revealing his scaffolding, the artist anchors the portrait to its process and his hand. *Keith* marks the beginning of the artist's move toward abstraction. After 1972, the grids regularly appear in the paintings. Close's interests broaden to include not just the nature of photographic reality, but of all visual perception. The grid is the structure that permits the examination to proceed.

* Walter Benjamin, "The Work of Art in the Age of Mechanical Reproduction" (1936), in *Illuminations*, trans. Harry Zohn (New York: Schocken Books, 1973), p. 236.

LITERATURE:

Lyons, Lisa and Martin Friedman. *Close Portraits* (exhibition catalogue). Minneapolis: Walker Art Center, 1980.

Shapiro, Michael, "Changing Variables: Chuck Close and His Prints." *The Print Collector's Newsletter*, 9 (July/August 1978), pp. 69–72.

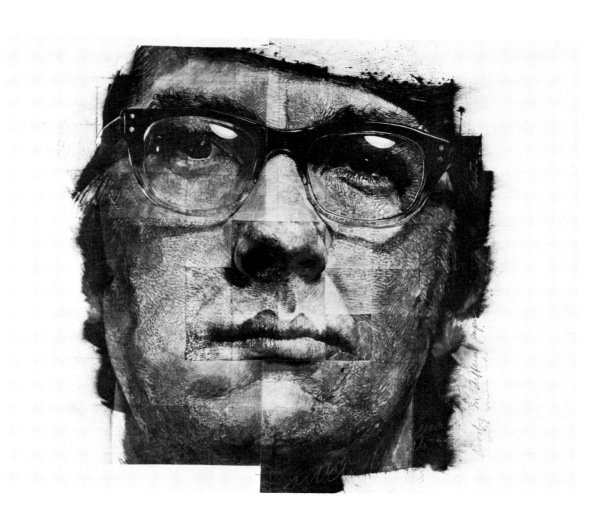

Keith, 1972
Collage of trial proofs
24 × 32 inches (61 × 81.3 cm)
Pace Editions, Inc., New York

Jim Dine

Jim Dine's early printed images were autobiographical—hearts, tools, bathrobes and palettes stood in for the artist, his family and past. Symbolic self-portraits, the robes conveyed a range of attitudes; they were staunch, burly, on occasion cute, brooding and buoyant. The robes announced artistic options, and Dine filled them with primary colors, landscapes or instructions from a paint-by-number kit. Early robes, rendered with stylized curving lines, implied a reassuring comfort. But the unpretentious robe was an unsettling image; it bore the shape of a physical presence yet was unoccupied—the literal cover-up had no head or hands.

Dine's printed palettes held predictable daubs of paint, brushstrokes and springtime visions. More direct than the robes, they were contemplative compared to the animated tools that elsewhere pervade Dine's iconography. Memories from his grandfather's Cincinnati hardware store, the tools grasp, grip, hold and penetrate. C-clamps, wrenches, pliers and hammers appear frenzied, determined, spent and splayed. The tools are an encyclopedia

Five Paintbrushes (first state), 1972
Etching
Image: 23½ × 35½ inches (59.7 × 90.2 cm)
Paper: 30 × 40 inches (76.2 × 101.6 cm)
Edition: 75
Printed by Maurice Payne
Published by Petersburg Press Ltd., London
Collection of Mr. and Mrs. Robert Benton

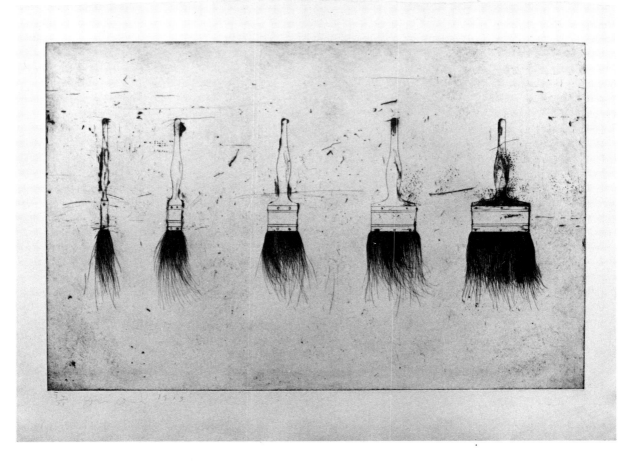

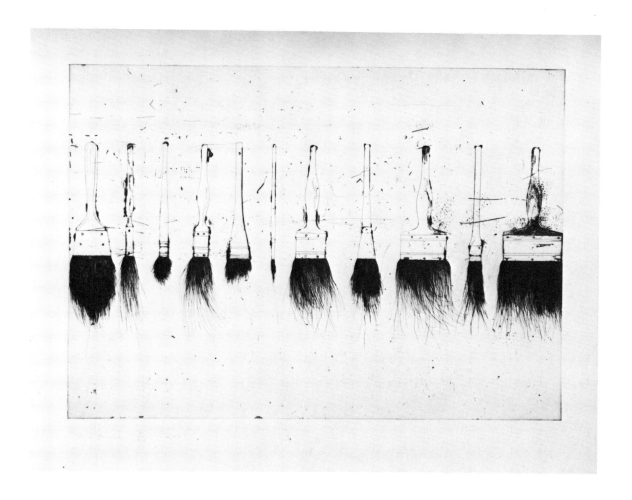

of sexual nuances—Dine once titled a 1972 drypoint portfolio of tools *Thirty Bones of My Body*. The punning tool does the artist's work. It is an everyday sort of tool, but not the kind one finds at the local hardware store.

In the late 1970s, Dine's work changed. In what seemed a surprising turn, he stopped making the pictures that brought him a Pop Art designation and turned to traditional still lifes and figure drawings. The change, more gradual than it appeared to be, had started in the prints. In a 1976 interview Dine said: "Printmaking was the only medium in which I felt free enough to be figurative ...Probably because the process was one step removed from me (with the printer in between).... Making prints was the first place my interest in figurative art raised its head."*

Dine may have also found freedom in printmaking because he was an instinctive graphic artist, a natural storyteller with line, who could effortlessly make a book or heart tell a tale. Even Dine's earliest prints were highly defined, readable images. In *Car Crash* (1960), his first lithographic series, a tangle of words meeting the word "Crash" spells the horror of the accident; in the

Five Paintbrushes (second state), 1973
Etching
Image: 23½ × 31¾ inches (59.7 × 80.6 cm)
Paper: 30 × 37 inches (76.2 × 94 cm)
Edition: 20
Printed by Allan Uglow and Winston Roeth
Published by Petersburg Press Ltd., London
Collection of John and Linda Talleur

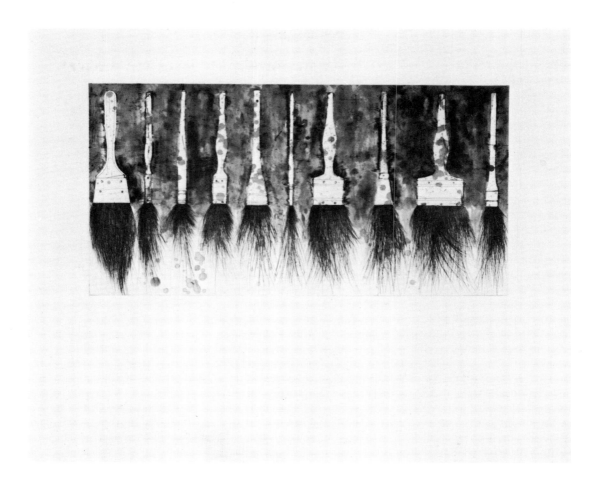

wordless final image, a red cross and scattered lines relay the fatal conclusion.

From the start, Dine worked with a fast assurance; experimenting, combining media, he explored the variables a stone or plate held. Reusing stones, he reprinted the outline of a palette or robe, filling it with colors or a new image; or he'd create hand-colored versions of black-and-white prints. Although he automatically worked in variations, he seldom labored or redid images.

In 1970, as Dine grew more involved with etching, the look and meaning of his prints changed. The metaphors once represented by robes, the rambunctious ambition once suppressed in a tool, became active. Options embodied in images were less veiled; symbolic possibilities began to act themselves out in the process of a print's making—actual transformations took place.

As he began to work regularly in states, change became the subject of his prints. In its second state, *Paintbrush* (1971) has grown stiff, long and erotic; old and inactive *Shoe* (1973) by its third state is a brand-new walking spat. In the first state of *Five Paintbrushes* (1972), the brushes are passive objects hanging in a

Five Paintbrushes (fourth state), 1973
Etching with drypoint and soft-ground
Image: 14 × 27¼ inches (35.6 × 69.2 cm)
Paper: 30 × 35½ inches (76.2 × 90.2 cm)
Edition: 15
Printed by Allan Uglow and Winston Roeth
Published by Petersburg Press Ltd., London
Pace Editions, Inc., New York

field. In the second state, Dine adds six brushes and cuts down the plate. In the third state, bristles are lengthened and the addition of drypoint anchors object and ground. The plate is further cut down at the top and the side. Dine's sexual punning runs rampant. Equating the creative and sexual acts, brushes multiply, thicken and lengthen. A tentative tool becomes a procreative force. (The final image includes ten brushes; the title refers to the original five.) By the fifth state, the background is further darkened, bristles lengthened, and the brushes hold their ground.

By the early 1970s, Dine's iconography began to shift and expand. The hearts and palettes disappeared. Tools and robes remained, but they are less charged with other meanings. In *Dartmouth Still Life* (1974–76), tools are only compositional elements, and an impression from the artist's gloved hand makes an appearance. By 1976, the robe is only a robe: a form and subject. It is about color and line; having been retired from its service as a stand-in, the robe can no longer be described by its personality.

In 1971, Dine began etching self-portraits. In an initial attempt, a tentative image (*Self-Portrait, Head*), Dine holds his head back from the picture like a camera-shy subject and we see more of his beard than his face. (The beard bears a striking resemblance

Five Paintbrushes (fifth state), 1973
Etching with drypoint and soft-ground
Image: 14 × 27 ¼ inches (35.6 × 69.2 cm)
Paper: 30 × 35 ½ inches (76.2 × 90.2 cm)
Edition: 15
Printed by Allan Uglow and Winston Roeth
Published by Petersburg Press Ltd., London
Collection of Werner Kramarsky

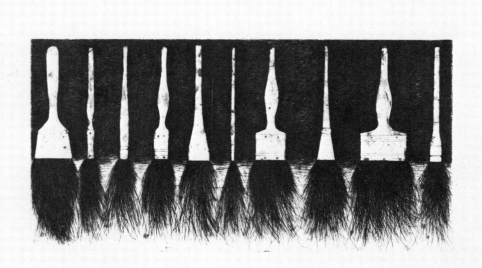

to the brush.) In *Self-Portrait in a Ski Cap* (1974), we see the painter transform himself into his subject. Reworking his face, he obliterates it with a still life of tulips. In *Self-Portrait in a Flat Cap* (1974), Dine rearranges a face, bearing little resemblance to his own, into a long-haired Rembrandtesque character — has he become an old-fashioned painter? But by the 1975 Dartmouth self-portraits, Dine's view is direct and expressive; feelings once concealed in the robe are now revealed in the face.

Dine's graphics take us on a psychoanalytic journey. As his methods become more elaborate and involved, his images carry more emotion. *Strelitzia* (1980) is not the work of the cool graphic artist of the 1960s, who once combined photographs with screen-print and rendered four different kinds of pubic hair. The immediacy of those graphic images relied on distance, on a distillation and a paring down of lines, on a reduction of color to the common denominator of primary shades or four-color process.

There is nothing pared down about *Strelitzia*. The expansive still lifes begin as a freely drawn, deeply bitten black-and-white etching. Painting over already inked plates one way and then another, Dine produces two more unique images and goes on to create six variations, adding lines, changing colors, loading an already inked plate with paint or monoprint, stopping to print an edition whenever he likes the result. For the *Strelitzia* series, Dine etches with the brush he once drew.

* Quoted in Thomas Krens, "Conversations with Jim Dine," in *Jim Dine Prints, 1970–1977*, exhibition catalogue (New York: Harper & Row in association with the Williams College Artist-in-Residence Program, 1977), p. 32.

LITERATURE:

Castleman, Riva and Thomas Krens. *Jim Dine Prints, 1970–1977* (exhibition catalogue). New York: Harper & Row in association with the Williams College Artist-in-Residence Program, 1977.

Russell, John, Tony Towle and Wieland Schmied. *Jim Dine: Complete Graphics* (exhibition catalogue). West Berlin: Galerie Mikro, 1970.

Opposite:
Strelitzia, 1980
Etching (unique image)
35 × 24 inches (88.9 × 61 cm)
Printed by Jeffrey Berman
Collection of the artist

Strelitzia, 1980
Etching with monotype (unique image)
35 × 24 inches (88.9 × 61 cm)
Printed by Jeffrey Berman
Collection of the artist

Overleaf:
Strelitzia, 1980
Etching with acrylic (unique image)
35 × 24 inches (88.9 × 61 cm)
Printed by Jeffrey Berman
Collection of the artist

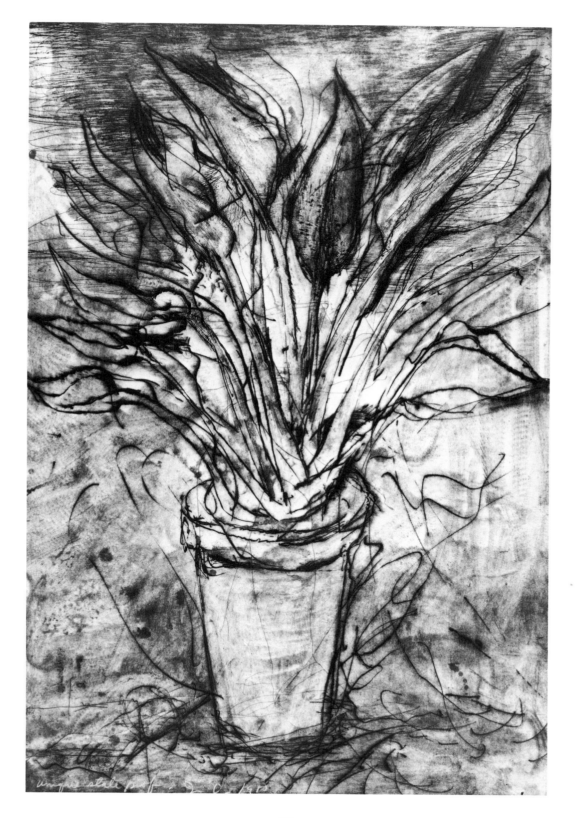

unique state proof 2 5 8 8 / 9 5

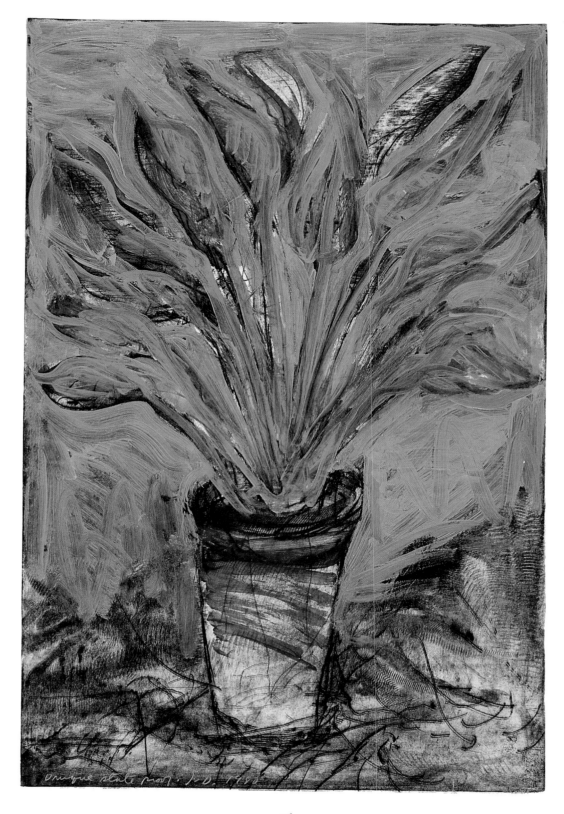

unique state proof · J.D. 1988

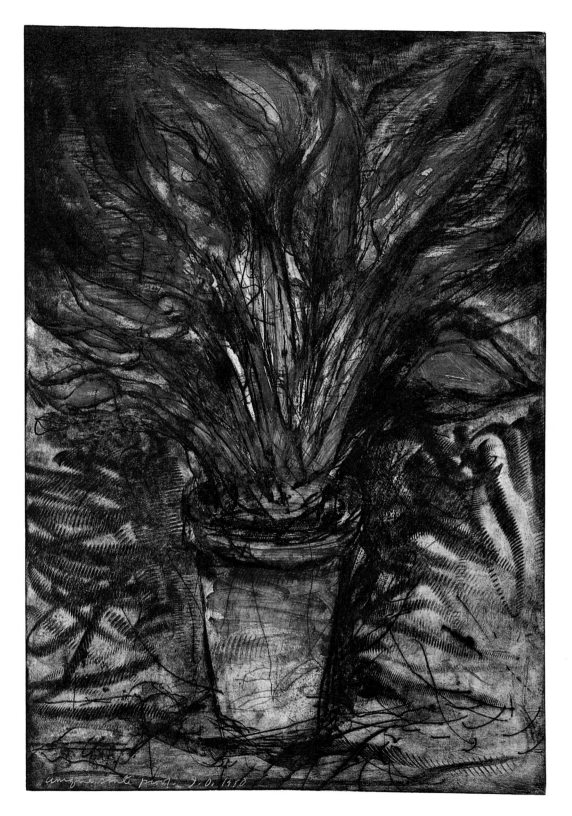

unique state proof. J.D. 1950

Sam Francis

In Paris in the 1950s, Sam Francis followed Abstract Expressionist aesthetics — except that his non-objective pictures were devoid of struggle. Francis' paintings had a painlessness to their immediacy, which separated them from New York School paintings. The fluid gray paintings from the early 1950s had a sometimes brooding presence, but they didn't have an iota of angst. Francis did not see fear in the void or grief in the sublime; he saw light and air and colors.

Light, air and colors remain his concerns. Francis' colors bleed, drip, overlap, create space and give off light. The pictures still have a distinctly non-New York look — their expansive space, the casualness with which colors splash, cavort and seep into surfaces reflect an openness of spirit indigenous to Francis' native California.

Paintings look as if they happened at once, but they are not at all randomly conceived. Overlays of colors create deep, dappled, translucent surfaces; breaking and bleeding arches form distant, billowing spaces; fragmented networks of lattice lines continue over edges, implying a continuum that creates scale.

Lover Loved Loved Lover, 1960
Lithograph
25 × 35½ inches (63.5 × 90.2 cm)
Edition: 18
Printed by Emil Matthieu
Published by Kornfeld, Bern,
 Switzerland
Collection of the artist

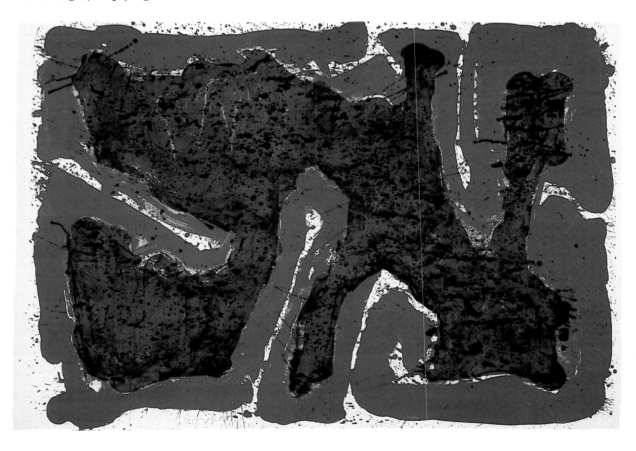

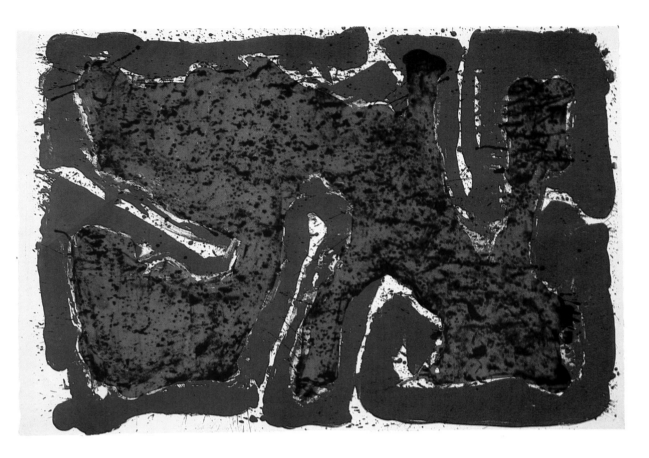

Francis determines compositions and controls process up to a point—and then lets the paint have its way. To Francis paintings are bridges to innumerable directions, to unconscious thoughts and to self-knowledge. To gain access to the self, Francis lets things be. Anchored in a Jungian concept of balance, in a reconciliation between the self and the elements, Francis' approach to art is also informed by dreams, Eastern mysticism, a Heraclitean notion of the world and, above all, by his feelings.

Like other painters of his generation, Francis scorned lithography as a commercial process, and in 1959, when Tatyana Grosman brought stones to his New York studio, he thought she was crazy. He drew on the stones, and fell in love with them, but before they were etched or printed, he left for Europe, where his friend and dealer Eberhard Kornfeld also suggested he make lithographs. Francis worked with the Swiss printer Emil Matthieu. Enthralled by stones, Francis found them as basic as fire or water; he liked their primordial presence and the ghost images they carried. He soon had a belief in the mystical properties of stones matched only by Tatyana Grosman's.

Although Francis' lithographs follow the aesthetic of his paintings, he has never reproduced paintings in print or searched for graphic equivalents to transmit painterly effects. Robert Mother-

Serpent on the Stone, 1960
Lithograph
25 × 35½ inches (63.5 × 90.2 cm)
Edition: 20
Printed by Emil Matthieu
Published by Kornfeld, Bern,
 Switzerland
Collection of the artist

well uses thick aquatint surfaces to convey the saturated hue of painting, exploiting the explicitness of graphics to tell something about paint. Similarly, working in woodcut, Helen Frankenthaler uses the grain of the wood to hold color like raw canvas. Equally as informed by painting as Motherwell or Frankenthaler, Francis does not try to push lithography around or bend the medium to meet his ends. In paintings, his overlapping colors bleed and merge into each other; in lithography, colors printed over one another, each from a separate stone or plate, do not bleed; remaining separate, they form deep layers of crisp, translucent colors.

He approaches lithography as he does painting; he does his part, paints on the stones with tusche and then lets the lithogra-

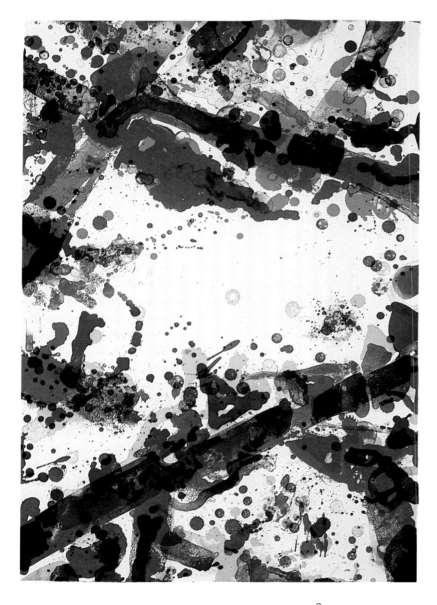

Untitled (Metal Field), Trial Proof, 1972
Lithograph
35¼ × 24 inches (89.5 × 61 cm)
Collection of the artist

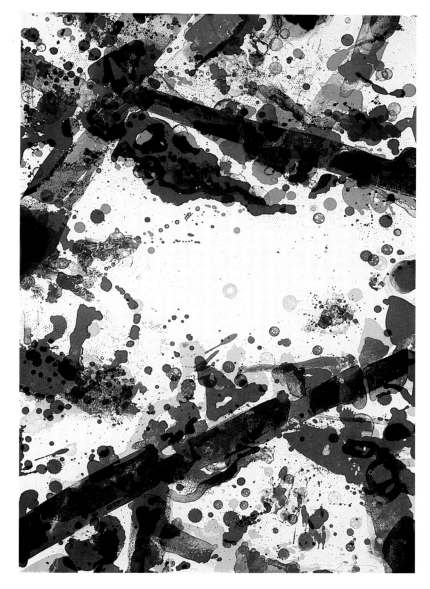

Untitled (Metal Field), Trial Proof, 1972
Lithograph
35 ¼ × 24 inches (89.5 × 61 cm)
Collection of the artist

phy have its way. "I would be very careful not to ignore the Gods of lithography," Francis has said. "They're very potent. I speak to them every day.... I'm not out to do anything to lithography. I don't want to extend lithography. I don't want to be a lithographer. I'm not involved with lithography from that point; I love it. I like to wash the stone."

Francis takes his cue from stones: he titled early compositions *Blue Stone* and *Blue/Blood Stone* and *Coldest Stone*, and when the stone he painted on for Tatyana Grosman was finally printed in 1968, he called it *Very First Stone*. His early compositions bore the shape of stones and he painted them with filmy washes and worked their surfaces to bring out their ancient porous

texture. Instinctively aware of the infinite variables possible from one stone, he printed early lithographs in different colors, creating three separate images from one stone: *Serpent on the Stone, Lover Loved Loved Lover* and *Beauty Walk*.

In more recent prints, Francis uses stones as modular units. In the lithograph *Straight Line of the Sun* (1976), created from six stones, Francis had two of the stones printed twice and two others printed three times, forming the composition by positioning overlapping stones.

In 1970, Francis built a lithography studio (The Litho Shop) next door to his Santa Monica painting studio, so that he could paint on stones when he wanted, without having to travel or meet the scheduling demands of publishers. A completely collaborative printmaker, he has worked with lithographer George Page since 1973. Francis paints on stones with black tusche, while he thinks about them in reverse and in colors. He works on a number of stones that will be combined into one lithograph without knowing which one carries the key image.

Proofing the stones in different colors, Page turns them around. Altering their sequence, he explores all the possible combinations. Sequence and color decisions are made after the proofing process. *Untitled (Metal Field)* (1972) was printed in combinations of colors before Francis decided on the black and gray version.

To Francis, his collaboration with George Page is as essential to the lithographic process as his hand. In a 1979 interview with publisher and dealer Brooke Alexander, Francis said, "George's work is just as important to me as any other part of...printmakingI don't just come in and say 'Well I want this color'...and I make a swatch of it...like I have to do in some places. With George or with Hibo too, I just play freely and they play and we play together."

Page chooses papers and mixes colors. His palette differs from Francis'—he likes colors "just a little off the beaten path." But Francis delights in the differences—through them, he finds resolutions for his printed art.

Untitled (Metal Field), 1972
Lithograph
35 ¼ × 24 inches (89.5 × 61 cm)
Edition: 17
Printed by Hitoshi Takatsuki, Keith Kirts, Susan Titelman, and Keiko Yoshimura
Published by the Litho Shop, Inc., Santa Monica, California
Collection of the artist

LITERATURE:

Alexander, Brooke. *Sam Francis* (exhibition catalogue). New York: Brooke Alexander, Inc., 1979.

Selz, Peter. *Sam Francis*. With an essay on his prints by Susan Einstein. New York: Harry N. Abrams, Inc., 1975.

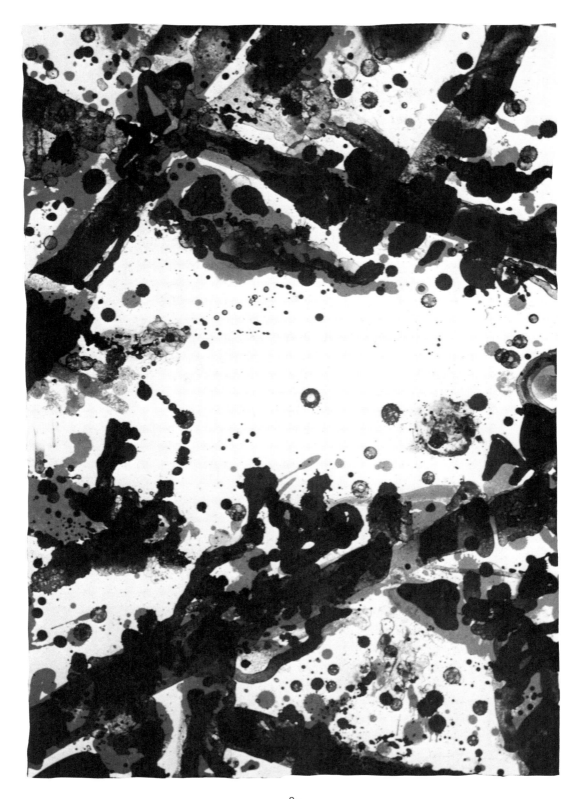

Helen Frankenthaler

Savage Breeze, Trial Proof, 1974
Woodcut
31¾ × 27½ inches (80.6 × 69.9 cm)
Collection of the artist

Helen Frankenthaler's intuitive and romantic paintings rely on ambiguities: color abstractions recall specific places or particular feelings; landscape-derived images appear abstract. When Frankenthaler stained paint into raw canvas, merging figure and ground, she emphasized the flat canvas and simultaneously created an illusion of depth. Lines form shapes, contours and define space; Frankenthaler's lines also hold color, texture and the feeling of paint. A line exists only to show a thick redness. Frankenthaler is a modernist: one way or another, her paintings acknowledge the distinction between materials and the illusion they convey.

Frankenthaler works fast. Like Jackson Pollock, she unrolls canvas on the floor and paints from above, inside and around its edges. If these methods weren't suited to printmaking, neither were her interests; and in 1961, when Tatyana Grosman invited her to make a lithograph, she accepted reluctantly. Frankenthaler found printmaking's fragmented procedures disorienting and re-

Savage Breeze, Trial Proof, 1974
Woodcut with collage
31¾ × 26½ inches (80.6 × 67.3 cm)
Collection of the artist

ferred to them as a foreign language. *First Stone* (1961), her initial attempt, shows her discomfort: filled with urgent marks and uncharacteristic angst, it reflects more effort than art.

After that, Frankenthaler stopped trying to make a lithograph and instead focused on ways to realize painterly effects in print. Approaching lithography as she did painting, Frankenthaler began with the medium's givens—building images out of the shape and surface of stones, the texture and size of paper. Working her own way, she poured, sponged and painted onto limestone slabs, and if an image displeased her she left it and moved on, discarding stones like typing paper until she got it right. In early prints, Frankenthaler was not particularly involved in the proofing process.

Although Frankenthaler's prints look as if they just happened, their means are considered. Images depend on the properties and materials of each graphic medium. In the lithograph *Brown Moons* (1961), the bleeding line embeds ink into paper; the open rectan-

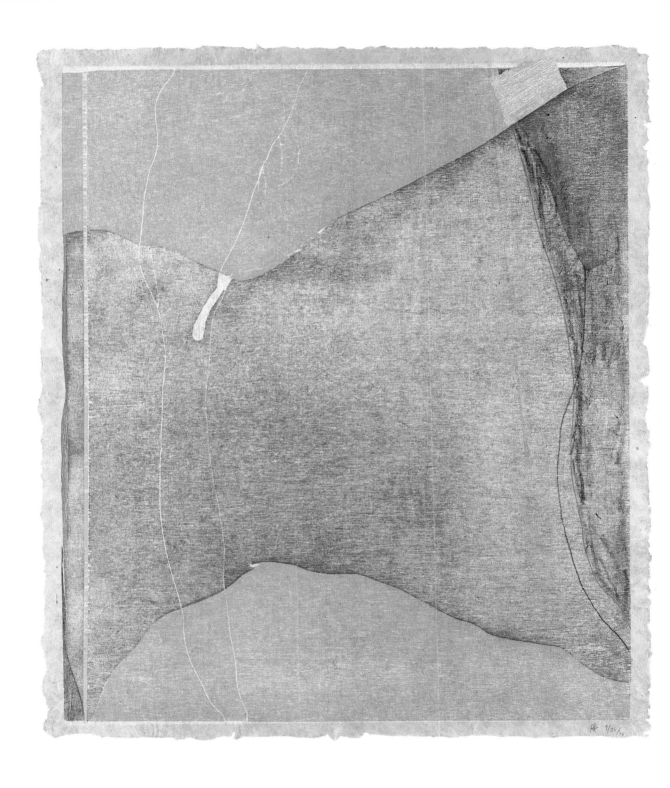

Savage Breeze, Working Proof, 1974. Woodcut with crayon, ink, and collage. 31¾ × 27 inches (80.6 × 68.6 cm). Collection of the artist.

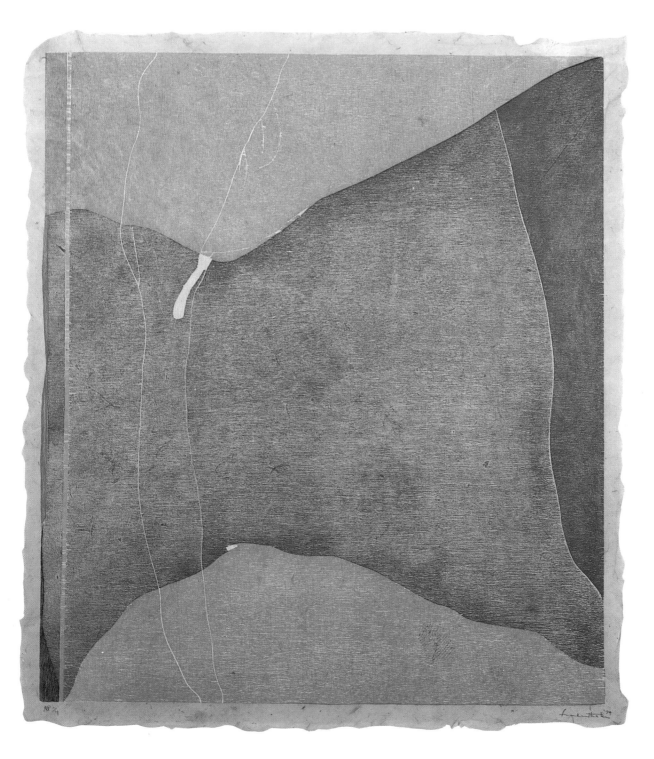

Savage Breeze, 1974. Woodcut. 31½ × 27 inches (80 × 68.6 cm). Edition: 31. Printed by Bill Goldston and Juda Rosenberg. Published by Universal Limited Art Editions, West Islip, New York. Collection of the artist.

gular shape allows the paper to move in and around it. The shape of the paper, by echoing that of the composition, creates scale. Paper and image are inseparable. Had Frankenthaler painted a closed rectangle, the paper would have framed the image; had a vertical sheet held the horizontal composition, it would not have achieved its illusion of scale.

For Frankenthaler, each medium presents a new set of problems. Etching meant using aquatint, incised lines and the indentations left by copperplates to create a scale and to stain color into paper. Aquatint, an eighteenth-century technique invented to simulate painted washes, was a natural; it allowed Frankenthaler to achieve the effect of paint stained into raw canvas, to merge figure and ground. Her first etching, the color-saturated *Yellow Span* (1968), looks effortless, but is full of decisions. The subtle, barely mottled yellow ground activates the surface. A completely even expanse would have had a static effect, while heavier mottling, which she tried and rejected, overemphasized the surface and looked belabored, like fake painting. The line of space Frankenthaler leaves between *Yellow Span's* wavy forms creates crucial movement. Abutting forms, for example, would have locked colors together, causing a static effect.

Frankenthaler rejects the obvious graphic options, avoiding strictly linear and flat colors and, time and again, uses graphic properties to transmit painterly intentions. In representational prints, plate marks confine an image and the surrounding paper frames it. The paper border is a decorative, inconsequential factor — borders were regularly cut off Old Master prints and it made no visual difference. In abstract prints, the entire sheet and its surface are aesthetic considerations. Plate indentations can interfere by breaking the paper's surface. In *Yellow Span*, Frankenthaler uses plate marks to abruptly cut the flowing forms; like cropping in her paintings, the sudden cuts create the effect of a Zen painting — the illusion that color continues. The suggestion that the image goes on, that we are only seeing part of the picture, makes the small 14-by-18-inch image appear far larger than it is.

Although cropping, staining and other painting techniques inform Frankenthaler's prints, her graphics never replicate paintings. On occasion, painted compositions, such as *Three Moons* (1961) and *Cloud Slant* (1968), are the basis for prints, but only as points of departure. Images grow out of the materials at hand. With each graphic technique, Frankenthaler finds new expressions. One never looks at a Frankenthaler print and says, "I know the painting."

Frankenthaler has described woodcutting as the most frustrating, demanding and satisfying graphic medium. The woodcut, a relief method, is a difficult one in which to convey an immediate gesture or flat surface, and all her woodcuts have been struggles. For *Savage Breeze* (1974) she cut shapes with a jigsaw instead of a gouge; the method allowed her to work with the wood's flat-grained surface. In *Savage Breeze*, the wood's grain holds col-

or and shows through it like the texture of a canvas; but in early stages, the grain's horizontal striations flattened the print out. To bring attention to the surface and suggest depth, Frankenthaler cut vertical bands into the wood, adding lines of yellow, orange and a wedge of green. In a later stage, she created more volume by dividing the curving pink form, so that it appears to bend toward the viewer. Still dissatisfied, convinced the image lacked life, Frankenthaler printed a white block under the final image, which, like a coat of primer, sharpened the colors.

Woodcutting has not become easier with experience. In the process of creating *Cameo* (1980), Frankenthaler went through fifty unique proofs. None satisfied her; finally, using a block from the discarded edition, she began all over again. *Cameo* is about the delicate balance of fields of overlapping colors. Neither the pink nor blue field dominates. Colors merge and separate. The pink shape appears to be on the surface of the blue ground. Blue shapes grow out of smoky pink fields. Seemingly random linear gestures, magenta and brown lines, sit on the surface, and maintain the balance between blue and pink grounds.

Cameo's final version comes close to its early states. But in between, Frankenthaler added a brown cartographic image, which froze the movement of the pink and blue fields. Then she cut it away, leaving only a gestural sliver. In *Cameo*, Frankenthaler once again resists the purely graphic and bends the medium to express the painter's interests.

LITERATURE:

Goldman, Judith. "Painting in Another Language." *Art News*, 74 (September 1975), p. 28

Krens, Thomas. *Helen Frankenthaler Prints, 1961–1979* (exhibition catalogue). New York: Harper & Row in association with the Williams College Artist-in-Residence Program, 1980.

Rose, Barbara. *Frankenthaler.* New York: Harry N. Abrams, Inc., 1970.

Overleaf:
Cameo, Trial Proof, 1980
Woodcut
42 × 31¾ inches (106.7 × 80.6 cm)
Collection of the artist

Cameo, 1980
Woodcut
42 × 32 inches (106.7 × 81.3 cm)
Edition: 51
Printed by Kenneth Tyler, Roger Campbell, and Lee Funderburger
Published by Tyler Graphics Ltd., Bedford, New York
Tyler Graphics Ltd., Bedford, New York

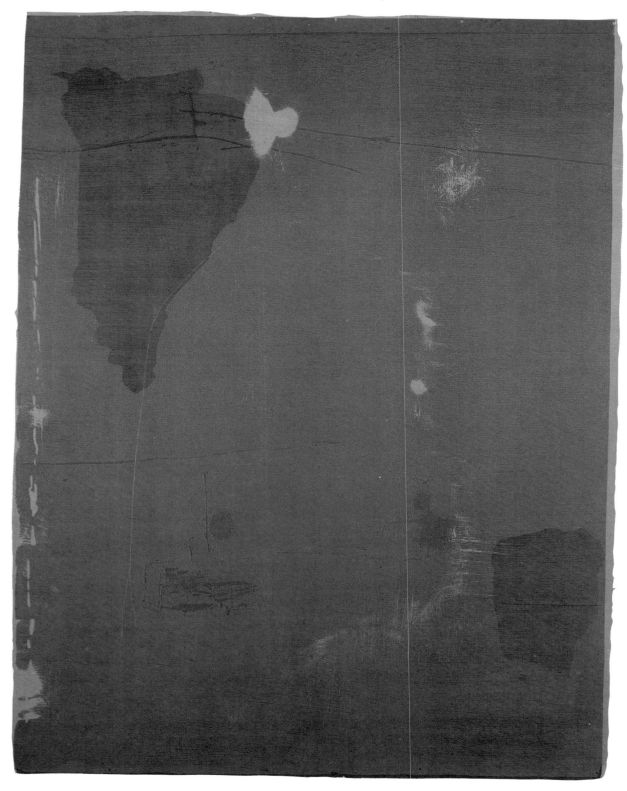

90

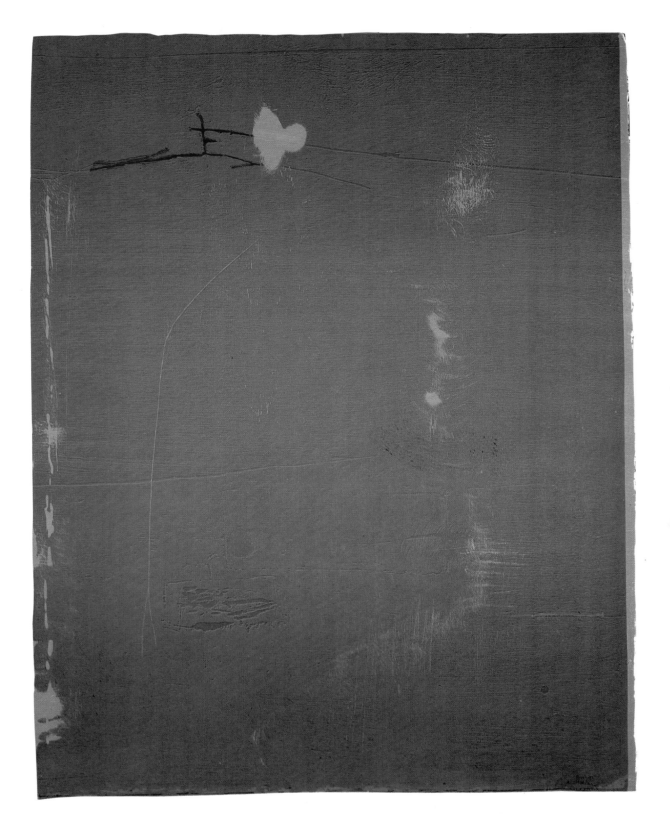

Jasper Johns

Jasper Johns draws, paints and prints the same images: flags and targets; numbers and letters; ale and coffee cans; fragmented parts of the body. In the late 1960s and early 1970s, his iconography expanded to include forms that look like flagstones and patterned lines that suggest crosshatching. He saw the flagstone shapes painted on a Harlem building; the lines decorated a passing truck. "What's interesting to me," Johns once explained about his image, "is the fact that it isn't designed but taken. It's not mine."

Beginning with an act of self-negation, Johns chose to paint symbols and objects "the mind already knows"; fixed signs — flags, targets. The images were not his own, and they weren't so much his subject as its foil. The flag sparked questions: Was it an object, a painting or both? A flat surface or a patriotic emblem? Every successive flag led to new inquiries about what was and had been, and how, if at all, one perception affected the other.

Change is Johns' working method and philosophical stance. He is interested in the differences and similarities caused by large shifts and small alterations. He works accordingly. Within rigorous limitations, he repeats his iconography. New images rarely appear. Change results from modifications in color, size, context and medium. Images resurface with crucial alterations: circles recall targets; painted in tones of gray, names of colors in *False Start I* and *II* (1962) raise questions about knowledge, designations and expectations. A mirror image in *Corpse and Mirror* (1976) reveals duplications and reversals. Ale and Savarin cans, mementos of the past and measures of the present, travel through paintings, drawings and prints, like earnest tourists. How is the viewer to read the ongoing retrospective?

A resurrected image means one thing if one knows the art, something else entirely if one does not. It depends on how you look at it. Is that Johns' point? How does it differ from other art? All art is self-referential. All art feeds on itself. *Broadway Boogie Woogie* may mean more to viewers who know Mondrian's theories and early art; but it does not, therefore, follow that it means nothing to viewers who do not. Turning in on itself, Johns' art contrasts his past and present images, but that is only part of its point. Images also stand alone. Johns' art is about ways of seeing. The meaning of the images' meanderings is one way to see things, but does not preclude others. (Familiarity with the vast critical literature Johns' art has inspired is not prerequisite to understanding his art — unless you are a critic.)

Johns took us back to Plato's shadowy cave, long before he began painting and printing retrospective images. Early flags and targets, not yet self-referential, posed philosophical questions about illusion and reality, art and perception. The inquiry remains the same, while the imagery has expanded and grown denser, its syntax more complex.

Prints can hold memories of what has been, evidence of what

Untitled, Working Proof, 1977
Lithograph with chalk
32 × 22⅞ inches (81.3 × 58.1 cm)
Collection of the artist

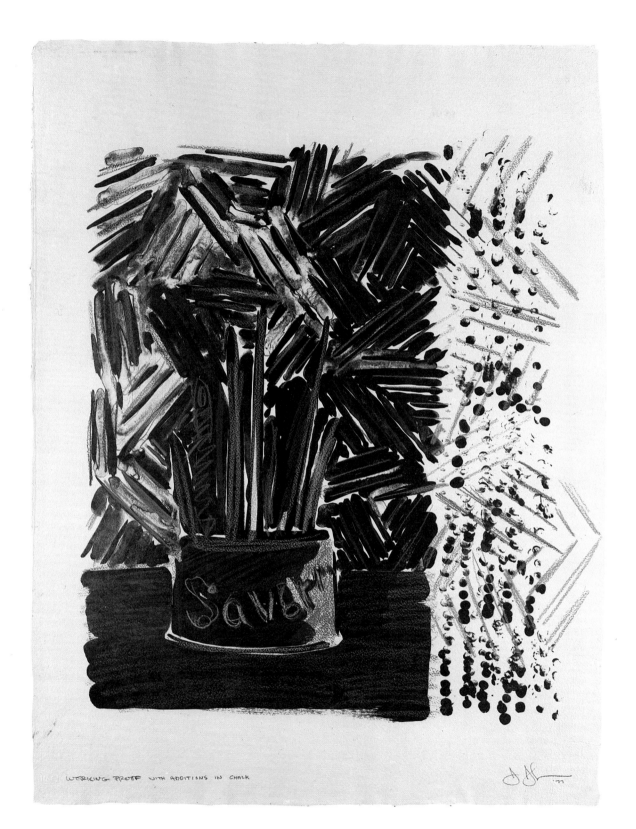

WORKING PROOF WITH ADDITIONS IN CHALK

is. The medium is one in which an artist can simultaneously move backward and forward. He can erase without leaving a sign, or cancel out and show traces. A modular medium in which parts can be discarded and replaced, it permits false starts and encourages revisions. The print's capabilities dovetail so precisely with Johns' interests that it is impossible to separate the intention of the paintings from that of the prints. Crosshatching in a painting suggests Johns' efforts as a printmaker; crosshatching in the prints recalls the work of the painter.

Printmaking allows Johns to track his own scent. By restating, he contrasts past and present, part and whole, reality and illusion. In one way or another, almost all of his prints repeat images that appeared first in paintings. Some, like the 1971 lithographs *Fragments—According to What*, separate and transpose the shapes of former art into new wholes. Others, like *Pinion* (1963–66), *Decoy* (1971) and *Passage I* (1966), *Savarin* (1977), and *Untitled* (1977), rearrange iconography into elaborate retrospective views.

Conceived as an advertisement for himself, *Savarin* (1977) was made for Johns' retrospective at the Whitney Museum of American Art. With the addition of lettering, *Savarin* became the exhibition's poster. In *Savarin*, the ever-present coffee can sits on a wooden ledge, representing the artist, his art and his tools. Is it the ledge once occupied by the real can in the artist's studio? Be-

Untitled, Working Proof, 1977
Lithograph with pencil, chalk, and collage
24¾ × 35¾ inches (62.9 × 90.8 cm)
Collection of the artist

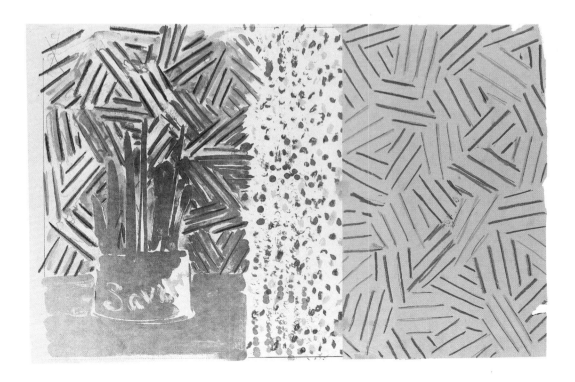

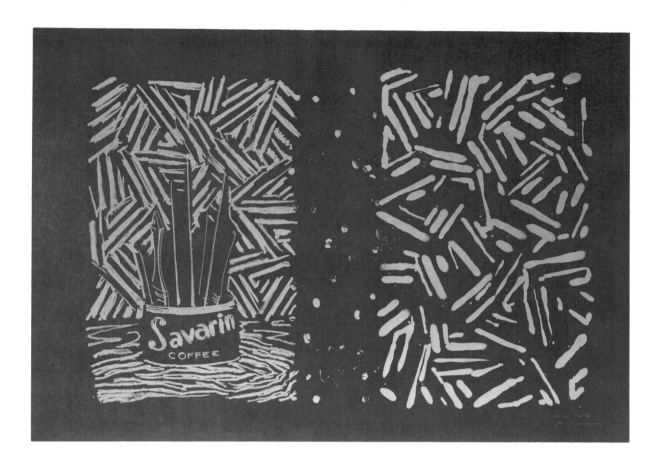

hind the can lie the marks of the brush; lines Johns once painted in primary colors appear printed in pastel pink, blue and yellow. By cutting primary shades with white—has he subdued them into memories?

Untitled (1977) tells the same story differently. The artist's fingerprints, shaped like celebratory confetti, unify old art and new idea. The proofs reveal the artist's logic. Starting with an old proof of a lithograph he began but never completed, Johns adds crosshatched lines to connect past and present art. Printing the Savarin can in a ghostly silver-gray, he attaches a drawing of the colored lines, extending the image into the present. Before arriving at his rigorous conclusion, he prints only the Savarin can, then the entire image in ghostly gray on black.

Direct and multilayered, Johns' symbolic still life recalls the art that has preceded it. Every image conjures up a past history: the fingerprints; the colored lines; the coffee can. Johns once said that he found the Savarin can interesting because it had been used to mix turpentine, and he liked the idea of one thing used with another for a purpose. The first Savarin can appeared in 1960. Cast in bronze, painted and marked with fingerprints, it merged object,

Untitled, Trial Proof, 1977
Lithograph
30 × 42 inches (76.2 × 106.7 cm)
Collection of the artist

subject and idea; the artist's materials became his work. Stilled forever, the Savarin can was Johns' Grecian Urn, a "foster child of silence and slow time." Was the bronze can about the artist's isolation? Or the stasis of art? Or simply meant to ignite the meditative silence, crucial to Johns' art?

Restating the Savarin can in *First Etchings* (1967–68), Johns contrasted a luxuriantly drawn Savarin can with a photoengraving of *Painted Bronze* (1960) — to pose his persistent questions about differences and similarities, reproductions and replications, the effect of time and memory on perception. Again, in *First Etchings, 2nd State* (1967–69), the Savarin can is acted upon and updated. Using the same plates, he re-etches the photoengraving with coarse open biting, blackens the line etching with aquatint, showing us two ways to do the same thing: additive aquatint and subtractive open biting. One covers up, the other corrodes.

The Savarin can's last appearance before *Untitled* (1977) is in the line-up at the base of the large retrospective lithograph *Decoy* (1971). Printed in reverse, in a faded gray, punctured by a hole through the paper, the Savarin can is one of many elements in the artist's murky private inventory. Verging on the reckless, *Decoy* resurrects past images in a new order, but there is no conclusion to the extraordinary display of visual rhetoric.

In comparison, the intent of the retrospective *Savarin* and *Untitled* is clear. An intentional advertisement, the bigger-than-life Savarin has been enlarged to meet the self-proclaiming demands of a poster. Carrying even more information, the three-sectioned *Untitled* recalls the artist's obsession with fragmentation, with parts and wholes. From left to right, the image reads from past to present. Later, when the print was folded to become the catalogue cover, the order was reversed. The fingerprints appeared on the book's spine; the lines, in primary and complementary colors, came first, the Savarin can last. The unexpected reversal, resulting from a simple, logical fold, reminds viewers of the ways a retrospective can be seen. *Untitled* was not planned as the catalogue cover; once again, inadvertently Johns' beginnings and ends meet to pose an ongoing question about how we see.

LITERATURE:

Crichton, Michael. *Jasper Johns* (exhibition catalogue). New York: Harry N. Abrams, Inc., in association with the Whitney Museum of American Art, 1977.

Field, Richard S. *Jasper Johns: Prints, 1960–1970* (exhibition catalogue). New York: Praeger Publishers in association with the Philadelphia Museum of Art, 1970.

——. *Jasper Johns: Prints, 1970–1977* (exhibition catalogue). Middletown, Conn.: Davison Art Center, Wesleyan University, 1978.

Geelhaar, Christian. *Jasper Johns Working Proofs* (exhibition catalogue). London: Petersburg Press, 1980.

Opposite, above:
Untitled, Working Proof, 1977
Lithograph with pencil, chalk, and ink
30 × 37½ inches (76.2 × 95.3 cm)
Collection of the artist

Opposite, below:
Untitled, 1977
Lithograph
27½ × 40 inches (69.9 × 101.6 cm)
Edition: 53
Printed by James V. Smith
Published by Universal Limited Art Editions, West Islip, New York
Whitney Museum of American Art, New York; Gift of the artist 77.122

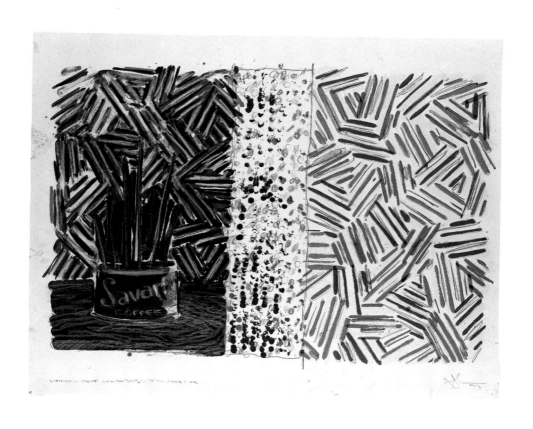

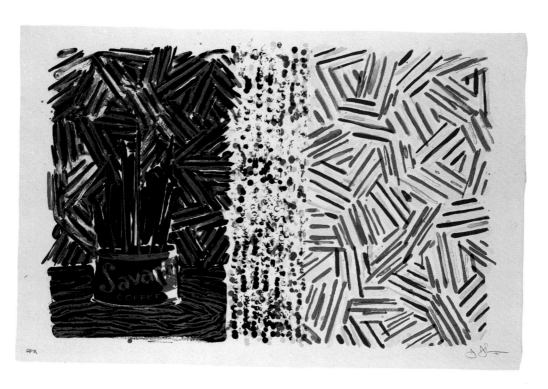

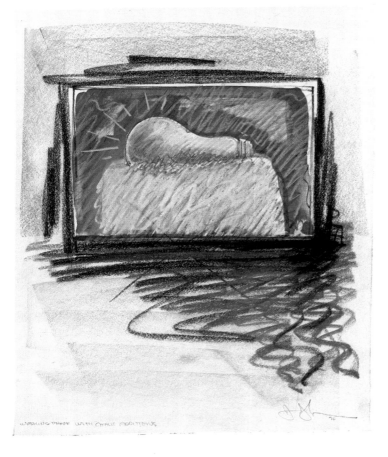

Above:
Light Bulb, Working Proof, 1976
Lithograph with crayon
11¼ × 17⅜ inches (28.6 × 44.1 cm)
Collection of the artist

Left:
Light Bulb, Working Proof, 1976
Lithograph with chalk
17⅛ × 13⅞ inches (43.5 × 35.2 cm)
Collection of the artist

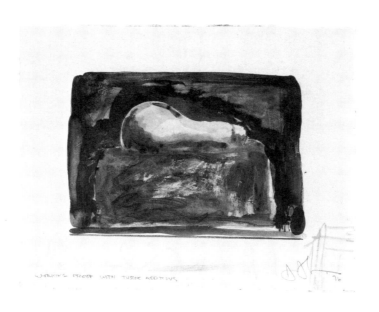

WORKING PROOF WITH TUSHE ADDITIVE

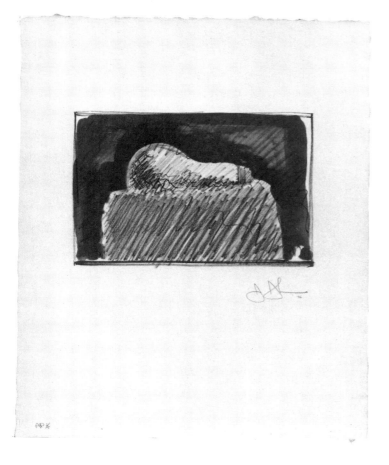

PP ¾

Above:
Light Bulb, Working Proof, 1976
Lithograph with tusche
10⅝ × 13⅛ inches (27 × 33.3 cm)
Collection of the artist

Left:
Light Bulb, 1976
Lithograph
17 × 14 inches (43.2 × 35.6 cm)
Edition: 48
Printed by Bill Goldston and James V.
 Smith
Published by Universal Limited Art
 Editions, West Islip, New York
Private collection

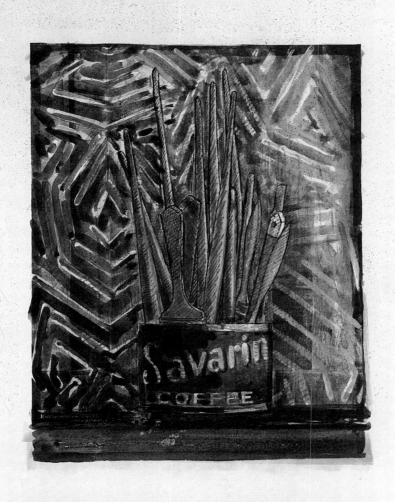

WORKING PROOF WITH ADDITIONS IN INK + PENCIL

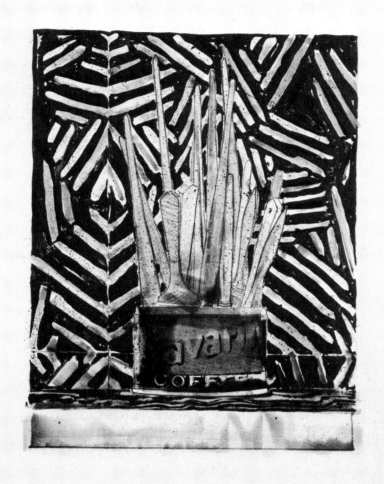

Left: *Savarin 5 (Corpse and Mirror)*, Working Proof, 1978. Lithograph with ink and pencil. 29⅞ × 22⅛ inches (75.9 × 56.2 cm). Collection of the artist.

Above: *Savarin 5 (Corpse and Mirror)*, 1978. Lithograph. 25 × 20 inches (63.5 × 50.8 cm). Edition: 42. Printed by James V. Smith and Thomas Cox. Published by Universal Limited Art Editions, West Islip, New York. The Museum of Modern Art; Gift of Celeste Bartos.

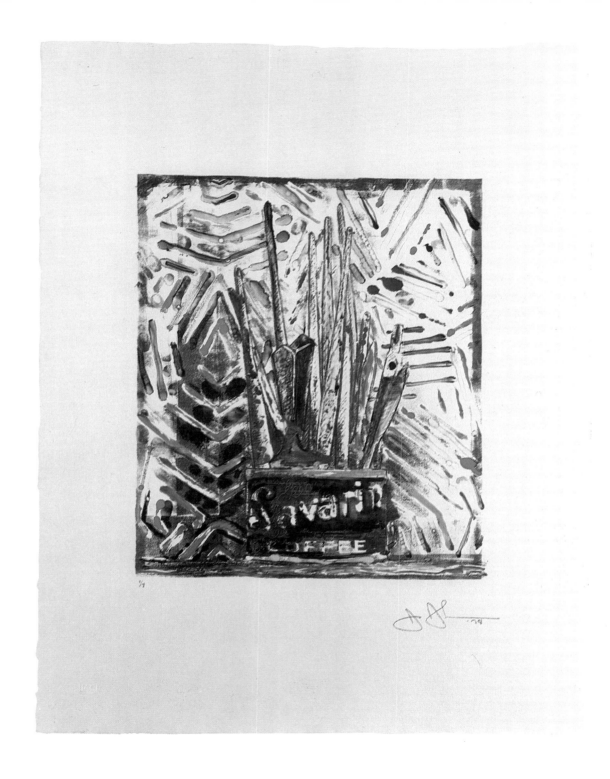

Savarin Monotype, 1978. Monotype from lithographic plate. 26 × 20 inches (66 ×
50.8 cm). Printed by Bill Goldston. Published by Universal Limited Art Editions,
West Islip, New York. Collection of the artist.

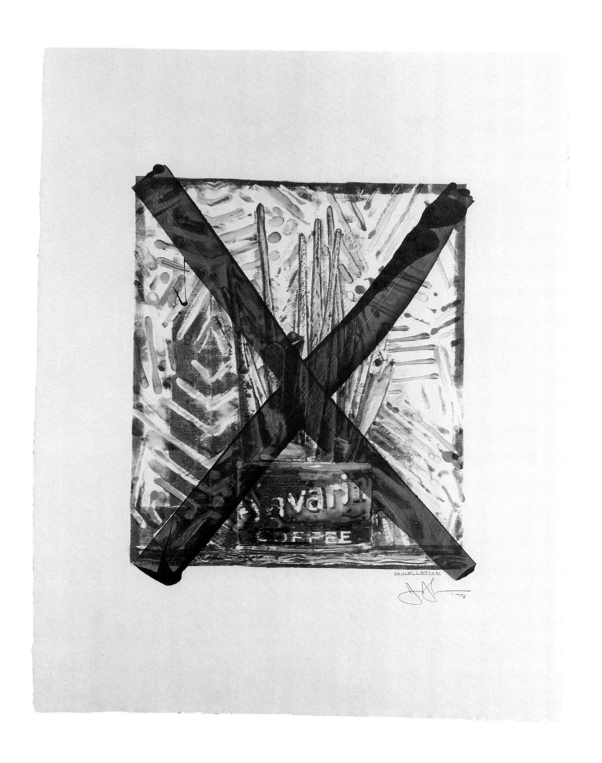

Cancellation of *Savarin Monotype*, 1978. Monotype from lithographic plate.
26 × 20 inches (66 × 50.8 cm). Collection of the artist.

Vincent Longo

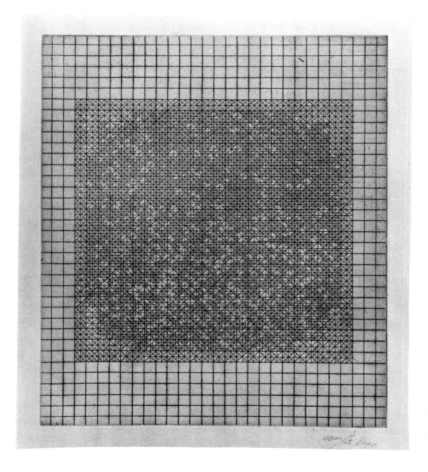

Screen, State I, 1967
Etching
$17^{13}/_{16} \times 18$ inches (45.2 × 45.7 cm)
Collection of the artist

Vincent Longo paints and prints circles, squares, mandalas and grids. Beginning with a quadrant, he crosses it with diagonals to form a grid; covering a grid with diagonals, he creates uneven crosshatched tones. A geometric logic appears to be in operation; but Longo's graphics are not preconceived or particularly logical. His predetermined structures are only points of departure. Using them to see what lines can do, he bisects grids and builds compositions of random spaces. Lines form patterns. Grids stand in relief and simultaneously become the ground.

Longo's initial premise is systemic, but his point is not conceptual. His art is not about variables or options, but about chance. Longo's prints are not didactic, like Sol LeWitt's. Brice Marden, who obviously looked as hard at Longo's prints as LeWitt did, comes closer to Longo. Longo's linear compositions convey sounds, silences and atmospheres.

Often Longo combines circles and squares to form mandalas. Since 1946, when he doodled the archetypal form in a notebook,

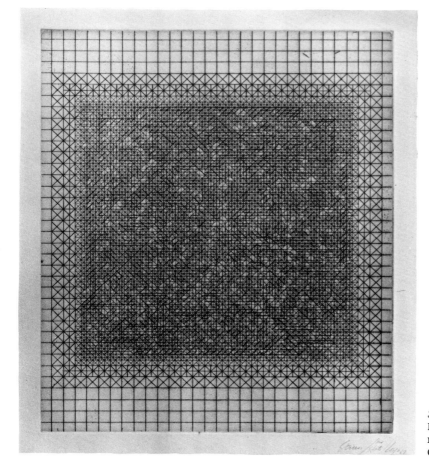

Screen, State II, 1967
Etching
19⅞ × 17 inches (50.5 × 43.2 cm)
Collection of the artist

he has been fascinated by mandalas, and has researched their extensive literature. In the 1950s, his paintings featured centered clusters; in 1962, he printed *Mandala*, a woodcut, and he has etched variations on the form ever since.

Longo etched circles over grids and into squares, and against the edges of a square plate. He uses mandalas as he does grids to define space and build surfaces. The radius of circles measures the distance to the edge of squares. By overlapping circles and squares, he merges figure and ground. Longo insists he does not draw mandalas as either religious or Jungian symbols, yet his images have a peaceful effect. They suggest answers and hint at resolutions.

Since 1953, when he cut his first woodcut, Longo's prints have mirrored their process. In early gestural woodcuts, he used wood like paper, painting directly on its surface with India ink. Carving away the space around the ink, he maintained the autographic effect and printed the drawing he had made on wood.

In reductive woodcuts, made in 1956 while he was living in

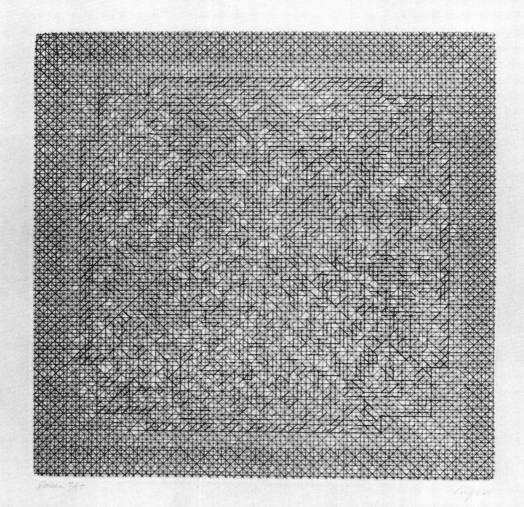

jamm 7/5 Cryson

France, Longo cut and printed a woodblock; cutting and printing the same woodblock again, each cut yielded a new image and he continued the process until the wood was used up. Longo invented the reductive process because wood was hard to come by. But he usually works within self-imposed limitations and relies on a pared-down process in which his ends reflect his means.

Longo's prints also reflect the properties of their media. Woodcuts depend on the texture of wood and the aggressive line a gouge makes when pulled against the grain. Etchings are built out of the raised, rounded, antiseptic lines only possible in that medium. He does not experiment with new techniques, sticking to graphic facts: his etchings are about line; his woodcuts are about wood. The ordered look of Longo's prints belies his methods. He cuts directly into the wood, draws on copperplates. Proceeding without a pre-set composition, one line leads him to the next. Often he does not proof an image until it nears completion. Longo's methods are seemingly contradictory. He is a superb technician. An impeccable printer who proofs and prints himself, he is not particularly concerned with technique or with printmaking's multiple aspects. Often he does not edition prints. As often, his first proof is a finished state. Yet, he keeps working an image, taking it farther, and like Jim Dine, he transforms it.

Individual proofs stand as separate works of art; when seen together, their meaning expands. *Screen*, State I (1967) contrasts an evenly scored grid and random markings. Further systematic scoring of the grid in State II increases scale and transforms part of the ground into a frame. In its third and final state, *Screen* becomes an entirely new image. Cutting away the evenly marked grid of State I, Longo extends the randomly marked center; contrasting exacting geometric line and random marks, *Screen*'s subject has not been altered, only restated.

In *Passing Through*, as in *Screen*, the simplest of means creates a complicated effect. *Passing Through* begins with an even, symmetrical black grid, against a vertically striated grain. The grid is only a beginning. Gouging white lines against the grain, Longo breaks its surface but leaves the grid intact. In State III he begins to cut through the grid until finally in State VII he fragments the geometric structure into a rough and violent plane, carving wood, as he etches metal, into a rich graphic surface.

LITERATURE:

Baro, Gene. *Vincent Longo Print Retrospective, 1954–1970* (exhibition catalogue). Washington, D.C.: The Corcoran Gallery of Art, 1970.

Opposite:
Screen, 1967
Etching
17⁹⁄₁₆ × 22 inches (44.6 × 55.9 cm)
Edition: 25
Printed by Emiliano Sorini
Published by the artist
Collection of the artist

Overleaf:
Passing Through, State I, 1976–77
Woodcut
36 × 24 inches (91.4 × 61 cm)
Printed by the artist
Collection of the artist

Passing Through, State VII, 1981
Woodcut
36 × 24 inches (91.4 × 61 cm)
Edition: 10
Printed and published by the artist
Collection of the artist

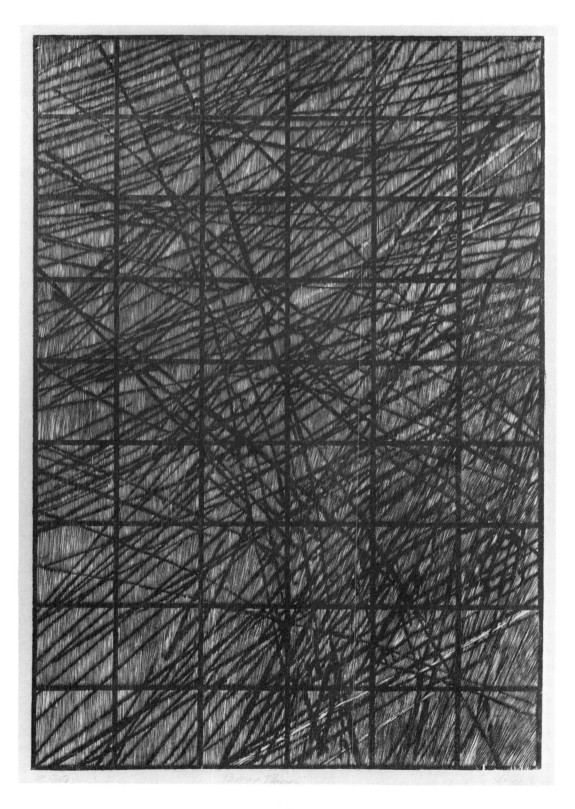

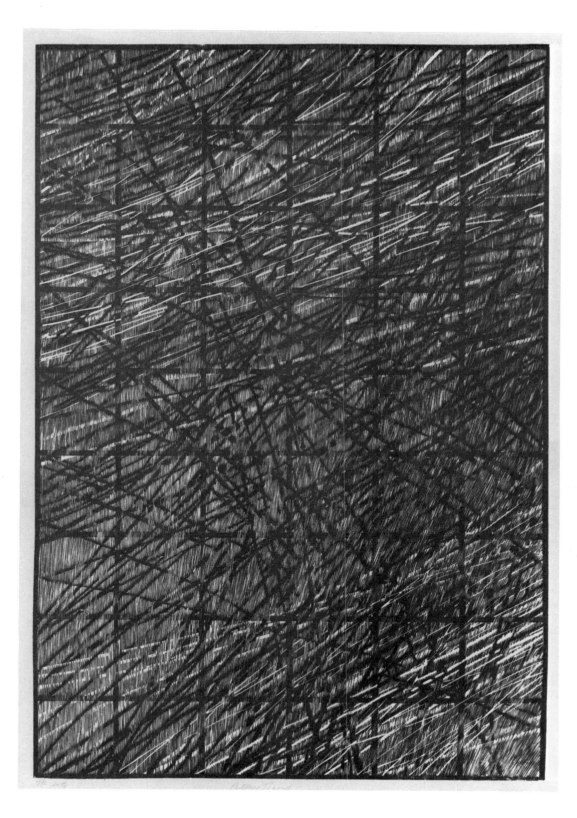

Michael Mazur

Michael Mazur etches isolated objects and enclosed spaces: mentally disenfranchised patients wander through closed wards; chairs sit in empty rooms; a badminton court is animated not by players, but by stillness. Mazur etches lonely vistas, where conversations do not take place. In his asylum etchings, he renders the permanently dislocated explicitly; in interior views and still lifes he depicts a benign, everyday type of alienation.

Both a painter and printmaker, Michael Mazur etched before he painted. He studied with Leonard Baskin at Amherst and Gabor Peterdi at Yale. Through them, he was exposed to a European *peintre-graveur* tradition—to the work of Dürer, Rembrandt, and Goya, to prints by Bresdin and Kollwitz. Unlike many artists who begin to print before they paint, Mazur did not adopt his teachers' techniques. He is not concerned with color like Peterdi, or like Baskin involved with line. Mazur builds black-and-white etchings out of tone.

Mazur's early prints show how hard he looked at Goya. In *Nightmare* (1959), frenzied lines engulf the restless sleeper; raised in fear, they tell the horror of the dream. A few years later, in the *Asylum* and *Closed Ward* prints, Mazur transforms the reality of a state hospital into the landscape of a nightmare. Positioning inmates in the ironic pose of a resting Degas dancer, Mazur unmercifully blackens faces, bows heads in listless abeyance, etches the ground out from under their feet—showing conditions of irretrievable distress.

Mazur has said that he likes the resistance of the graphic media, that his "most valued tools are not the ones that make the mark but those that erase or soften it: the scraper, the eraser and the rag." A metal plate is not pliable like paper; to make a line or tone, one must cut into or eat away the metal's smooth, hard surface. Mazur makes a mark and removes it, lays down an aquatint tone and then scrapes it away. In the process of altering the original mark, of revising tones, Mazur finds his image.

Mazur creates images in the act of making a plate. But he does not lay down a line, refine it and then lay down another. One mark leads him to the next as it does Vincent Longo, and like Longo, he has no predetermined goal. But Mazur's process is essentially subtractive; Longo's is additive. Working the metal like a sculptor, Mazur scrapes into it, he burnishes away its surface. Yet he is not after sculptural effects: his final printed image is flat.

Mazur exploits etching's expressionistic potential. Scraping down or biting large areas of bare metal with acid yields a raw surface as painful to see as an open sore. Mazur uses this method in the asylum prints to physically convey scenes of terrible disorders.

In the late 1960s, Mazur's subject switched from people to places. Restraining his natural expressionism, he implies instead of reveals feelings: he suppresses them into shafts of light, the silence of rooms and close-up views. A vacant chair seen head-on in front

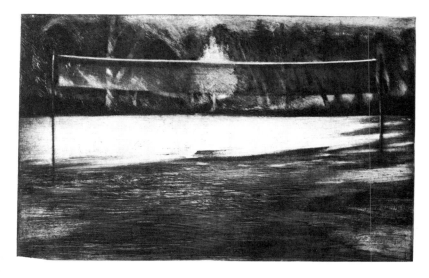

Net #1, Trial Proof, 1976
Etching with aquatint, soft-ground,
 scraping, and drypoint
21 × 32⅜ inches (53.3 × 82.2 cm)
Collection of the artist

of an empty easel tells of the anxiety that accompanies making art; a close-up of a wooden table, holding one ashtray with one burning cigarette, is a still life about loneliness.

Though Mazur's images have ceased to be explicitly expressionistic, his methods have not changed. Making *The Net* (1980), an eerily vacant badminton court, he drew the initial image into a soft-ground and then accidentally etched it too deeply. He wanted the dewy emptiness of a summer playing field, but the overbitten soft-ground yielded a coarse, gravelly texture that Mazur didn't like. Scraping down the soft-ground, he adds drypoint lines and softens the harsh blacks and whites into warm tones. In the next trial proof, he cuts one inch off the plate's bottom edge; tightening the composition, he narrows the view. Adding a layer of aquatint, he thickens and darkens the forest and delineates shadows. In the proof which becomes *Net #1*, Mazur further blackens the forest with additional aquatint and by once again scraping the aquatint away, he delineates the trees and reverses the foreground shadows.

Drawing over a proof with white chalk and erasures, Mazur continues the image. Etching the corrections into the plate, in the proof, which becomes *Net #2*, he modifies them with aquatint. The dusky evening of *Net #1* turns into dappled nighttime in *Net #2*. In the study for *Net #3*, Mazur draws with chalk and erasure, narrowing the net, covering up the trees; the sun appears to be rising. He is on his way somewhere else.

LITERATURE:

Robinson, Frank. *Michael Mazur: Vision of a Draughtsman* (exhibition catalogue). Brockton, Mass.: Brockton Art Center, 1976.

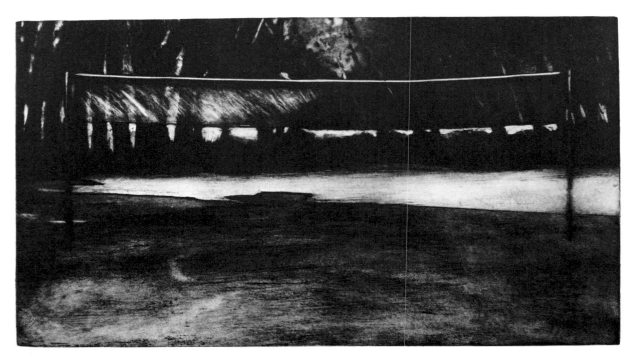

Net #1, 1976. Etching with aquatint. 18⅞ × 33 inches (47.9 × 83.8 cm). Edition: 20.
Printed by the artist. Collection of the artist.

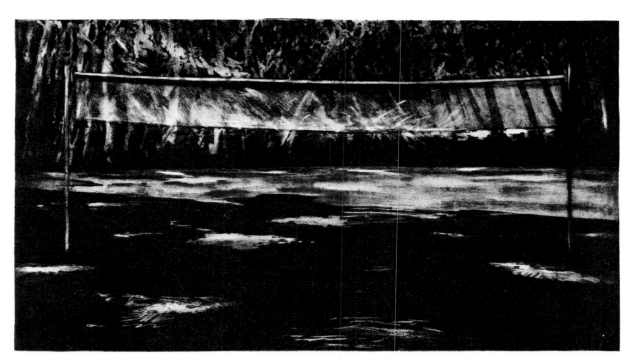

Net #2, Working Proof, 1976. Etching with aquatint and charcoal. 18½ × 32½
inches (47 × 82.6 cm). Collection of the artist.

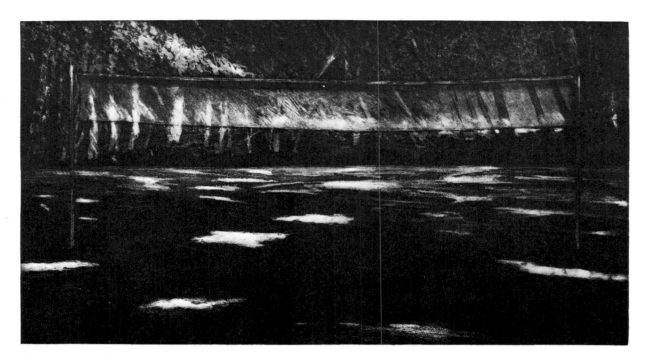

Net #2, 1976. Etching with aquatint. 18⅞ × 32½ inches (47.9 × 82.6 cm). Edition: 20. Printed by the artist. Collection of the artist.

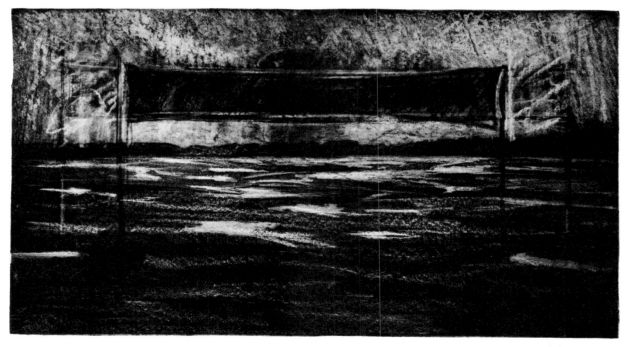

Net #3, Working Proof, 1976. Etching with aquatint, pastel, and erasure. 18½ × 32¾ inches (47 × 83.2 cm). Collection of the artist.

Robert Motherwell

A la Pintura
Printed by Donn Steward and Juda Rosenberg
Published by Universal Limited Art Editions, West Islip, New York

Study for *"White" 1-2*, 1968, from *A la Pintura*
Black crayon
10½ × 19 inches (26.7 × 48.3 cm)
The Art Institute of Chicago

"The problem is to seize the glimpse," Motherwell wrote in a letter to the poet Frank O'Hara. "The ethic is not making the glimpse presentable." Motherwell translates felt, factual glimpses into an abstract, visual language. Rooted in actual experience and unconscious thoughts, Motherwell's paintings convey feelings aroused by war, the sea, Mediterranean light, being alone. He focuses on the sensual aspect of things—the skin of paint, the weave of paper. Condensing meaning into colors, he paints essences—creates light in a build-up of blues, fear in a random spray of black.

He continues to paint the black-and-white elegies to the Spanish Republic he started in 1948, and the more recent *Open* series, three-sided rectangles on colored ground, he began in 1967. In the collages he has made since 1943, he allows himself literal, autobiographical references: cigarette packs, wrapping paper from the French publisher Gallimard function as color or shape, pay homage and, like his gestural, automatic brushstroke, mark his presence and preferences.

Refinements count—the jagged tear of collaged paper, its placement—are exacting decisions. Nothing is unessential. The paintings' effect is emotional and sensual. Meanings can be felt, but not easily parsed. For all their up-to-date modernism, the flat, seamless "open" paintings, above all, evoke kinds of feelings. The Republican cause and Franco's Fascism are not the elegies' subject. Their imposing black forms, like the hue of a saturated red, built out of the reds of "wine, blood and hunters' caps," stand for the conditions of all wars; they are heroic icons to struggles for freedom, to lives lived in the face of death.

From 1944 to 1951, Motherwell had a separate career as a bookman. He wrote extensively and eloquently on art, and he still designs books. The painter and bookman share a respect for paper and type; but the bookman is an intellectual, concerned with type

Opposite:
"White" 1-2, Trial Proof, 1971, from *A la Pintura*
Etching with sugar-lift and aquatint
12⅜ × 23¾ inches (31.4 × 60.3 cm)
The Art Institute of Chicago

"White" 1-2, Trial Proof, 1971, from *A la Pintura*
Etching with sugar-lift and aquatint
25⅛ × 38¾ inches (63.8 × 98.4 cm)
The Art Institute of Chicago

White Blanco

1
Walls are my history. To recover
that wonder, feast your eyes
on the thrust of those surfaces.

Mi vieja historia es la pared. Si buscas
deslumbrarte conmigo,
recréate los ojos en su tirante frente.

2
The whiteness of Crete ablaze or lukewarm,
almost blue in its backward reflections.

Blanco de Creta, tibio,
caliente, casi azul, reverberante.

White Blanco

1
Walls are my history. To recover
that wonder, feast your eyes
on the thrust of those surfaces.

Mi vieja historia es la pared. Si buscas
deslumbrarte conmigo,
recréate los ojos en su tirante frente.

3
The whiteness of Crete ablaze or lukewarm,
almost blue in its backward reflections.

Blanco de Creta, tibio,
caliente, casi azul, reverberante.

as a linear, rational system, and the painter is committed to the expression of private, and often unwieldy, feelings.

Type and books did not lead the painter to printmaking; neither did an early exposure to graphics. In 1941, while still a student, he briefly studied Kurt Seligmann's engravings, but it was the Surrealists he met through Seligmann that influenced Motherwell. He had a similar experience in 1944 at Stanley William Hayter's Atelier 17, where he produced a few engravings, but became more involved with the European artists working at Hayter's—Miró, Max Ernst and André Breton—than with engraving. Like other New York School painters, Motherwell had no interest in the slow, fragmented graphic process.

Until the early 1960s when first Tatyana Grosman and then Irwin Hollander invited him to try lithography, Motherwell did not make prints. Depressed at the time by personal problems, and what he thought had been the too-large 1965 retrospective of his paintings at the Museum of Modern Art, Motherwell found comfort in printmaking's collaborative aspects. Taking him out of his studio and away from himself, making a print did not demand the self-confrontation painting did.

In the last fifteen years, Motherwell has produced over 200 prints. They are all notations of sorts, fast gestures, sustained

Study for *"Red"* 4-7, 1969, from *A la Pintura*
Acrylic and crayon with dummy type
24 × 36 inches (61 × 91.4 cm)
The Art Institute of Chicago

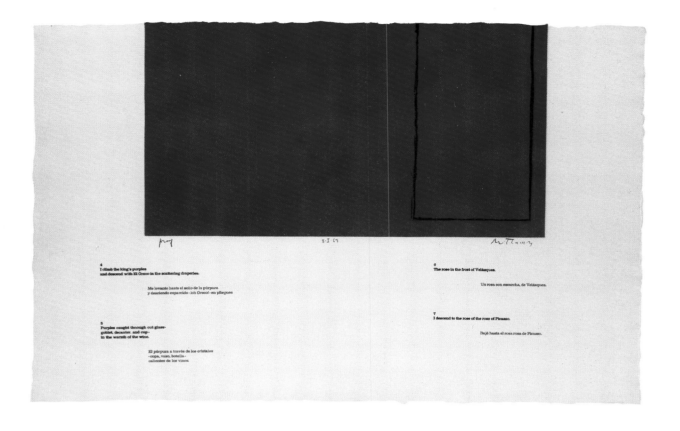

Within the image:
4
I climb the king's purples
and descend with El Greco in the scattering draperies.

Me levanto hasta el solio de la púrpura
y desciendo esparcido - ioh Greco! - en pliegues

5
Purples caught through out glass-
goblet, decanter, and cup-
in the warmth of the wine.

El púrpura a través de los cristales
- copa, vaso, botella-
calientes de los vinos.

6
The rose in the frost of Velásquez.

Un rosa con escarcha, de Velásquez.

7
I descend to the rose of the rose of Picasso.

Bajó hasta el rosa rosa de Picasso.

glimpses; following the themes of his paintings, they carry feeling in color, depth on a flat surface. Their success relies on Motherwell finding graphic equivalents for a gouache ground or calligraphic line. A surface printed too flat or smooth falters; an automatic line evenly rendered lacks vitality. Because Motherwell's images are so recognizable, distinctions can be hard to see; but his graphics require a connoisseurship one usually associates with Old Master prints.

Motherwell relies on the collaborative process. Like Sam Francis, he regards printers and publishers as active contributors. He is affected by place and personalities, and where and with whom he works make a crucial difference. Random, immediate lithographs, such as *Automatism A & B* and the *Madrid Suite* made in 1965, reflect a good deal about Motherwell's art — and as much about the printer, Irwin Hollander, who had an Abstract Expressionist's approach to lithography. Hollander's belief in process, in the mystical properties of stones, encouraged accidents and spontaneity. Motherwell's *livre d'artiste, A la Pintura* (1968–72), made at Universal Limited Art Editions, where projects evolve slowly, embodies the timeless luxury which marks ULAE editions and reveals not only intaglio printer Donn Steward's extraordinary skill, but his comprehension of Motherwell's art.

"Red" 4-7, Trial Proof, 1969, from *A la Pintura*
Etching with sugar-lift and aquatint
25 × 38½ inches (63.5 × 97.8 cm)
The Art Institute of Chicago

Motherwell's prints reflect the interaction between the painter and his collaborators. With publisher Brooke Alexander from 1973 to 1976, he created quiet, restrained prints as economically composed as his paintings; at Gemini G.E.L. in Los Angeles, he made spare, sooty black lithographs, unfettered by place, and with publisher and printer Kenneth Tyler, he has produced large, complicated and technically ambitious prints.

A conceptual collaborator, Motherwell stays removed from the printing process. Once drawn, an image is seldom reworked. He regards printers as guides and translators; he is not a tourist in the graphic arts, but a well-seasoned traveler—who is respectful of foreign customs and knows his place. Kenneth Tyler made the enlarged cigarette labels which appear in *Bastos* (1974–75) and *St. Michael I, II* and *III*. As dissatisfied by *St. Michael*'s first two states as he had been pleased by the large, elegant *Bastos* which preceded them, Motherwell found a solution for *St. Michael III*; by printing the plate of the lithograph *Monster* (1974–75) over the large St.-Michel label, he modified the label, merging Tyler's technical contributions with his own.

Once the decision to combine *St. Michael* and *Monster* had been reached, Tyler experimented. The print's resolution depended on its surface texture and Tyler printed *St. Michael III* as a litho-

Study for *"Black" 4*, 1969
Collage
24⅛ × 36 inches (61.3 × 91.4 cm)
The Art Institute of Chicago

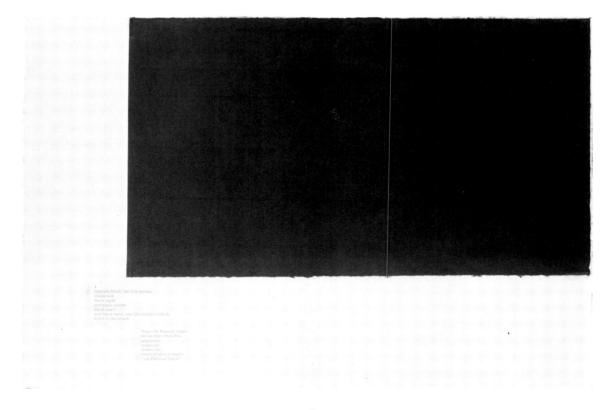

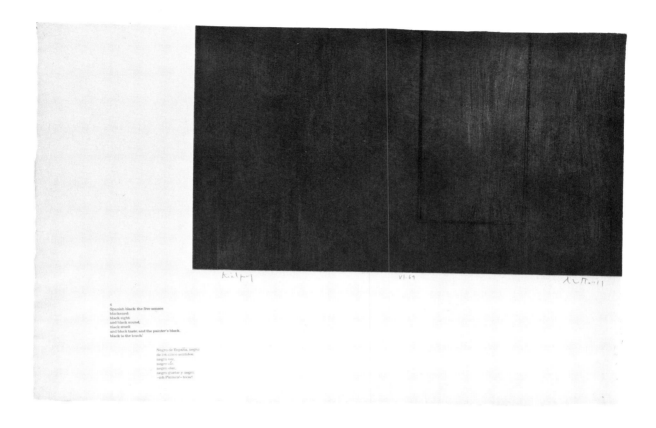

graph, a screenprint, and on different kinds of papers. Motherwell considered the options, and finally decided to print the St.-Michel label as a lithograph.

A la Pintura, illustrating Rafael Alberti's cycle of poems in homage to painting, is Motherwell's major graphic work. The grand book's brilliance stems from the visual and literary collaboration and from a more essential one between the painter and bookman. In *A la Pintura*, the sensibility of the painter, editor, translator and man who knows type, work together. Motherwell designed the book, laid out the type, and determined the placement of each image on the unlikely sized, hand-torn loose sheets of J. B. Green paper. He had the original Spanish verse printed in color, keyed to the poem's subject (the English translation appears in black) to unite word and image. Alberti's poem travels a gallery of art and colors and evokes in words what Velázquez, Brueghel and Bosch could say only with paint. The poem is rooted in specifics, in Titian's Venice and El Greco's purple drapes. To illuminate Alberti, Motherwell followed the painter's process; working from specifics, he conveys the feeling carried by words in precisely placed colored rectangles.

A la Pintura's proofs show the painterly roots of Motherwell's graphic sensibility. The loosely mottled red gouache surface of the

"Black" 4, Trial Proof, 1969
Etching with aquatint
25 ¼ × 38 inches (64.1 × 96.5 cm)
The Art Institute of Chicago

Overleaf:
Monster, Working Proof (signed "Trial Proof"), 1974–75
Lithograph with gouache
41 × 31 inches (104.1 × 78.7 cm)
Tyler Graphics Ltd., Bedford, New York

Monster, 1974–75
Lithograph
41 × 31 inches (104.1 × 78.7 cm)
Edition: 26
Printed by Kenneth Tyler
Published by Tyler Graphics Ltd., Bedford, New York
Tyler Graphics Ltd., Bedford, New York

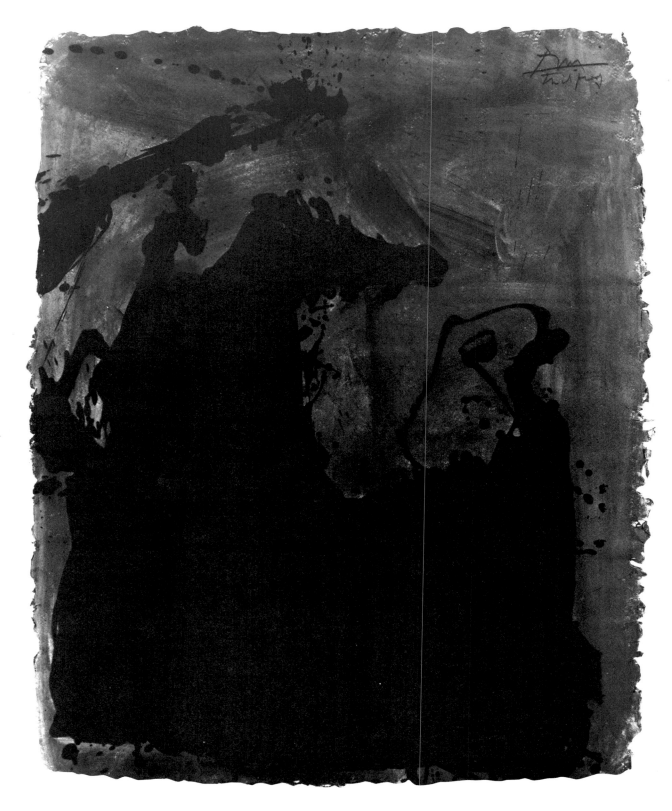

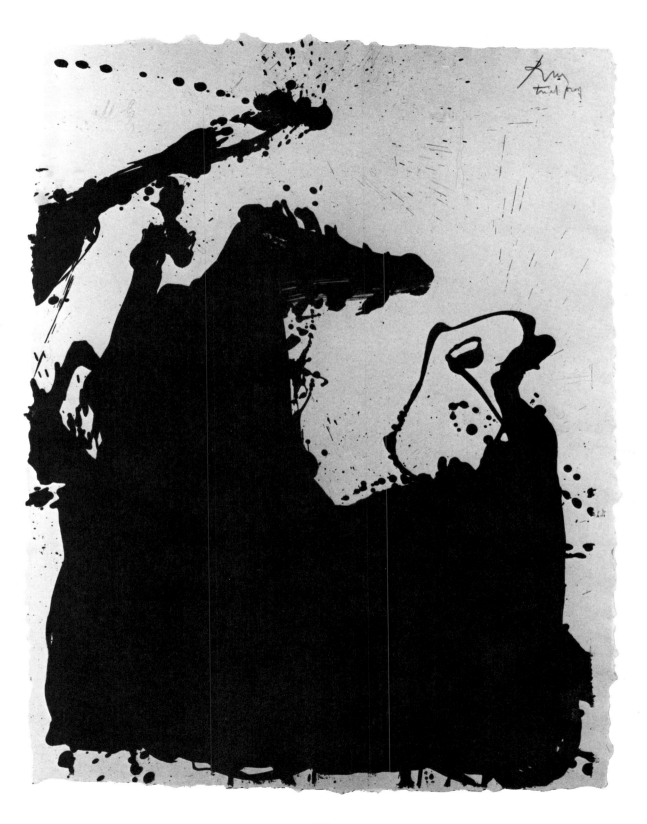

study for *"Red" 4–7* is translated graphically into a red rectangle of uneven, layered aquatint. The intense and various reds yielded by the levels of aquatint precisely illuminate Alberti's lines, "the rose in the frost of Velázquez...the rose of Picasso." In Motherwell's American vernacular they are the reds of blood, wine and hunters' caps. The study for *"Black" 4*, a sensuous collage of two sheets of Japan paper, illuminates the line "black sight and black sound, black smell and black taste." Rendered into print, the burnished black aquatint holds grays, whites, and suggests other colors that make one hear, see and feel blackness.

LITERATURE:

Arnason, H. H. *Robert Motherwell.* New York: Harry N. Abrams, Inc., 1977.

Cohen, Arthur A. *Robert Motherwell: Selected Prints, 1961–1974* (exhibition catalogue). New York: Brooke Alexander, Inc., 1974.

Colsman-Freyberger, Heidi. "Robert Motherwell: Words and Images." *The Print Collector's Newsletter*, 4 (January/February 1974), pp. 124–29.

McKendry, John J., Robert Motherwell and Diane Kelder. *Robert Motherwell's "A la Pintura": The Genesis of a Book* (exhibition catalogue). New York: The Metropolitan Museum of Art, 1972.

Motherwell, Robert. *Robert Motherwell: Prints, 1977–1979* (exhibition catalogue). New York: Brooke Alexander, Inc., 1979.

Terenzio, Stephanie. *The Painter and the Printer: Robert Motherwell's Graphics, 1943–1980.* With a catalogue raisonné by Dorothy C. Belknap. New York: The American Federation of Arts, 1980.

St. Michael III, 1975–79
Lithograph and screenprint
41½ × 31½ inches (105.4 × 80 cm)
Edition: 90
Printed by Kenneth Tyler and Kim Halliday
Published by Tyler Graphics Ltd., Bedford, New York
Tyler Graphics Ltd., Bedford, New York

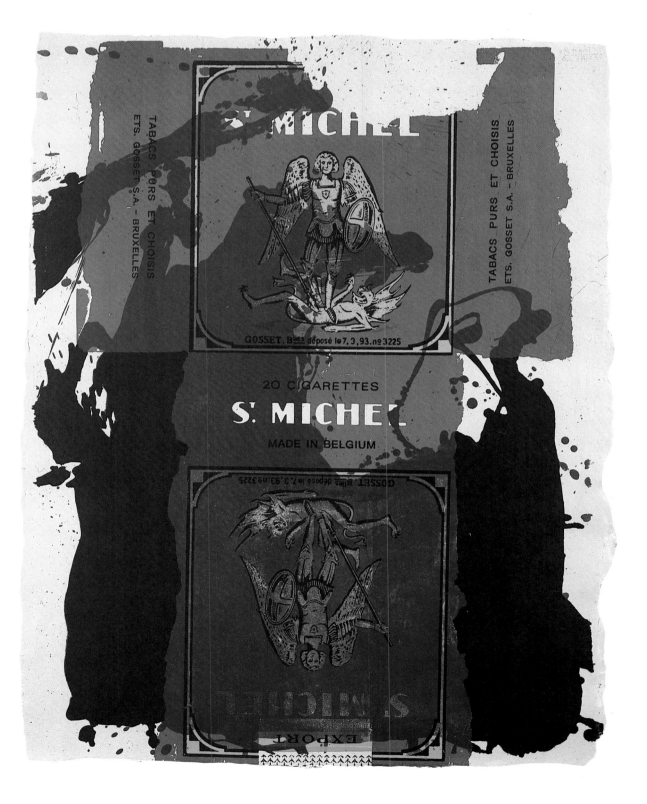

Claes Oldenburg

Layered with private allusions, dependent on visual and verbal puns, Claes Oldenburg's objects and sculptures—phallic ray guns and soft ice bags, steel mitts and baseball bats—travel circuitous, lifelike routes. They gestate between the conscious and unconscious, the probable and impossible, the old idea and new materials. Rooted in childhood experiences and free associations, Oldenburg's art depends on a process in which the past acts on the present and random connections are followed wherever they may lead.

Objects begin as drawings, fanciful proposals and casual notes. In drawings, Oldenburg projects new images and documents old ones. In diary entries, he keeps track of ideas, noting every vagrant association. Objects evolve slowly. The 1974 sculpture *Standing Mitt with Ball* stems from a 1969 notebook page on which Oldenburg pasted a picture of a mitt lying on a field along with the words "soft," "hard," and "pie à la mode." His 1977 sculpture *Batcolumn* is the end product of a string of personal associations concerning the ambience, art and architecture of Oldenburg's native Chicago. The first bat appeared in the drawing *Proposed Monument for the Southeast Corner of North Avenue and Clark Street, Chicago: Bat Spinning at the Speed of Light* (1967), a proposal for a monument to be located in front of the high school Oldenburg attended. That bat, according to the artist, was an anti-masturbatory fantasy which spun so fast it burned one's fingers up to the shoulders to touch it.

Oldenburg is a sculptor, draftsman, reporter, diarist and

Double Screwarch Bridge, State I, 1980
Etching
Image: 24 × 51 inches (61 × 129.5 cm)
Paper: 31½ × 58 inches (80 × 147.3 cm)
Edition: 15
Printed by Pat Branstead
Published by Multiples, Inc., New York
Multiples, Inc., New York

Double Screwarch Bridge, State II,
 Working Proof, 1980
Etching with aquatint, pencil, and
 erasure
Image: 24 × 51 inches (61 × 129.5 cm)
Paper: 31½ × 58 inches (80 × 147.3 cm)
Collection of the artist

natural analysand, and as a printmaker his work reflects all aspects of his sensibility. Early prints incorporated sculptural ideas. Cut from a shaped plate, the etching *Legs* (1961) rises from the paper in relief; in the animate lithograph *Pizza* (1964), a wedge of pie flies onto the paper's space, suggesting the blade of a fan. In literal three-dimensional prints, Oldenburg created hard surfaces that look soft. *Tea Bag* (1965) was made with vacuum-formed vinyl; *Profile Airflow* (1969) combined molded polyurethane with lithography. The sculptor informed the printmaker. Utilizing available technology, Oldenburg produced object-like prints and an array of three-dimensional objects: a fiberglass *Baked Potato* (1966) with a hard interior that looked soft, a cast-iron Swedish cracker *Knäckerbröd* (1966), and kinetic ice bags.

The prints were also the work of the reporter and wordsmith. Oldenburg used graphics as a way to send images out into the world, to document ideas and communicate information. In 1970, impressed by the capabilities of the offset press, Oldenburg considered issuing an offset bestiary of his iconography. In lithographs such as *Typewriter Eraser* (1970) and *Alphabet in the Form of a Good Humor Bar* (1970) he exactly replicated drawings. In others, such as *Proposed Colossal Monument for Battersea Park, London Drum Set, 1966* (1969), Oldenburg employed offset techniques to alter size and transform colors. The offset lithographs were excellent, but because they reflected technology, not the artist's hand, they upset conservative print factions and passed unnoticed.

Oldenburg's graphics not only disseminated images, but were primers on his sensibility that documented how he thought. The private notes of artists seldom bear up well under public scrutiny. But Oldenburg is as literary as he is visual, and his objects

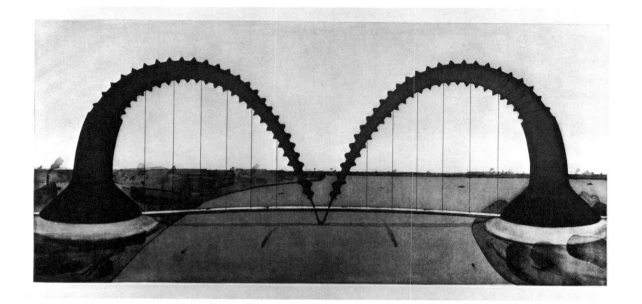

and sculptures incorporate words and rely on puns. Combining words, photographs and drawings, the lithographic series *Notes* (1968) revealed the errant yet logical connections between a war memorial in the form of an H-bomb blast and a Chicago fire hydrant, between the tongue of a gym shoe and Mickey Mouse's ear.

Oldenburg also produced non-didactic, non-sculptural prints. Accepting invitations from publishers, he worked in Los Angeles, London, New York and Chicago. Collaborating with publishers and master printers invariably meant working on deadline and being out of town, and though he made assured etchings and lithographs, particularly at the Landfall Press in Chicago, Oldenburg never felt quite comfortable with printmaking. In a 1972 interview he said: "My drawings require a lot of privacy, which you don't get making lithographs. When I go into printmaking, it's like stepping on a stage. You're doing something in front of everybody. It's a very stylized technique. I don't think just because a person can draw, he's naturally going to be a good printmaker. Printmaking is something you have to learn. It's like learning a sport or how to cook. By the time print-publishing offers started arriving, I was an established artist and expected to produce prints."

Oldenburg met the demands of his public and worked as a printmaker. When asked to contribute prints to portfolios and to causes, he complied. He masterfully used reproductive technology to replicate images and industrial methods to create editioned objects. But he did not bring the involvement with process, so essential to his sculpture, to traditional graphics. He kept his distance. One felt his diffidence.

Oldenburg's attitude toward printmaking began to change in the late 1970s, after he spent time in Amsterdam at the Rijks-

Double Screwarch Bridge, State II, 1980
Etching with aquatint
Image: 24 × 51 inches (61 × 129.5 cm)
Paper: 31½ × 58 inches (80 × 147.3 cm)
Edition: 35
Printed by Pat Branstead and Sally Sturman
Published by Multiples, Inc., New York
Multiples, Inc., New York

museum studying the etchings of Hercules Seghers and Rembrandt. The results of that change can be seen in the three states of *Double Screwarch Bridge*, the etching he began in 1980. The image of a screw, curving, bent, seen in mid-section, rendered as a tornado and a waterfall and, on occasion, straight up, has a lengthy iconographic history. Like Oldenburg's other staple images, the bent screw, with its punning sexual implications, reverses expectations. We do not expect a screw to be soft or to form a bridge or to curve at all. By bending the screw and turning it pliable, Oldenburg activates and humanizes the common object.

Since 1969, the screw has appeared in various guises. For the Los Angeles County Museum of Art's Art and Technology program in 1969, Oldenburg proposed a 45-foot screw which, as it moved in and out of the earth, would produce its own lubricating fluid. A model was built, but the project was never realized. In 1975, the screw assumed new roles. Rendered in a series of lithographs, screws tumbled over one another in acrobatic turns; set in nature, they stood straight as trees and assumed the out-of-control spirals of a tornado; bent over, a screw formed an arch which was to traverse a small corner of Times Square. A year later, Oldenburg created the flexible, malleable *Soft Screw*, out of a material—vinyl —which actually held body heat; and in 1978, the screw once again curved into an arch and turned hard again in bronze.

The screw soon underwent another transformation. In Holland, Oldenburg had become interested in the country's bridges and canals. On a 1976 notebook page, Oldenburg had drawn two bent screws and one that stood straight up. Two years later, for a commission from the Museum Boymans-van Beuningen in Rotterdam, Oldenburg joined two screws together in a proposal for a

Double Screwarch Bridge, State III, Trial Proof, 1981
Etching with aquatint and monotype
Image: 24 × 51 inches (61 × 129.5 cm)
Paper: 31½ × 58 inches (80 × 147.3 cm)
Collection of the artist

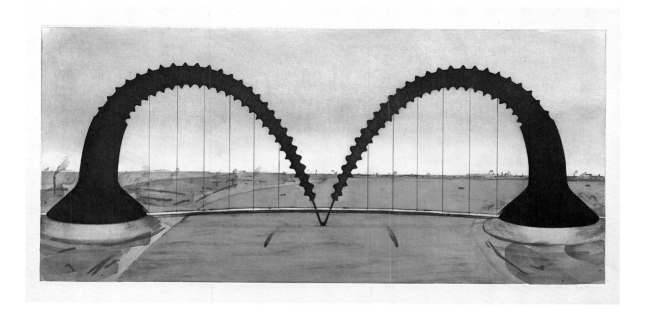

screwarch to be erected over the Nieuwe Maas river in Rotterdam. In 1980, Oldenburg began the large screwarch etchings.

Lean, linear, drawn without embellishment, in its first state the screwarch is as antiseptic as an architectural rendering. Hardened into line, the bent screws are not about to take an acrobatic turn or whirl into a frenzied spiral. They are not about to become something else. Female forms can be spotted in the curves of the arching screws, in the V formed where they meet; but the sexual implications carried in the screw's name and print's title have been neutered. A transformation has already taken place. Hardly tumescent, rendered as arches, the screws are hardworking supports forming a bridge that carries cars.

In a working proof for a color version, the addition of watercolor sets the screw in a landscape. The hand humanizes the screw. Modeling makes the elephantine screw appear pliable, humorous and unlikely. Oldenburg did not proceed immediately to a color version; instead he rendered the second state in black and white. Adding aquatint, he forms a river, bridge and horizon line, giving the bridge a function and a site.

But in its second state, the place of Screwarch remains non-specific. In its third state, Oldenburg attempts to capture the feeling of Rotterdam. Dots on the bridge represent cars; trees appear; smokestacks indicate industry. Monotype applications of ink, laid down by brush on the water's surface, give the river movement.

In a series of color proofs, Oldenburg turns the flat metropolitan place into a desert landscape, the colors surrounding the Thames and the ice blue of an American Great Lake. In its final state, black, bent screws span a deep blue-green river. The fanciful, final proposal brings to mind the drawbridges that span the Chicago River, but satisfied that he had caught the mood of Rotterdam, Oldenburg editioned the print.

LITERATURE:

Leavin, Margo. *Oldenburg: Works in Edition.* Los Angeles: Margo Leavin Gallery, 1971.

Rose, Barbara. *Claes Oldenburg.* New York: The Museum of Modern Art, 1970.

Van Bruggen, Coosje, Claes Oldenburg and R. H. Fuchs. *Claes Oldenburg: Large Scale Projects, 1977–1980.* New York: Rizzoli International Publications, Inc., 1980.

Opposite, above:
Double Screwarch Bridge, State III, Trial Proof, 1981
Etching with aquatint and monotype
Image: 24 × 51 inches (61 × 129.5 cm)
Paper: 31½ × 58 inches (80 × 147.3 cm)
Collection of the artist

Opposite, below:
Double Screwarch Bridge, State III, 1981
Etching with aquatint and monotype
Image: 24 × 51 inches (61 × 129.5 cm)
Paper: 31½ × 58 inches (80 × 147.3 cm)
Edition: 25
Printed by Pat Branstead and Yong Soon Min
Published by Multiples, Inc., New York
Multiples, Inc., New York

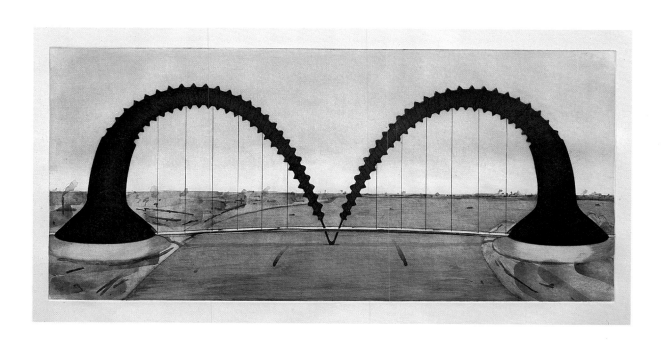

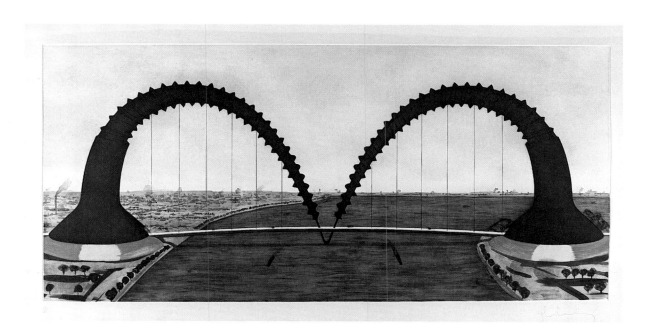

Nathan Oliveira

Nathan Oliveira gives ideas sensuous forms like a symbolist; he charges the paint's texture with feeling like an expressionist. Both aesthetics inform his private, independent vision, which is equally influenced by mythic symbols, black magic, and light.

A figurative artist, Oliveira paints almost faceless figures. Viewed head-on, wrapped in thick, expressive swathes of color, his figures have a mysterious presence. He calls his equally non-specific landscapes sites: nameless places, they are plateaus in which something has just happened or is about to happen; defined by rectangles and perspectival lines, they hold incandescent light.

Oliveira is also an old-fashioned printmaker who learned to print in the mid-1950s, when an ethic of technique surrounded

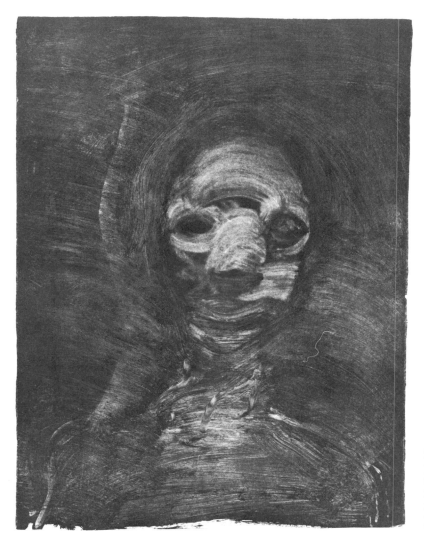

Man, 1971
Lithograph
30⅛ × 22⅜ inches (76.5 × 56.8 cm)
Edition: 15
Printed by Kenjilo Nanao
Published by the artist
Collection of the artist

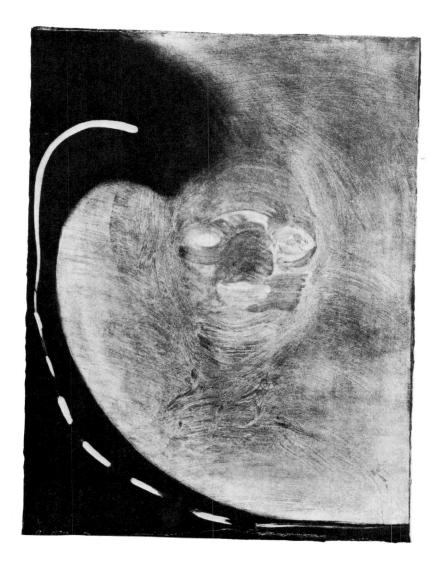

Man, 1971
Lithograph (unique image)
30⅛ × 22⅜ inches (76.5 × 56.8 cm)
Printed by Kenjilo Nanao
Collection of the artist

graphics and Abstract Expressionists scorned the medium as a hobbyist pastime. The prevailing prejudice did not deter him. Fiercely independent, Oliveira created prints anyway, because he was instinctively drawn to lithography.

At first he attempted to break down the technical proscriptions surrounding graphics by printing on stones with asphaltum and undiluted acid. However, the majority of his prints are classic black-and-white lithographs, built with rich tusche washes. He has studied Goya and Rembrandt and made monotypes after Goya's *Tauromaquia* and Rembrandt's *Three Crosses*. His prints show the influence of Eugène Carrière, Odilon Redon and Alberto Giacometti. Given to visual paraphrase, the expression of Oliveira's *Woman's Face* (1966) recalls Picasso's 1953 *Italienne* and its last version suggests Redon's oil *Silence* (c. 1911). His homage to Eugène Carrière

brings to mind Edvard Munch's stark 1913 *Self-Portrait*, and one cannot look at the scrambled, painterly tangle of Oliveira's *Man* (1971) without thinking of Giacometti.

Oliveira's regard for the fantastic is not unlike Redon's, and in graphics he explores the dark side of his vision. Working with the stuff of printmaking — the inky washes, the way stones look when they have been degreased — his graphic aesthetic is tied to the stone. And since his first lithograph in 1956, he has worked directly, without preliminary drawings or plans.

Oliveira finds images in inky surfaces and ghostly impressions. Exploiting variables, he prints one image several ways. Variations are both steps along the way and independent solutions. Like Vincent Longo, Michael Mazur and Sam Francis, he mines a plate for possibilities. After editioning the first and second states of *Woman's Face* (1966), he added a gray oval to form a unique impression. He printed the lithograph *Man* (1971) in two separate color editions, and then he partially removed the image with counter-etching..Oliveira's ends are often beginnings.

Oliveira discovers where he is going by seeing where he has been, and ghost impressions are crucial to him. For his most ambitious graphic project, *To Edgar Allan Poe* (1971), he worked sequentially, producing forty separate images to create the portfolio's seven final impressions. The biomorphic shapes floating against a thick blackness recall the dark words of Poe. For each impression, Oliveira worked and reworked the stone, removing and changing images with counter-etching and snakeslipping.

Though he had the collaborative help of a printer, Oliveira found the Poe project exhausting and began questioning the physical ordeal lithography required. He continues to work in lithography and etching, but in 1972, after he saw Eugenia Janis' influential 1968 catalogue *Degas Monotypes*, he began creating monotypes which allowed him to work directly and sequentially.

Oliveira's first sustained monotype series was based on plate twenty-one of Goya's *Tauromaquia* , in which a bull charges into the crowd, with a gored spectator on its horns. To transpose Goya's economical linear etching into solid, painterly masses, Oliveira took an impression from the painted metal, reworked the ghost image left on the plate, took another impression, creating approximately 100 different images. What began as a bull in a grandstand becomes an empty rectangle transversed by a diagonal. In the final impression, Oliveira paints the bull back into the plate's corner, a coda, as it were, that reiterates the sequence of the drama.

Process is not only Oliveira's way to images, but to an entirely new iconography. The empty space found in the *Tauromaquia* series becomes Oliveira's abstract site. That site is the place of his abstract landscape paintings and the place he etches in *Archive Site* (1979). Proceeding in etching as he does in monotype and lithography, he reworks the site, which looks like a derelict shipyard. He adds charcoal, paint, collage and aquatint. One

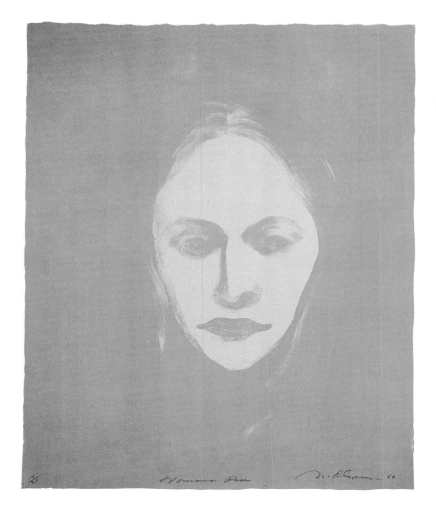

Woman's Face, 1966
Lithograph
21 × 17 inches (53.3 × 43.2 cm)
Edition: 20
Printed by Joseph Zirker
Published by the artist and Felix Landau
Collection of the artist

image does not lead sequentially to the next. The proofs for *Archive Site* are not discarded options — even to call them proofs misses the point. Independent works, they are the printed art Oliveira makes along the way.

LITERATURE:

Ball, Maudette W. *Nathan Oliveira: Print Retrospective, 1949–1980* (exhibition catalogue). Long Beach, Calif.: The Art Museum and Galleries, California State University, 1980.

Eitner, Lorenz. *Nathan Oliveira: A Survey of Monotypes, 1973–1978* (exhibition catalogue). Pasadena, Calif.: Baxter Art Gallery, California Institute of Technology, 1979.

Overleaf:
Woman's Face, State II, 1966
Lithograph
21¼ × 17⅛ inches (54 × 43.5 cm)
Edition: 20
Printed by Joseph Zirker
Published by the artist and Felix Landau
Collection of the artist

Woman's Face with Grey Oval, 1966
Lithograph with gouache (unique image)
21 × 17 inches (53.3 × 43.2 cm)
Printed by Joseph Zirker
Collection of the artist

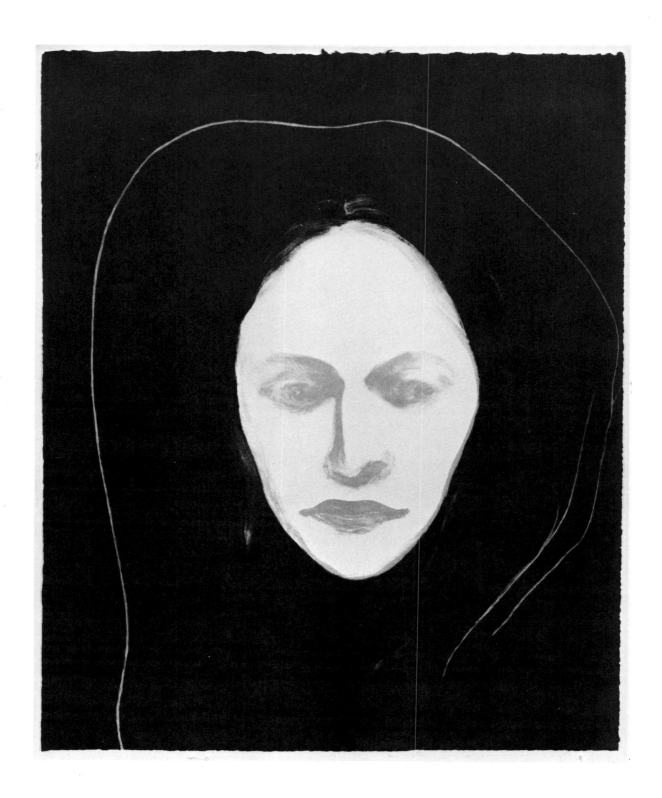

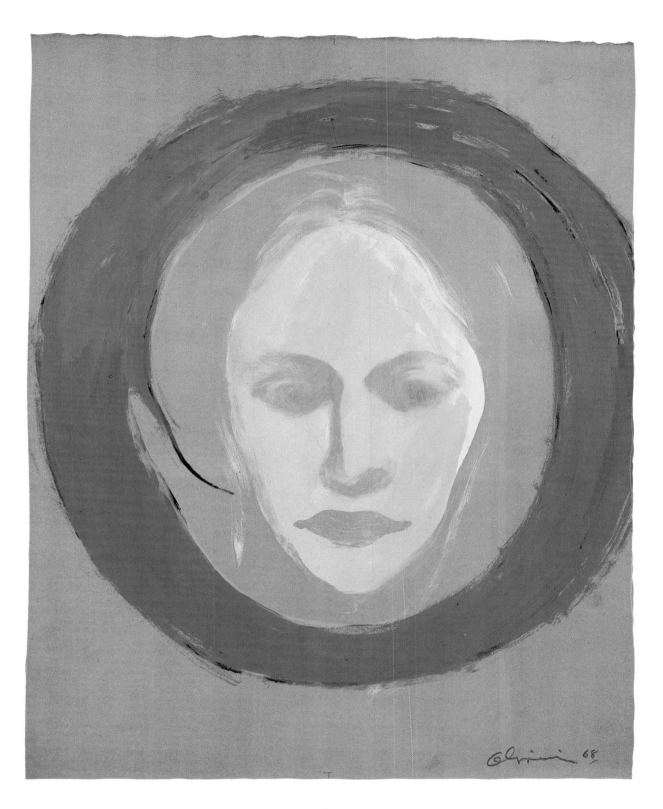

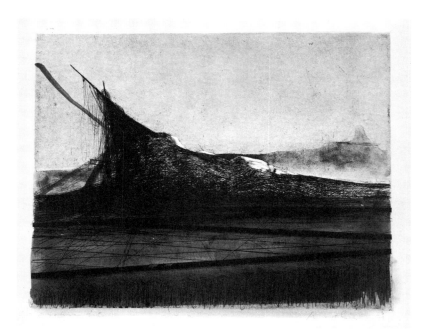

Archive Site, Working Proof, 1979
Etching with aquatint and ink
Image: 11½ × 14¾ inches (29.2 × 37.5 cm)
Paper: 22¼ × 31⅛ inches (56.5 × 79.1 cm)
Collection of the artist

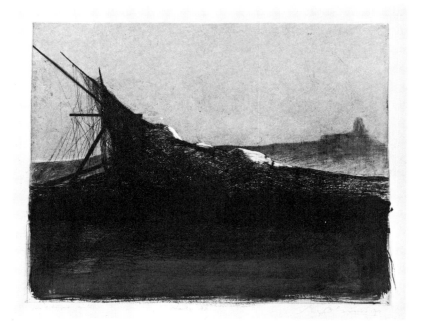

Archive Site, Working Proof, 1979
Etching with aquatint, pencil, ink,
 chalk, and collage
Image: 11½ × 14¾ inches (29.2 × 37.5 cm)
Paper: 22¼ × 31⅛ inches (56.5 × 79.1 cm)
Collection of the artist

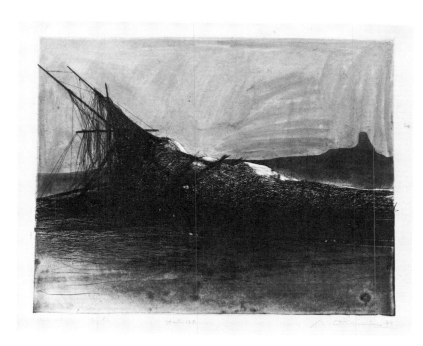

Archive Site, Working Proof, 1979
Etching with aquatint, watercolor,
 gouache, and ink
Image: 11½ × 14¾ inches (29.2 × 37.5 cm)
Paper: 22¼ × 31⅛ inches (56.5 × 79.1 cm)
Collection of the artist

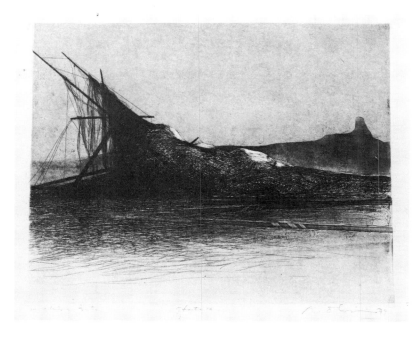

Archive Site, 1979
Etching with aquatint
Image: 11½ × 14¾ inches (29.2 × 37.5 cm)
Paper: 22¼ × 31⅛ inches (56.5 × 79.1 cm)
Edition: 50
Printed by Lee Altman and Katherine
 L. Bradner
Published by 3 EP Press Ltd., Palo
 Alto, California
Collection of the artist

Philip Pearlstein

Philip Pearlstein's naked figures sit on Victorian sofas and sprawl across Oriental carpets. Seen at rest, in seemingly intimate positions, they appear uncomfortable, asexual. Interacting neither with each other nor with the viewer, they carry no narrative or erotic implication. Invulnerable and impersonal, they have, instead of personalities, matter-of-factly rendered imperfections: breasts that sag, rippled flesh.

What is disturbing is not the bodies' flaws, but the flat, deadpan manner in which they are rendered. Pearlstein paints a well-formed rib cage with the same dispassion and awkward correctness as he does passive flesh on bodies past their prime. Similar flaws, reflected in a photograph, do not disturb us; we accept the camera's facts and expect, are even aroused by, brutal photographic secrets we do not normally see. Only paid observers or those emotionally committed to finding fault perceive ungainly physical data with Pearlstein's bluntness. The human eye compensates, edits, instinctively provides cosmetic illusions; it pretties up the picture. Pearlstein's eye does not.

Pearlstein does not exploit unattractive physical facts; in fact, his handling of paint neutralizes their bluntness. Flat, evenly applied shadows and contours, schematized into geometric shapes, sit on the skin's surface; devoid of carnal overtones, they call attention to their paintedness. Pearlstein's subject is not the nude, it is hired models at work in his studio. The artist paints their bodies and their boredom. He paints the act of modeling.

Neither love objects nor muses nor anatomically precise images, the models represent reality to the modernist figurative painter. Pearlstein paints the traditional studio nude by taking it down to essentials; he shows it as—only a model. Cropping heads and limbs out of the pictures, he dehumanizes subjects. Rendering furniture with the same attention as the figure it supports, he turns bodies into objects.

Nudes are forms in a volumetric space, a space Pearlstein accentuates by his eccentrically positioned models. Sitting side by side, models in the same room occupy separate spaces. Knees, arms, or elongated figures break the picture plane. At the same time, because he paints with an all-over evenness, emphasizing the surface as surface, he unifies figure and ground, giving paint and material priority over subject and content.

Pearlstein's reality leaves no room for chance. Like Chuck Close, he depicts an impersonal, predetermined realism. Attuned to modernist tenets, it is a late twentieth-century reality—private, fragmented, and technologically inspired, in which the hand assumes the anonymous precision of the machine.

In prints as in paintings, Pearlstein works from the model. Even when redoing compositions that existed first in oil or watercolor, he re-poses his models. He proceeds like a nineteenth-century figure painter, plate propped on easel, model in front of him,

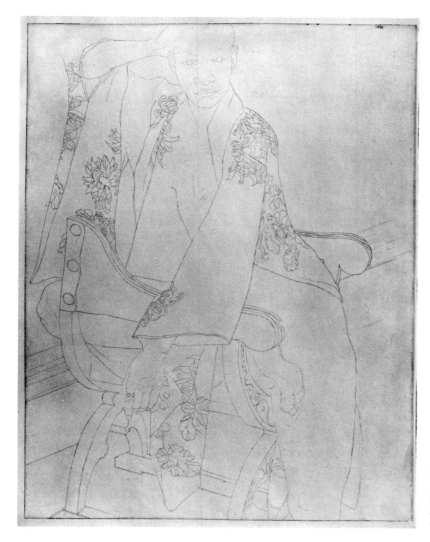

Model in Green Kimono, Trial Proof, 1979
Etching
42½ × 31⅜ inches (108 × 79.7 cm)
Collection of the artist

a mirror to his left so that, as he draws, he sees the image as it will print in reverse. Once his image is worked out, he takes it to a printer for etching and proofing. Back in his studio, he begins again; re-posing the model, and using the proof as a guide, he reworks the original plate so that the final image depends as much on the working proofs as on the working model.

Drawn in crayon, painted in tusche, lithographic nudes appear human. Liquid tusche—a loose, difficult medium to control—yields an expressionistic surface. Modeling in line and tone shows evidence of the hand—a tentative line or sure curve conveys hesitation or assurance. Rendered in lithographs, models no longer serve only formal and compositional functions. Carrying narratives, nudes appear naked, lonely, dejected, or pensive. Heads cropped out of lithographs, as in *Girl in a Striped Robe* (1972), do

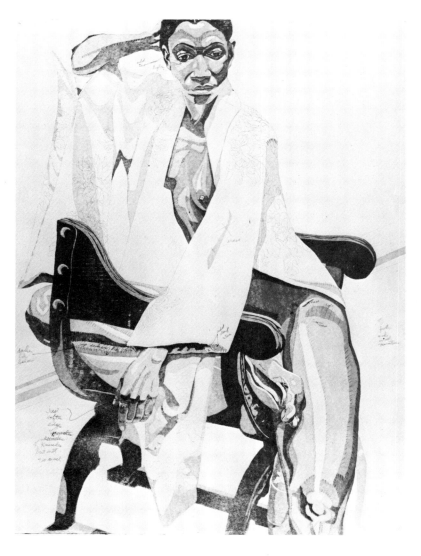

Model in Green Kimono, Trial Proof,
 1979
Etching with aquatint and pencil
 notations
40 ¼ × 29 ¼ inches (102.2 × 74.3 cm)
Collection of the artist

not depersonalize or set the eye roving, but imbue the composition with a poignant air. Instead of isolating figures as forms, cropping in the lithographs creates unseen dramas. Why do naked women sit alone in rooms? Cropping alone does not cause the narrative effect. Line, paper, the hand's mark, all change the nature of Pearlstein's reality..

Pearlstein's prints tell stories. We read figures against a ground as we read lines of type on a page. The figurative carries narrative expectations. By uniting figure and ground, the even, all-over surface of the paintings seals out any narrative. However, lithographic figures against the paper's ground demand to be read.

Pearlstein's etchings are closer to his paintings. After two early grainy images in which he struggled with technique, Pearlstein began using aquatint to model figures and schematize

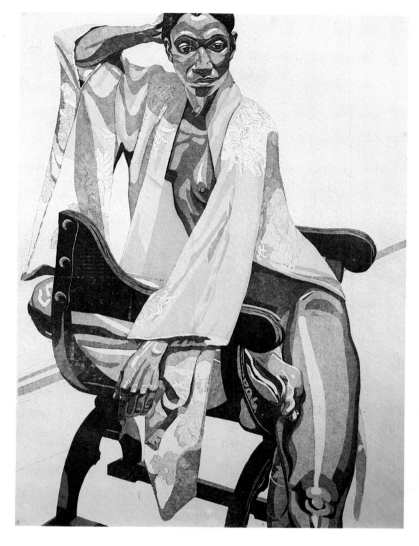

Model in Green Kimono, Trial Proof,
 1979
Etching with aquatint
40¼ × 29⅜ inches (102.2 × 74.6 cm)
Collection of the artist

shadows, building tones and compositions without relying on
line or expressive marks.

 In the etching process, we see Pearlstein negate his natural
expressionism. *Model in Green Kimono* (1979) begins, as do most
of his prints, as a finished black-and-white line etching; the draw-
ing is stylish and immediate. Why not stop here? Because, Pearl-
stein says, it is too reminiscent of other people's art, too easy. It
recalls Matisse's line etchings and the commercial illustrations of
Pearlstein's former roommate, Andy Warhol. The line also con-
veys a definite feeling of languor. Pearlstein uses the drawing only
as a map for the composition to come; its dotted lines indicate
areas that will become tones; angles of chairs and molding are po-
sitioned to create depth.

 In the following proofs, aquatint effaces lines; when dark-

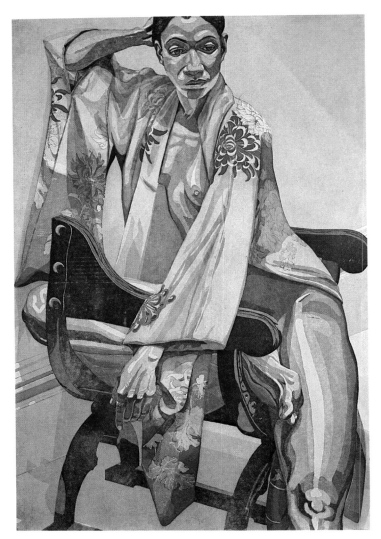

Model in Green Kimono, Trial Proof,
 1979
Etching with aquatint
40⅛ × 26⅝ inches (101.9 × 67.6 cm)
Collection of the artist

ened, it determines the composition. The plate is cut down, space
condensed. The nude is objectified. In the final image, the model
appears neither languorous nor inviting, but as inanimate as the
wooden chair she sits in. The chair recedes into space; her knee
breaks the picture plane. Revealing more arrogance than a painted
nude, she sits, implacable — a lesson against the strictures of
modernism.

LITERATURE:

Field, Richard S. *The Lithographs and Etchings of Philip Pearlstein* (exhibition
catalogue). Springfield, Mo.: Springfield Art Museum, 1978.

Viola, Jerome. *Philip Pearlstein: Landscape Aquatints, 1978–1980* (exhibition
catalogue). New York: Brooke Alexander, Inc., 1981.

Opposite:
Model in Green Kimono, 1979
Etching with aquatint
40⅜ × 27¼ inches (102.5 × 69.2 cm)
Edition: 41
Printed by Orlando Candeso
Published by 724 Prints, Inc., New
 York
Collection of the artist

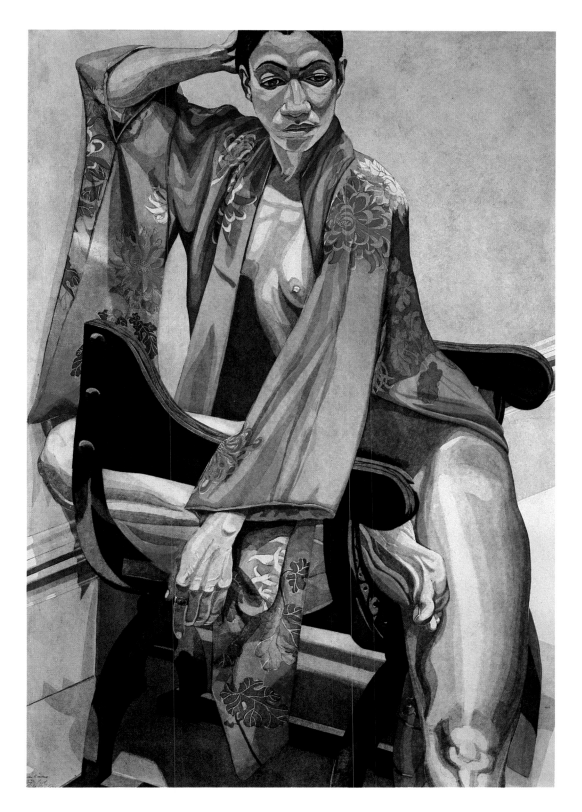

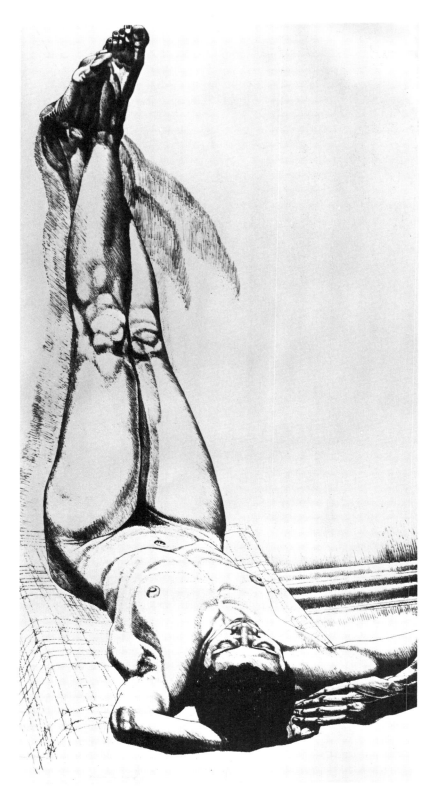

Female Nude with Legs Up, 1976
Lithograph
72 × 36 inches (182.9 × 91.4 cm)
Edition: 10
Printed by Julio Juristo
Published by Pyramid Arts, Ltd.,
 Tampa, Florida
Collection of the artist

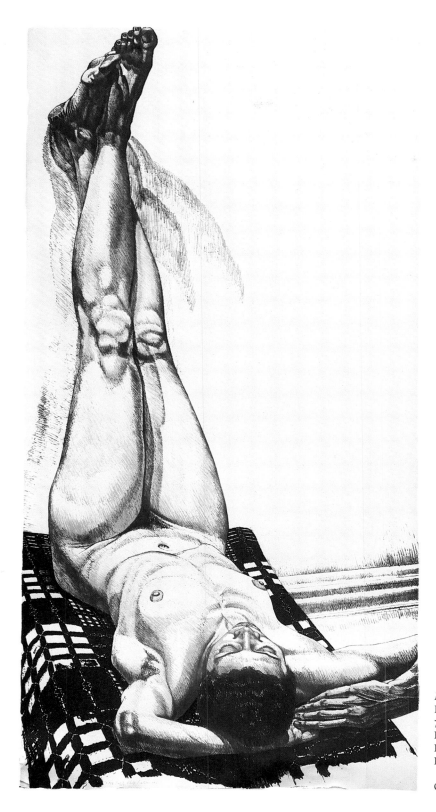

Female Nude with Legs Up, 1976
Lithograph
72 × 36 inches (182.9 × 91.4 cm)
Edition: 13
Printed by Julio Juristo
Published by Pyramid Arts, Ltd.,
 Tampa, Florida
Collection of the artist

Larry Rivers

At the height of Abstract Expressionism, Larry Rivers painted realistic pictures that incorporated common words and popular signs or, like *Washington Crossing the Delaware* (1953), took as their subject a national cliché. Handling paint with an Abstract Expressionist's energy, Rivers was a realist with an eye for mass culture, and his collage-inspired compositions were a bridge between Abstract Expressionism and Pop Art.

In the early 1960s, Rivers' style grew closer to Pop. He based paintings on restaurant menus and French money, on a Rembrandt-esque-decorated cigar box and Camel cigarettes. In *Camels, 6 × 4* (1962), he repeated the image serially, but he did not paint in Pop's clean, graphic outlines. His autographic line was shaggy and digressive, and he applied paint in patches and abstract blocks of color.

Rivers embraced Pop's subject matter, but resisted its look. In *Buick Painting with P* (1960) he laid paint down in broad, abstract expanses, and in *First New York Film Festival Billboard* (1963) he stenciled words and numbers over a fragmented ground. In the mid-1960s, when Pop was the reigning aesthetic, almost com-

15 Years, Working Proof, 1965 (signed 1976)
Lithograph with pastel and collage
22¾ × 31½ inches (57.8 × 80 cm)
The Art Institute of Chicago

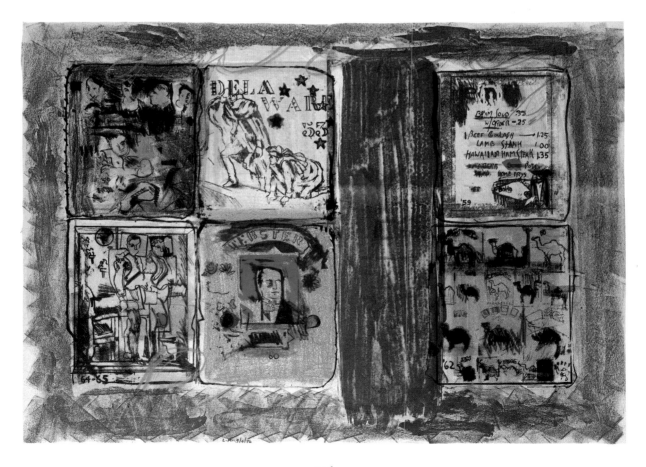

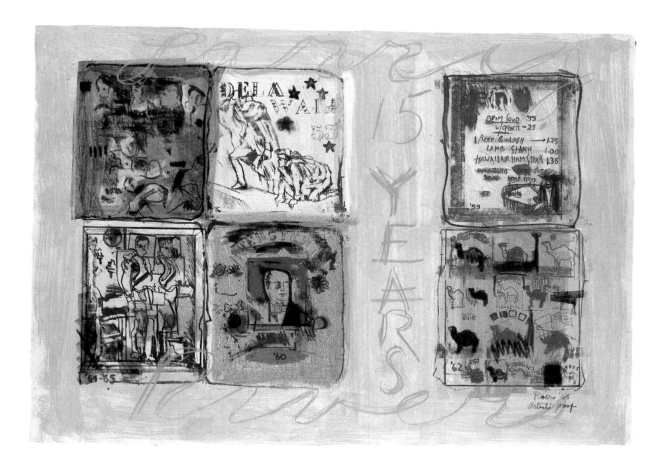

petitively, Rivers pushed its concepts further: he extended his collage compositions into three-dimensional objects, such as *Webster and Cigars* (1966), and he utilized every imaginable material in paintings and objects—plexiglass, neon, wood, photographs.

Rivers was always more closely aligned with Abstract Expressionism than with Pop. Like the New York School painters, his subject was the self—only he didn't transpose it into abstract forms—he painted literal representations. "I have to put my life in my work," he wrote, "because that's me, that's what I'm about." Even when he made excursions into art history, he rendered the subject personal. Depicting a culture of narcissism before the idea had currency, Rivers' painting *Studio* (1956) is not a worldly place; the large, fragmentary composition holds his subjects—the people in his life: his mother-in-law Bertie, sons, the poet Frank O'Hara.

Rivers paints his friends and family—wives, girlfriends, relatives from old photographs he never knew. Before he paints he draws in peripatetic, assured lines that slide and break across a page. He draws and then erases, forming images out of smudges and mistakes. Countless studies precede paintings; and once he has a finished drawing, Rivers transfers it to canvas, beginning his process of erasure all over again, before he applies color.

15 Years, 1965
Lithograph
22½ × 31½ inches (57.1 × 80 cm)
Edition: 35
Printed by Bob Blackburn
Published by Universal Limited Art Editions, West Islip, New York
Collection of Mr. and Mrs. Peter A. Ralston

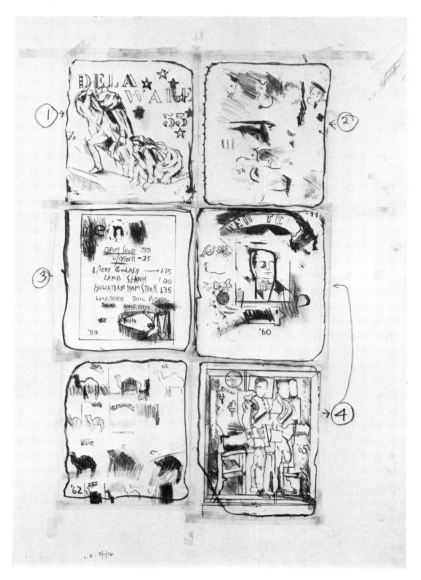

15 Years (poster), Working Proof, 1965–
66 (signed 1976)
Lithograph with collage and charcoal
32 × 22 inches (81.3 × 55.9 cm)
The Art Institute of Chicago

Rivers regards drawing as the most important element in his paintings: "Drawing is the ability to use a line or mark to produce air, space, distractions, peculiarities, endings, beginnings. It is like the backfield in a football team; it is the star. . . . I think drawing the most thrilling part of painting and the one which I feel most sure about. . . ."

Despite his gifts as a draftsman, Rivers resisted printmaking. "Unless I was thinking about Picasso or Matisse, I thought printmaking was a dull occupation of pipe-smoking corduroy jacket-type artisans." Rivers shared the Abstract Expressionist prejudice that printmaking was not quite art and regarded working in the media

15 Years (poster), Working Proof, 1965–66 (signed 1976)
Lithograph with collage, acrylic, and pencil
33¼ × 21½ inches (84.5 × 54.6 cm)
The Art Institute of Chicago

as "jumping back into the 15th century." Even after he started printing, he found graphics cumbersome. Images came out backwards; the litho crayon left rubbery, smooth marks; liquid tusche was hard to control—and it was difficult to erase or create smudges.

Tatyana Grosman cajoled Rivers into printmaking. Her first publication, *Stones* (1957–59), a collaboration between Rivers and Frank O'Hara, was also Rivers' first lithograph. But Rivers did not illustrate O'Hara's poem. Rivers drew and O'Hara wrote or sometimes O'Hara wrote and Rivers drew. O'Hara's words led to images and vice versa. *Stones* was not the illustrated book Tatyana Grosman had envisioned, but a collaborative visual poem.

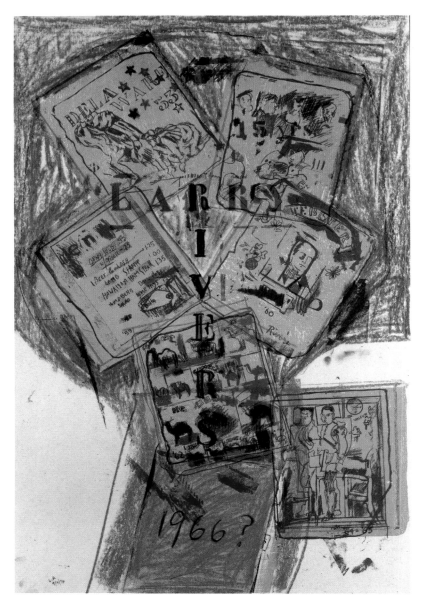

15 Years (poster), Working Proof, 1965–
66 (signed 1976)
Lithograph with crayon and collage
35 × 23 inches (88.9 × 58.4 cm)
The Art Institute of Chicago

Since *Stones*, Rivers has produced innumerable prints, and
he has made many of his best graphics at Tatyana Grosman's Uni-
versal Limited Art Editions. The slow pace of ULAE is the perfect
foil for Rivers unwieldy energy; Mrs. Grosman's steely will matches
Rivers' headstrong determination.

The working proofs for *15 Years* (1965) show the decisions
behind Rivers' best graphics. Made for a 1965 retrospective of his
work at the Rose Art Museum at Brandeis University, *15 Years*,
like Jasper Johns' *Untitled* (1977), is a retrospective image. Each of
the print's panels contains drawings after the paintings that earned

him the retrospective: *Washington Crossing the Delaware* (1953); a portrait of Frank O'Hara; *Menu*, after a Rivers painting commemorating his salad days at New York's Cedar Bar in the company of de Kooning, Kline and Pollock; his crib from high art, *The Greatest Homosexual*, after David's *Napoleon*; a drawing after *Camels*, 6 × 4, and another after *Webster*.

Rivers works in lithography as he does in painting. He draws first, then paints and utilizes collage. For *15 Years*, he drew the images and then cut them up. Re-positioning them, he covered them with pastel. Discarding the proof, he put them back together again and experimented with a purple ground, which he also rejected, choosing instead a soft beige, a color that conjures up memories.

Using the same images, Rivers reworked the lithograph to create a poster. Cutting the images up again, he added a seventh rectangle and positioned the rectangles one on top of another at zigzagging angles. Covering the seven rectangles with a fleshy pink paint, he conceals the images. Finally he decides on the more graphic crayon version and adds the year "1966" and a question mark onto the blank rectangle—a query about the future of his art.

The process of *Diana with Poem* (1970–74) was long, complicated and led to four separate editions along the way. At the time he started the print, Rivers was involved in three-dimensional paintings, and he wanted to make a sculptural multiple of his then current girlfriend, Diane. The idea did not sit well with Tatyana Grosman, who regards herself as a publisher of books and prints, not sculptural objects. A struggle of wills ensued that lasted four years. During that period, Rivers kept producing prints of Diane, each from the same stone; and to remind Mrs. Grosman of his intention to create a three-dimensional image, he titled his flat prints *Diane Raised I, II, III*. Four years later a compromise was reached. From the same stone as the earlier *Diane*s, the three-dimensional *Diana with Poem* pops up and stares through a windowpane; facing her is a poem by Kenneth Koch, which is how Mrs. Grosman turned the sultry, three-dimensional *Diana* into a book.

LITERATURE:

Hunter, Sam. *Larry Rivers*. New York: Harry N. Abrams, Inc., 1969.

Rivers, Larry. "My Life Among the Stones." *Location*, Spring 1963.

Rivers, Larry with Carol Brightman. *Drawings and Digressions*. New York: Clarkson N. Potter, Inc., 1979.

James Rosenquist

In Grand Forks, North Dakota, where James Rosenquist grew up during the Depression, material possessions had a special significance. Cars were expensive; food was scarce. Rosenquist's Middle American childhood informs his imagery, and the scale of his paintings also comes off that landscape. In Grand Forks, the land is flat and empty and stretches into space until it meets the horizon. Against that open flatness, objects assume unusual proportions: even at a distance, cows and horses appear larger than life.

The scale of Rosenquist's paintings also comes from working as a sign painter. In the Midwest, he painted the Phillips 66 signs across Iowa, and after he came to New York to study at the Art Students League, he worked as a billboard artist. Painting Kirk Douglas' dimple or the head on a glass of beer in the gargantuan scale of an outdoor advertising poster, he realized how abstract reality could look.

Often described as an ex-sign painter, Rosenquist has been regarded as a heartland primitive with a flair for Surrealism, but nothing could be farther off the mark. Long before he found work as a billboard artist, Rosenquist studied painting with Cameron Booth at the University of Minnesota; and his designation as a naif has been one way to deal with his paintings' resistance to interpretation. Of the artists labeled Pop, Rosenquist is the least literal or literary. His larger-than-life images on mural-sized canvases do not rely on wit or carry specific meanings. Rosenquist chooses images common enough to pass without notice, old enough to have been forgotten, but not so old as to trigger nostalgia.

Rosenquist paints things that stick in his mind, objects from the culture at large — consumer products, fragments of foods that come in cans, smiles that sell toothpaste, fenders of cars and pickup trucks. He renders objects in close-up enlargement and tough technological colors. Using Surrealist techniques, he yokes disparate images, but the strange, multiple pairings do not generate meanings or tell stories. Representational fragments, enlarged and divorced from any known context, function abstractly.

Bacon floats in the space of the painting *Starthief* along with a fragment of a woman's head and callipered wires; liquid chocolate pours through a car window in *Chocolate Highway Trust* (1980). In the lithograph *Off the Continental Divide* (1973), a staircase is coupled with crumpled paper and colored nails. The staircase reappears in the painting *Dog Descending a Staircase* (1979), along with a dalmatian and a doll's face. What, if anything, are the connections? Knowing that Rosenquist's dealer, Leo Castelli, owned a dalmatian or that as a child the artist hid under a staircase does not make a difference. Autobiographical facts do not add up.

Joined by a smooth, meticulously even-painted surface, jarring, spatially splayed images attract attention. But one looks only to discover no connections, that the private iconography has no key. The mammoth scale turns realistically rendered objects abstract. One sees images and colors never encountered before: the

Circles of Confusion I, Working Proof,
1966
Lithograph with pencil
22⅛ × 30⅛ inches (56.2 × 76.5 cm)
The Art Institute of Chicago

viscous yellow of butter, the coagulated gristle of bacon.

Paintings confront the viewer and present visual disassocia-
tions that distance one. Rosenquist risks the alienation of his au-
dience with unyielding imagery. One travels through the paintings
only to realize that what you see is what you see: abstract com-
positions built out of realistic fragments, flatness determined by
scale, a violent aura suggested by the sharp fragmentations.

Despite his stint as a billboard painter and use of printed ad-
vertisements as a source, graphics did not come easily to Rosen-
quist. Unlike other Pop artists, he did not build paintings out of
the properties of print. Nor was he concerned with the residual
meanings buried in the photogravure face of a movie star. His in-
terest lay in neither print nor its effect, but in images common
enough to appear contentless, which he rendered ironically, in a
painterly manner that excised their graphic quality.

In paintings, Rosenquist relies on size, to turn realistic objects
abstract, and on an evenly applied, continuous surface which, by
equalizing subjects, neutralizes their content. The small format
of graphics, the figure/ground relationship inherent to paper and
ink, presented problems.

In prints that follow paintings, such as *Chambers* (1980) and *Horse Blinders* (1975), reduced size requires adjustments. Rosenquist deleted the keyhole from the lithographic version of *Chambers* because in a small format the keyhole became anecdotal. The lithographic *Horse Blinders*, printed on reflective mylar and paper, repeats the painting's disjointed imagery. But unlike the painting, which assaults the viewer with visual information, the lithograph is accessible and readable.

Scale is less of a problem in prints that precede paintings. *Off*

Circles of Confusion I, Working Proof, 1966
Lithograph with collage
41 ¼ × 29 ½ inches (104.8 × 74.9 cm)
The Art Institute of Chicago

the Continental Divide (1973) began with a sketch. Like those that come before large paintings, the drawing is a map to be altered in the course of the print's making. It shows a boy and girl in swimsuits, about to dive into the darkness under a staircase, which is framed by a car window and cut by the outline of a rear-view mirror.

In the final lithograph, far more enigmatic than the drawing, a circle, triangle and square have replaced the children. The car window remains but the rear-view mirror is gone. The nails appear in primary and secondary colors.

Circles of Confusion I, Working Proof, 1966
Lithograph with conté
40¼ × 26 inches (102.2 × 66 cm)
The Art Institute of Chicago

The print is about decisions and dreams. Its title, *Off the Continental Divide*, suggests a choice of directions. The geometric shapes and primary colors on the nails and the wall behind the staircase are the artist's materials. Under the staircase is where children hide and dream and plan their escape. But the children do not appear in the final lithograph; their presence, by providing a narrative, might disturb its disjunctive quality. What Rosenquist leaves out of a picture tells as much about his art as what he leaves in.

How Rosenquist works as a printmaker depends on where he works. He is as susceptible to the ambience of place as Motherwell. A collaborative printmaker, Rosenquist talks about printers as finely tuned Stradivariuses, or as sympathetic comrades. With each, he proceeds differently and has no set procedure. He uses any material at hand from a toothbrush to an airbrush. Often, he works from an initial conception to a final image without revisions. Most changes indicate problems in scale.

The lithograph *Circles of Confusion I* (1965–66) began as a disordered out-of-focus composition. The problem is scale, and in the course of creating the image, Rosenquist twice increased size, beginning each time with a new stone.

Once size was resolved, Rosenquist stuck a cardboard G.E. emblem onto the print's center. In following proofs, he incorporated the enlarged corporate logo of electric light into the composition, contrasting a symbol of light with light's colored reflections. In concluding proofs, Rosenquist adjusted the colors and, by partially obscuring the trademark's letters, unweighted the central red circle. In the final print, no one element overpowers another. What one sees depends on how one looks. Light, the source of the confusion, is also the print's subject, whose title, *Circles of Confusion*, refers to the reflective colored circles created when a camera lens captures light.

LITERATURE:

Tucker, Marcia. *James Rosenquist* (exhibition catalogue). With notes on the prints by Elke Soloman. New York: Whitney Museum of American Art, 1972.

Circles of Confusion I, 1965–66
Lithograph
38½ × 28 inches (97.8 × 71.1 cm)
Edition: 12
Printed by Donn Steward
Published by Universal Limited Art
 Editions, West Islip, New York
The Museum of Modern Art, New
 York; Gift of the Celeste and
 Armand Bartos Foundation

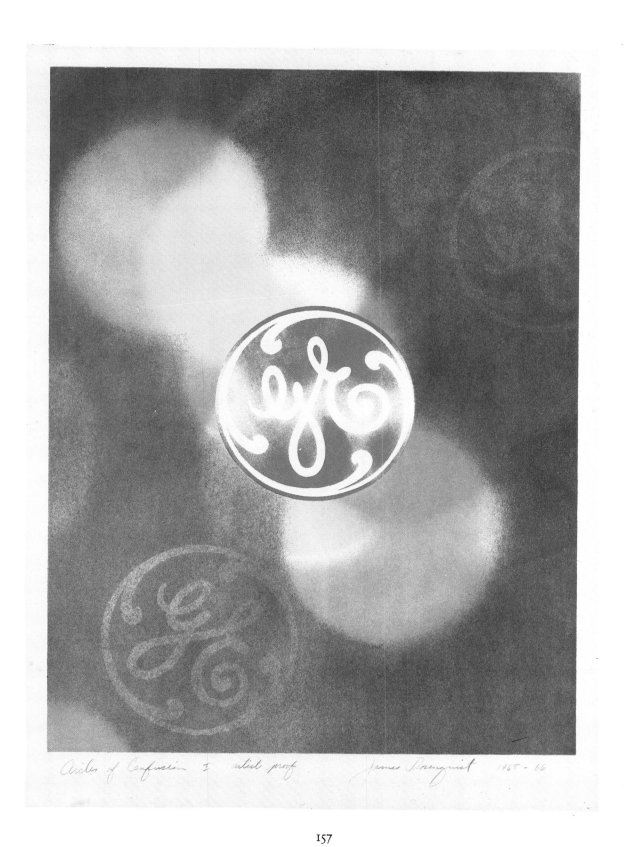

Circles of Confusion I artist proof James Rosenquist 1965 - 66

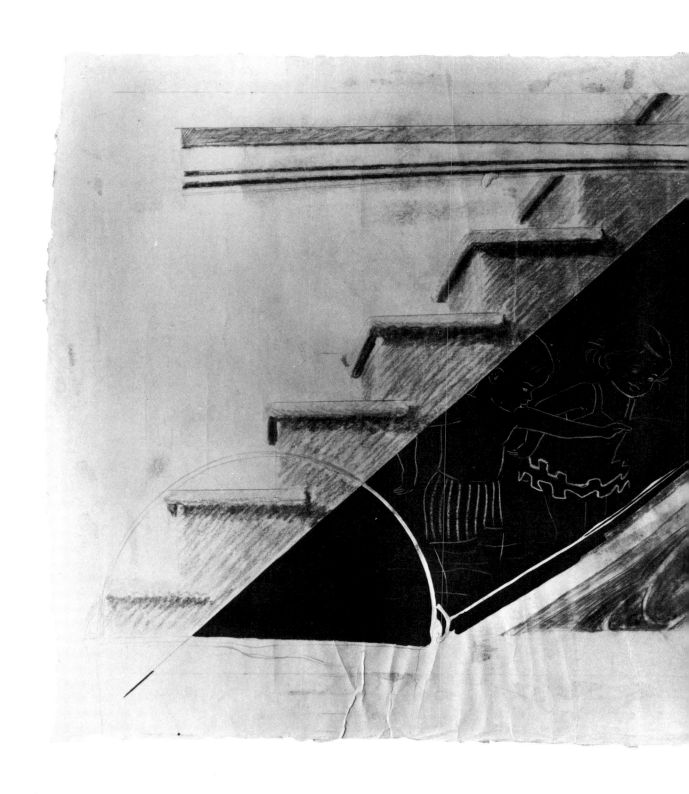

Study for *Off the Continental Divide*, 1973. India ink, crayon, chalk, conté, and pencil. 42 × 78 inches (106.7 × 198.1 cm). The Art Institute of Chicago

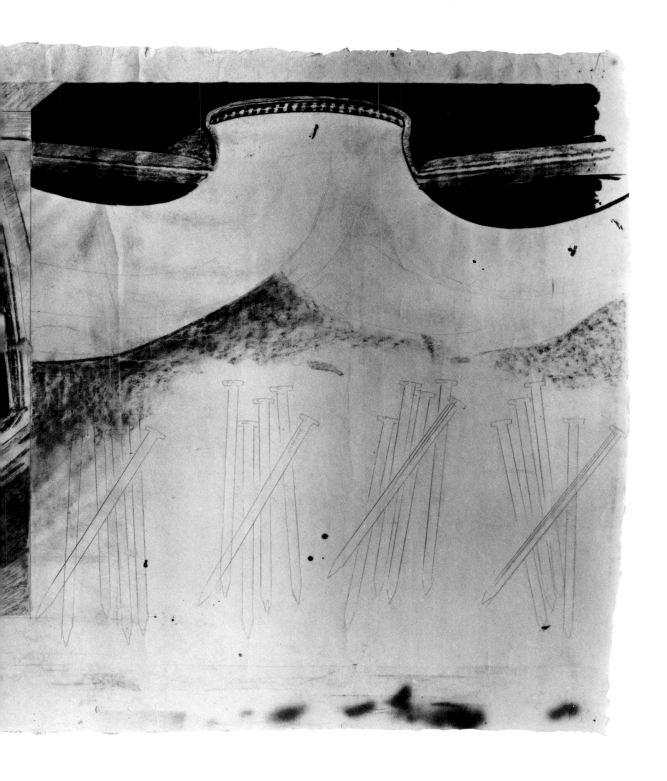

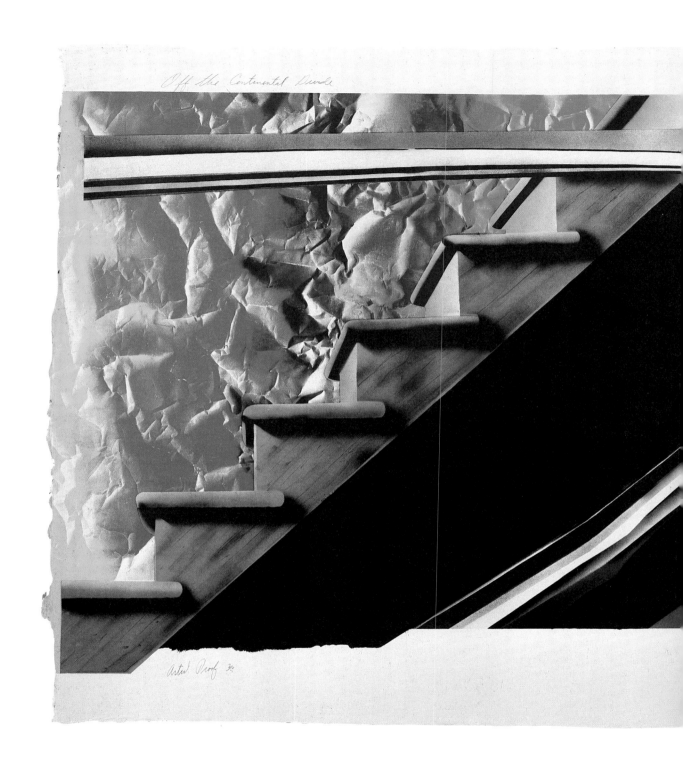

Off the Continental Divide, 1973. Lithograph. 42 × 78 inches (106.7 × 198.1 cm).
Edition: 48. Printed by James V. Smith. Published by Universal Limited Art Editions, West Islip, New York. The Museum of Modern Art, New York; Gift of Celeste Bartos.

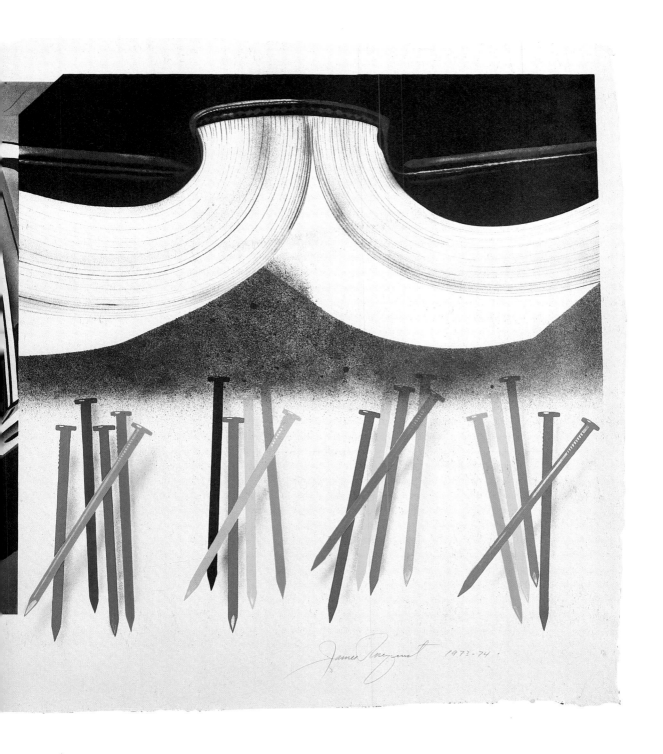

James Rosenquist 1973-74.

Frank Stella

Frank Stella, like Jasper Johns, restates paintings as prints. He uses graphics to do the same thing differently. But unlike Johns, whose prints extend the perceptual inquiry of his paintings by posing philosophical questions, Stella's graphic restatements operate independently of his paintings. They do not raise questions, but find solutions to abstract problems of scale, surface and texture.

Though Stella has said that he considers printmaking a necessary evil, he has produced over 120 editions. He has made prints after his *Black*, *Aluminum* and *Copper* paintings, and rendered the *Benjamin Moore Series*, *Irregular Polygons* and *Protractor* paintings in print. He has editioned and printed paper reliefs after the *Polish Series* and combined lithography and silkscreen in prints after his *Exotic Bird* pictures. Most prints follow painting compositions, but Stella neither replicates paintings nor is he after graphic equivalents to imitate painterly effects. Stella's graphics are as insistently graphic as his paintings are painterly.

In the *Black Series* (1960) and paintings which followed, until the *Irregular Polygons* of 1965–66, Stella did exactly as he has stated —he forced "illusionistic space out of the painting at a constant rate by using a regulated pattern." Evenly spaced repetitions, by equalizing figure and ground, yielded a flat, continuous surface.

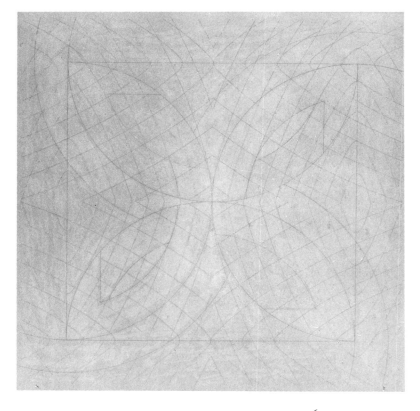

Polar Co-ordinates for Ronnie Peterson III, Working Proof, 1979–80
Lithograph and screenprint with hand-painting
38½ × 38 inches (97.8 × 96.5 cm)
Collection of the artist

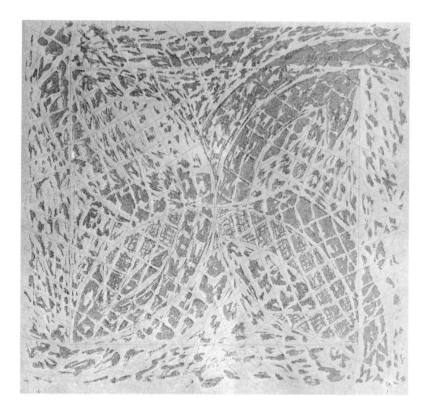

*Polar Co-ordinates for Ronnie Peterson
III*, Trial Proof, 1979–80
Lithograph and screenprint
38½ × 38 inches (97.8 × 96.5 cm)
Collection of the artist

Lines of raw canvas between rectilinear bands achieved scale by
reiterating the painting's shape. Size was also crucial to the echo-
ing scale — so were the paintings' opaque black, silver and copper
surfaces. The radical pictures equated structure and shape.

Paper and ink, the basic graphic properties, traditionally form
a figure/ground relationship. For Stella, the transposition of the
Black and *Aluminum* images into print meant dealing with the
figure/ground relationship he had so definitively pushed out of
the picture. Stella had a number of options. By covering the entire
sheet with an image, he could have avoided the figure/ground prob-
lem. Or by translating images into screenprint or mezzotint he
might have matched the dense and metallic painted surfaces. But
Stella chose not to simulate paintings in print. Working with simple
graphic materials, he drew with litho crayons on stones and plates.
Rendered small, when printed the compositions occupied only part
of the paper. Stella, instead of sidestepping the figure/ground prob-
lem that graphics posed, confronted it.

Though Stella did not entirely excise the figure/ground rela-
tionship from the *Black* and *Aluminum* lithographs, he tried and
came close to neutralizing it. For the *Black Series* lithographs,
Stella drew and redrew and pushed the composition into the sheet.
Flatness was maintained in other ways: by printing; by soft edges
on the repeating rectilinear bands which kept images from popping

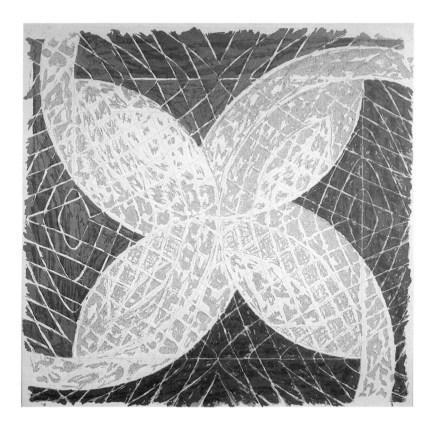

Polar Co-ordinates for Ronnie Peterson III, Trial Proof, 1979–80
Lithograph and screenprint
38½ × 38 inches (97.8 × 96.5 cm)
Collection of the artist

off the page; and by positioning images so that their interior white bands echoed the shape of the paper.

Until the *Eccentric Polygon* lithograph-screenprints (1974), Stella found ways to create a taut, graphic surface. The polygons, like the irregularly shaped, bright and often unlikely colored paintings they followed, represented a departure. The paintings had flat, evenly applied surfaces; for the lithographs, Stella filled in the eccentric geometric shapes with litho crayons. The unevenly marked color did not lie flat; it sprang from the surface toward the viewer.

"My main interest is to make what is popularly called decorative painting truly viable in unequivocal abstract terms," Stella said in a conversation with William Rubin. Since the mid-1970s, about the time he produced the *Eccentric Polygon* lithographs, Stella has pursued that course. His paintings—complex, three-dimensional, sometimes etched metal structures—consist of interlocking elements and planes: rectangles, squares, French curves and sections of French curves. By glazing, marking and coloring the surface of planes and shapes, Stella defines images and forms pictures in which illusionism is actual and literal, as intended and controlled as the iron-flat, taut surfaces of his early *Black* and *Aluminum* paintings.

Stella's graphics still follow but never replicate paintings. Though prints have grown more painterly, Stella continues to

work graphically. In the series of lithograph-screenprints after the *Exotic Bird* pictures, Stella built three-dimensional images on a flat surface. Using as a guide the same graph-paper drawing which had been a study for the painting's maquette, Stella drew, painted and worked surfaces to form recessive and projective spaces. Reversing his graphic procedure, he filled the flat surface with illusionism.

Polar Co-ordinates for Ronnie Peterson (1980), a series of eight lithograph-screenprints plus two variants, represents another graphic departure. They are not after specific paintings. Based on drawings for Stella's 1968–69 *Saskatoon* and *Flin-Flon* paintings, the prints do not restate the drawings, they update them. The *Flin-Flon* paintings marked the beginning of Stella's grand, intelligent illusionism. In those paintings, the slightest change in the coloration of one of the four petals altered the compositions. The recent *Polar Co-ordinate* prints show the full maturation of the concept.

For *Polar Co-ordinates for Ronnie Peterson Variant IIIA*, Stella begins with a printed geometric drawing; he fills in petals and completes what is to be the final working proof. Then, dissatisfied with the result, he begins all over again. Starting with another printed geometric drawing on a white ground, he adds glitter, then a metallic silver and copper ground. In the following proofs, Stella fills in petals and focuses on their surface. He scribbles and paints in pink and decides on a more defiant purple. He changes blue to

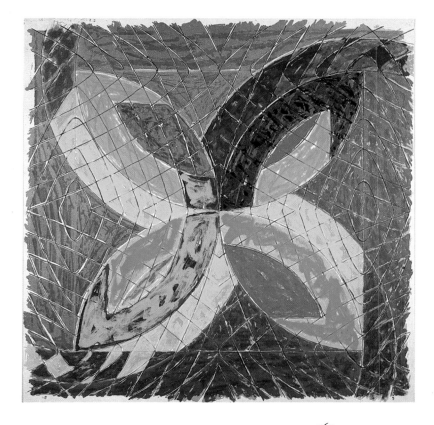

Polar Co-ordinates for Ronnie Peterson III, Working Proof, 1979–80
Lithograph and screenprint with hand-painting
38½ × 38 inches (97.8 × 96.5 cm)
Collection of the artist

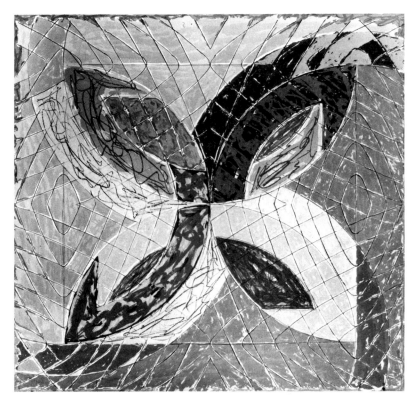

Polar Co-ordinates for Ronnie Peterson III, 1979–80
Lithograph and screenprint
38½ × 38 inches (97.8 × 96.5 cm)
Edition: 100
Printed by John Hutcheson, Norman
 Lassiter, Bruce Porter, and Jim Welty
Published by Petersburg Press, Inc.,
 New York
Petersburg Press, Inc., New York

orange, overprints white on green; in all, he uses forty-eight colors. There is nothing cosmetic or incidental about these changes; the smallest alteration affects the balance of the entire composition. A rigorous intelligence is operating behind Stella's grand, decorative illusionism.

LITERATURE:

Leider, Philip. *Stella Since 1970* (exhibition catalogue). Fort Worth: Fort Worth Art Museum, 1978.

Richardson, Brenda. *Frank Stella: The Black Paintings* (exhibition catalogue). Baltimore: The Baltimore Museum of Art, 1976.

Rubin, William S. *Frank Stella* (exhibition catalogue). New York: The Museum of Modern Art, 1970.

Opposite:
*Polar Co-ordinates for Ronnie Peterson
 Variant IIIA*, 1978–80
Lithograph and screenprint
38½ × 38 inches (97.8 × 96.5 cm)
Edition: 32
Printed by John Hutcheson, Norman
 Lassiter, Bruce Porter, and Jim Welty
Published by Petersburg Press, Inc.,
 New York
Petersburg Press, Inc., New York

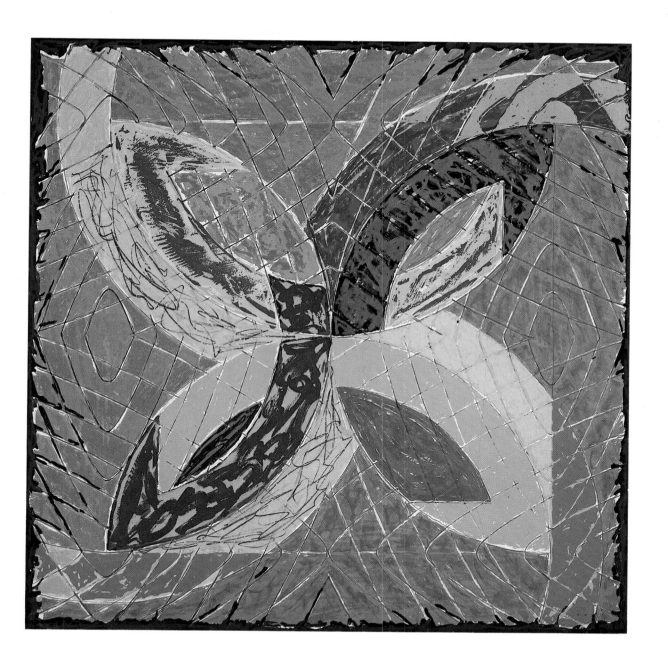

Glossary

Italicized words have separate entries in the Glossary.

AQUATINT
An *etching* technique used to create tones. A *ground* of acid-resistant powdered resin, spray paint, or other substance is applied to a metal plate and heated, creating a porous surface. When the plate is placed in an acid bath, the acid eats into the areas not covered by resin. When inked, the result is a textured tone. Lightness or darkness of tone depends on the amount of time the plate is exposed to the acid.

BURIN
A metal tool, also called a graver, consisting of a steel shaft with a sharp square- or wedge-shaped head used for engraving metal plates or the end-grain of boxwood.

BURNISHING
A method of smoothing the surface of a metal plate with a curved and polished metal tool (burnisher). Burnishing eliminates recessed marks from a plate and creates highlights in tones. The process is often preceded by scraping indentations off a plate's surface with a *scraper*.

BURR
A ridge of metal left when a *burin* or *drypoint* tool is moved across the surface of a metal plate. In *mezzotint*, burr refers to the even ridges produced by the serrated teeth of a rocker.

COUNTER-ETCHING
The removal of the etch which fixes the image on a lithographic surface.

DRYPOINT
An *intaglio* process in which lines are cut into the surface of a plate with a pointed instrument—a fine needle or a dental tool.

The cut of the needle creates a ridge of metal called a *burr*. In printing, the burr holds the ink and yields a soft, warm, furry line.

EDITION
Any set number of *impressions* printed from the same plate; usually numbered.

ENGRAVING
An *intaglio* process in which a *burin* is used to incise lines into a plate. Curves are created by turning the plate as the line is being engraved. If a *burr* is created, it is removed with a *scraper*. The depth of an engraved line depends on the angle and pressure with which the burin is moved across the plate. This, in turn, yields printed lines of varying width and darkness.

ETCHING
An *intaglio* process based on the chemical reaction of acid on metal. The plate is first coated with an acid-resistant *ground* and lines are then drawn through the ground, exposing the plate. When the plate is placed in an acid bath, the acid eats or "bites" away exposed areas to create the image.

GROUND (HARD GROUND)
An acid-resistant coating used to cover *etching* plates. When the ground hardens, the etcher cuts through it to the plate with a pointed tool. See also *soft-ground*.

IMPRESSION
A print made directly from an inked stone, plate, or wood block.

INTAGLIO
Derived from the Italian *intagliare* ("to engrave" or "carve into"). Intaglio is the generic term for recessed printing techniques, including *etching, engraving, aquatint, drypoint,* and *mezzotint*. When an intaglio plate is inked and wiped, the recessed lines hold ink. The pressure of the printing press forces the inked lines onto the paper. The lines created are raised off the paper's surface.

LITHOGRAPHY
Invented by Alois Senefelder in 1797, lithography ("stone drawing") is a planographic, or "surface" process which involves no cutting into or away from the surface of the plate. Lithography depends on the antipathy of grease and water. The image is drawn with greasy tusche ink or litho crayon onto a slab of limestone or an aluminum plate. The printing surface is then treated with a solution of gum arabic and nitric acid, called an etch, which stabilizes the image. Before printing, the surface is sponged with water, then rolled with a greasy ink. Wet areas repel the ink, but the tusche or crayon marks hold it and yield the printed image.

MEZZOTINT

An *intaglio* technique first popularized in seventeenth- and eighteenth-century England. Mezzotint ("half-tone") is a means of creating images out of tones. The surface of a plate is first roughened with a rocker, a tool with an even, serrated edge, to create an overall *burr* which prints as a dark, velvety black. The lines and areas to be lightened are smoothed down by scraping or *burnishing* so that they do not take the ink in printing.

MONOTYPE

A one-of-a-kind print made by painting directly on a flat surface, usually metal or glass, and then pressing the paper onto the surface while the paint is still wet. A monotype can also be produced by painting on a plate and running it once through the press.

PLATE MARK

The imprint made by the edges of the metal plate on the paper when it is passed through the press.

PROOF

An *impression* taken at any stage in the making of a print.

ARTIST'S PROOF

Impressions outside the numbered edition made especially for the artist, usually marked "A.P.," "artist's proof," or with Roman numerals to distinguish them from the numbered edition.

TRIAL PROOF

An impression taken in the process of creating an image, often incorporating new revisions to the plate or stone.

WORKING PROOF

A trial proof in which the artist has added work by hand.

CANCELLATION PROOF

An impression taken from a plate, often marked with an X to designate the end of an edition.

SCRAPER

A triangle-shaped, rough-surfaced steel tool used in the making of *intaglio* plates for removing *burrs* or indentations from the surface of the plate. In *lithography*, a scraper refers to the leather bar under which the stone passes that applies pressure to force the ink onto the paper.

SCREENPRINT

Also called a serigraph; the term refers to an image produced by a stencil process. Ink is passed through a stencil made of fabric. A separate screen or stencil is used for each color required.

SNAKESLIP
An abrasive stick, made of pressed pumice, used like a scraper, to delete images from a lithographic stone.

SOFT-GROUND
An *etching* technique in which an acid-resistant pliable *ground* is applied to the plate. A sheet of paper is then laid down over it and the artist draws firmly, usually with a pencil, making clear impressions in the ground. When the paper is lifted off, the marked areas of the ground pull away with it. The plate is then bitten with acid as in an etching. A soft-ground etched line can simulate the effect of a chalk or pencil line.

STATE
Every revision of a plate, block, or stone from which one or more *impressions* are pulled is called a state. States are frequently numbered, in the order of execution, to differentiate them from the final version.

SUGAR-LIFT
An *etching ground* made of sugar, ink (litho or India), and water. With a brush or pen dipped in sugar-lift ground, an artist draws directly onto a bare metal or aquatinted plate. The plate is then covered with a hard etching ground. After the hard ground dries, the plate is soaked in warm water. The sugar's dissolution in water lifts the areas of ground off the plate. The exposed areas are then etched.

WOODCUT
A relief process, the oldest printmaking technique. In contrast to *intaglio* printing, in a woodcut the lines or area to be printed are left standing in relief. On a plank of wood, the artist gouges out or cuts away the lines or areas to be printed white. When the block is inked, therefore, the ink covers only the raised areas, which print as black lines.

Selected Bibliography

The following is not intended to be a comprehensive bibliography of American prints and their history, but rather a list of the works consulted in the preparation of this exhibition and catalogue. Further bibliographical references follow the essays on individual artists.

Alloway, Lawrence. *Systemic Painting* (exhibition catalogue). New York: The Solomon R. Guggenheim Museum, 1966.

Art and Commerce: American Prints of the 19th Century. Boston: Museum of Fine Arts, 1975.

Baro, Gene. *30 Years of American Printmaking* (exhibition catalogue). Brooklyn, N.Y.: The Brooklyn Museum, 1976.

Bassham, Ben L. *John Taylor Arms, American Etcher* (exhibition catalogue). Madison, Wis.: Elvehjem Art Center, University of Wisconsin, 1975.

Beall, Karen F. *American Prints in the Library of Congress: A Catalog of the Collection.* Baltimore: The Johns Hopkins Press, 1970.

Beam, Philip C. *Winslow Homer's Magazine Engravings.* New York: Harper & Row, Inc., 1979.

Bellows, Emma S., ed. *George W. Bellows: His Lithographs.* New York: Alfred A. Knopf, Inc., 1927.

Bloch, E. Maurice. *Tamarind: A Renaissance of Lithography* (exhibition catalogue). Washington, D.C.: International Exhibitions Foundation, 1971.

——. *Words and Images: Universal Limited Art Editions* (exhibition catalogue). Los Angeles: Frederick S. Wight Art Gallery, University of California, 1978.

Breeskin, Adelyn D. *The Graphic Art of Mary Cassatt* (exhibition catalogue). New York: The Museum of Graphic Art; Washington, D.C.: Smithsonian Institution Press, 1967.

Breeskin, Adelyn D. *Mary Cassatt: A Catalogue Raisonné of the Graphic Work.* Washington, D.C.: Smithsonian Institution Press, 1979.

Brigham, Clarence S. *Paul Revere's Engravings.* Worcester, Mass.: American Antiquarian Society, 1954.

Carey, Frances, and Antony Griffiths. *American Prints, 1879–1979* (exhibition catalogue). London: British Museum Publications Limited, 1980.

Castleman, Riva. *Technics and Creativity: Gemini G.E.L.* (exhibition catalogue). New York: The Museum of Modern Art, 1971.

Chappell, Warren. *A Short History of the Printed Word.* New York: Alfred A. Knopf, Inc., 1970.

Coplans, John. *Serial Imagery* (exhibition catalogue). Pasadena, Calif.: The Pasadena Art Museum, 1968.

Dolmetsch, Joan. "Colonial America's Elegantly Framed Prints." *Antiques,* 119 (May 1981), pp. 1106–12.

——. "Prints in Colonial America: Supply and Demand in the Mid-Eighteenth Century." In *Prints in and of America to 1850*, edited by John D. Morse. Charlottesville, Va.: The University Press of Virginia, 1970.

Dunlap, William. *A History of the Rise and Progress of the Arts of Design in the United States*. Boston: C. E. Goodspeed & Co., 1918.

Durand, John. *The Life and Times of A. B. Durand*. New York: Charles Scribner's Sons, 1894.

Eichenberg, Fritz. *The Art of the Print*. New York: Harry N. Abrams, Inc., 1976.

Fath, Creekmore, ed. *The Lithographs of Thomas Hart Benton*. Austin, Tex.: University of Texas Press, 1969.

Fielding, Mantle. *American Engravers upon Copper and Steel, Part III*. Reprint. New York: Burt Franklin, n.d.

Flexner, James Thomas. *History of American Painting, Volume One: First Flowers of Our Wilderness (The Colonial Period)*. Reprint. New York: Dover Publications, Inc., 1969.

——. *History of American Painting, Volume Two: The Light of Distant Skies (1760–1835)*. Reprint. New York: Dover Publications, Inc., 1969.

——. *History of American Painting, Volume Three: That Wilder Image — The Native School from Thomas Cole to Winslow Homer*. Reprint. New York: Dover Publications, Inc., 1970.

Flint, Janet. *George Miller and American Lithography* (exhibition catalogue). Washington, D.C.: Smithsonian Institution Press, 1976.

Goldman, Judith. *Art off the Picture Press: Tyler Graphics Ltd.* (exhibition catalogue). Hempstead, N.Y.: Emily Lowe Gallery, Hofstra University, 1977.

——. *Brooke Alexander: A Decade of Print Publishing* (exhibition catalogue). Boston: Boston University Art Gallery, 1979.

——. "The Master Printer of Bedford, New York." *Art News*, 76 (September 1977), pp. 50–54.

Goodrich, Lloyd. *The Graphic Art of Winslow Homer* (exhibition catalogue). New York: The Museum of Graphic Art, 1968.

Harris, Neil. *The Artist in American Society: The Formative Years, 1790–1860*. New York: George Braziller, Inc., 1966.

Hayter, Stanley William. *About Prints*. London and New York: Oxford University Press, 1962.

——. *New Ways of Gravure*. London and New York: Oxford University Press, 1966.

Helm, MacKinley. *John Marin*. Boston: Pellegrini & Cudahy in association with the Institute of Contemporary Art, 1948.

Hitchings, Sinclair H. "The Graphic Arts in Colonial New England." In *Prints in and of America to 1850*, edited by John D. Morse. Charlottesville, Va.: The University Press of Virginia, 1970.

Holman, Richard. "John Foster's Woodcut Map of New England." *Printing and Graphic Arts*, 8 (1960), pp. 53–96.

——. "Seventeenth-Century American Prints." In *Prints in and of America to 1850*, edited by John D. Morse. Charlottesville, Va.: The University Press of Virginia, 1970.

——. "Some Remarks on 'Mr. Richard Mather.'" *Printing and Graphic Arts*, 7 (1959), pp. 57–63.

Ivins, William M., Jr. *Prints and Visual Communication*. New York: Da Capo Press, 1969.

Johnson, Elaine L. *Contemporary Painters and Sculptors as Printmakers* (exhibition catalogue). New York: The Museum of Modern Art, 1968.

Johnson, Una E. *American Prints and Printmakers*. Garden City, N.Y.: Doubleday & Company, Inc., 1980.

——. *Milton Avery: Prints and Drawings, 1930–1964*. Commemorative essay by Mark Rothko. Brooklyn, N.Y.: The Brooklyn Museum, 1966.

——. *Paul Cadmus: Prints and Drawings, 1922–1967*. Brooklyn, N.Y.: The Brooklyn Museum, 1968.

Karshan, Donald H. "American Printmaking, 1670–1968." *Art in America*, 56 (July/August 1968), pp. 22–55.

Kelder, Diane. *Graphics in Long Island Collections from the Studio of Universal Limited Art Editions* (exhibition catalogue). Hempstead, N.Y.: Emily Lowe Gallery, Hofstra University, 1970.

Kennedy, Edward G., ed. *The Etched Work of Whistler*. Reprint. San Francisco: Alan Wofsy Fine Arts, 1978.

Lieberman, William S., and Virginia Allen. *Tamarind: Homage to Lithography* (exhibition catalogue). New York: The Museum of Modern Art, 1969.

Lunn, Harry H., Jr., ed. *Milton Avery: Prints, 1933–1955*. Washington, D.C.: Graphics International Ltd., 1973.

Mason, Lauris, and Joan Ludman. *The Lithographs of George Bellows: A Catalogue Raisonné*. Millwood, N.Y.: KTO Press, 1977.

Mayor, A. Hyatt. *Prints & People: A Social History of Printed Pictures*. New York: The Metropolitan Museum of Art, 1971.

McCarron, Paul. *Martin Lewis: The Graphic Work*. New York: Kennedy Galleries, Inc., 1973.

McClinton, Katharine Morrison. *The Chromolithographs of Louis Prang*. New York: Clarkson N. Potter, Inc., 1973.

Miller, Jo. *Josef Albers: Prints, 1915–1970* (exhibition catalogue). Brooklyn, N.Y.: The Brooklyn Museum, 1973

Morse, Peter. *John Sloan's Prints: A Catalogue Raisonné of the Etchings, Lithographs, and Posters*. New Haven, Conn.: Yale University Press, 1969.

Moser, Joann. *Atelier 17* (exhibition catalogue). Madison, Wis.: Elvehjem Art Center, University of Wisconsin, 1977.

Peck, Glenn C. *America in Print, 1796–1941* (exhibition catalogue). New York: Hirschl & Adler Galleries, 1981.

Philadelphia Reviewed: The Printmaker's Record, 1750–1850. Winterthur, Dela.: The Henry Francis du Pont Winterthur Museum, 1960.

Prasse, Leona. *Lyonel Feininger: A Definitive Catalogue of His Graphic Work — Etchings, Lithographs, Woodcuts*. Cleveland, Ohio: Museum of Art, 1972.

Pratt, John Lowell, ed. *Currier & Ives: Chronicles of America*. Maplewood, N.J.: Hammond, Inc., 1968.

Quimby, Ian M. G. "The Doolittle Engravings of the Battle of Lexington and Concord." *Winterthur Portfolio 4, 1968*, pp. 83–108.

Reich, Sheldon. *Graphic Styles of the American Eight* (exhibition catalogue). Salt Lake City, Utah: Utah Museum of Fine Arts, University of Utah, 1976.

Richardson, Edgar P. "Charles Willson Peale's Engravings in the Year of National Crisis, 1787." *Winterthur Portfolio I*, 1964, pp. 166–81.

Sasowsky, Norman. *The Prints of Reginald Marsh*. New York: Clarkson N. Potter, Inc., 1976.

Scott, John. "The Hill Family of Clarksville." *South of the Mountains*, 19 (January/March 1975), pp. 5–7.

Shadwell, Wendy J. *American Printmaking: The First 150 Years* (exhibition catalogue). New York: The Museum of Graphic Art, 1969.

Stauffer, David McNeely. *American Engravers upon Copper and Steel, Part I*. Reprint. New York: Burt Franklin, n.d.

——. *American Engravers upon Copper and Steel, Part II*. Reprint. New York: Burt Franklin, n.d.

Stokes, I. N. Phelps and Daniel C. Haskell. *American Historical Prints, Early Views of American Cities, Etc.* New York: The New York Public Library, 1932.

Tatham, David. "The Pendleton-Moore Shop: Lithographic Artists in Boston, 1825–1840." *Old Time New England*, 62 (October/December 1971), pp. 29–46.

Tomkins, Calvin. "The Moods of a Stone [Tatyana Grosman]." *The New Yorker*, June 7, 1976, pp. 41–76.

Towle, Tony. *Contemporary American Prints* (exhibition catalogue). Toronto, Ontario: Art Gallery of Ontario, 1979.

Trumbull, John. *Autobiography, Reminiscences and Letters of John Trumbull, from 1756–1841*. New Haven, Conn.: B. L. Hamlen, 1841.

Two Decades of American Prints: 1920–1940. Washington, D.C.: Smithsonian Institution Press, 1974.

Weitenkampf, F. *American Graphic Art*, 2nd ed. New York: The Macmillan Company, 1924.

Williams, William Carlos, Duncan Phillips, Dorothy Norman, MacKinley Helm, and Frederick S. Wight. *John Marin*. Berkeley and Los Angeles: University of California Press, 1956.

Zigrosser, Carl. *The Complete Etchings of John Marin*. Philadelphia: Philadelphia Museum of Art, 1969.

——. "The Etchings of Edward Hopper." In *Prints: Thirteen Essays on the Art of the Print Selected for the Print Council of America*. New York: Holt, Rinehart and Winston, 1962.

Zobel, Hiller B. *The Boston Massacre*. New York: W. W. Norton & Company, Inc., 1970.

Works in the Exhibition

Unless otherwise noted, dimensions for etchings refer to image size and for all other works refer to paper size. All works are on paper unless otherwise noted. For prints which exist in more than one state, the final state (if included in the exhibition) is given first, followed by an indented listing of prior states, proofs, and preparatory drawings.

American Prints 1670–1960

JOSEF ALBERS (1888–1976)

W+P, State IV (final state), 1944–68
Woodcut
13¾ × 10¾ inches (34.9 × 27.3 cm)
The Brooklyn Museum, New York;
 Gift of the artist

> State I, 1944–68
> Woodcut
> 13¾ × 10¾ inches (34.9 × 27.3 cm)
> The Brooklyn Museum, New York;
> Gift of the artist

> State II, 1944–68
> Woodcut
> 13¾ × 10¾ inches (34.9 × 27.3 cm)
> The Brooklyn Museum, New York;
> Gift of the artist

> State III, 1944–68
> Woodcut
> 13¾ × 10¾ inches (34.9 × 27.3 cm)
> The Brooklyn Museum, New York;
> Gift of the artist

JOHN TAYLOR ARMS (1887–1953)

The Gates of the City, 1922
Etching and aquatint
9 × 8⅝ inches (22.9 × 21.9 cm)
The Herman Wunderlich Memorial
 Collection, The New York Public
 Library, Astor, Lenox and Tilden
 Foundations

The Gates of the City, 1922
Color etching and aquatint
9 × 8⅝ inches (22.9 × 21.9 cm)
The Herman Wunderlich Memorial
 Collection, The New York Public
 Library, Astor, Lenox and Tilden
 Foundations

JOHN JAMES AUDUBON (1785–1851)

Townsend's Rocky Mountain Hare,
 c. 1841
Watercolor
29½ × 19 inches (74.9 × 48.3 cm)
The American Museum of Natural
 History, New York

Townsend's Rocky Mountain Hare,
 1845, printed by John Bowen
Lithograph with hand-coloring
20¾ × 26⅞ inches (52.7 × 68.3 cm)
W. Graham Arader III, King of Prussia,
 Pennsylvania

MILTON AVERY (1893–1965)

Umbrella by the Sea, 1948
Drypoint
4¹¹⁄₁₆ × 7⁷⁄₁₆ inches (11.9 × 18.9 cm)
Associated American Artists, Inc.,
 New York

GEORGE BELLOWS (1882–1925)

In the Park, Light, State II
1916
Lithograph
16⅞ × 21⅛ inches (42 × 53.7 cm)
The Boston Public Library, Print De-
 partment, Albert H. Wiggin Collec-
 tion

In the Park, Dark, State I, 1916
Lithograph
16⅞ × 21⅛ inches (42.9 × 53.7 cm)
The Boston Public Library, Print De-
 partment, Albert H. Wiggin Collec-
 tion

Dempsey Through the Ropes, 1923–24
Lithograph
17⅞ × 16½ inches (45.4 × 41.9 cm)
The Boston Public Library, Print De-
 partment, Albert H. Wiggin Collec-
 tion

> Study for *Dempsey Through the
> Ropes*, 1923–24

Crayon
21½ × 19⅝ inches (54.6 × 49.8 cm)
The Metropolitan Museum of Art,
 New York; Rogers Fund

THOMAS HART BENTON (1889–1975)

Rainy Day, 1938
Lithograph
Image: 8¹¹⁄₁₆ × 13¹⁵⁄₁₆ inches (22.1 ×
 35.4 cm)
Paper: 12 × 16 inches (30.5 × 40.6 cm)
Whitney Museum of American Art,
 New York; Gift of Arthur G. Alt-
 schul 72.72

> Study for *Rainy Day*, 1938
> Pencil and ink wash
> Image: 7 × 12 inches (17.8 ×
> 30.5 cm)
> Paper: 10¾ × 17 inches (27.3 ×
> 43.2 cm)
> Thomas Hart Benton and Rita P.
> Benton Trusts, Kansas City,
> Missouri

JOHN H. BUFFORD (c. 1810–1870)

Boston Massacre, March 5th, 1770, 1856,
 drawn by William L. Champney
Chromolithograph
17½ × 24 inches (44.5 × 61 cm)
The Bostonian Society, Boston

MARY CASSATT (1844–1926)

The Fitting, State VI (final state), c. 1891
Drypoint and soft-ground
14¾ × 10⅛ inches (37.5 × 25.7 cm)
S. P. Avery Collection, The New York
 Public Library, Astor, Lenox and
 Tilden Foundations

> Study for *The Fitting*, c. 1891
> Chalk
> Image: 15⅛ × 10¼ inches (38.4 ×
> 26 cm)
> Paper: 19½ × 12 inches (49.5 × 30.5
> cm)
> National Gallery of Art, Washing-
> ton, D.C.; Rosenwald Collec-
> tion

> State I, c. 1891
> Drypoint and soft-ground
> 14¾ × 10⅛ inches (37.5 × 25.7 cm)
> National Gallery of Art, Washing-
> ton, D.C.; Rosenwald Collec-
> tion

State III, c. 1891
Drypoint and soft-ground
14¾ × 10⅛ inches (37.5 × 25.7 cm)
S. P. Avery Collection, The New
York Public Library, Astor,
Lenox and Tilden Foundations

State IV, c. 1891
Drypoint and soft-ground
14¾ × 10⅛ inches (37.5 × 25.7 cm)
S. P. Avery Collection, The New
York Public Library, Astor,
Lenox and Tilden Foundations

The Letter, State III (final state), c. 1891
Drypoint, soft-ground, and aquatint
13⅝ × 8¹⁵⁄₁₆ inches (34.6 × 22.7 cm)
The Metropolitan Museum of Art, New
York; Gift of Paul J. Sachs

State I, c. 1891
Drypoint
13⅝ × 8¹⁵⁄₁₆ inches (34.6 × 22.7 cm)
The Metropolitan Museum of Art,
New York; Gift of Arthur Sachs

State II, c. 1891
Drypoint, soft-ground, and aqua-
tint
13⅝ × 8¹⁵⁄₁₆ inches (34.6 × 22.7 cm)
S. P. Avery Collection, The New
York Public Library, Astor,
Lenox and Tilden Foundations

NATHANIEL CURRIER (1813–1888)

*Awful Conflagration of the Steam Boat
Lexington in Long Island Sound*,
1840, drawn by N. Sarony and W. K.
Hewitt for the New York *Sun*
Lithograph
Image: 8½ × 12 inches (21.6 × 30.5 cm)
Paper: 18¹⁵⁄₁₆ × 13 inches (48.1 × 33 cm)
Museum of the City of New York;
Harry T. Peters Collection

*Washington Taking Leave of the Offi-
cers of His Army . . . Dec. 4th, 1783*,
1848
Lithograph with hand-coloring
8¹³⁄₁₆ × 12⅝ inches (22.4 × 32.1 cm)
Museum of the City of New York;
Harry T. Peters Collection

CURRIER & IVES (1857–1907)

*Washington's Farewell to the Offi-
cers of His Army*, 1876

Lithograph with hand-coloring
8⅛ × 12³⁄₁₆ inches (20.6 × 31 cm)
Museum of the City of New York;
Harry T. Peters Collection

STUART DAVIS (1894–1964)

2 Figures and El, 1931
Lithograph
20 × 25¹⁵⁄₁₆ inches (50.8 × 65.9 cm)
Whitney Museum of American Art,
New York; Gift of Mr. and Mrs. Mi-
chael H. Irving (and purchase) 77.4

Study for *2 Figures and El*, 1931
Pencil
17⅞ × 24 inches (45.4 × 61 cm)
Associated American Artists, Inc.,
New York

WILLEM DE KOONING (b. 1904)

Untitled, illustration for "Revenge" by
Harold Rosenberg, from *21 Etchings
and Poems*, 1960
Etching with aquatint
11⅞ × 13½ inches (30.2 × 34.3 cm)
Print Collection, The New York Public
Library, Astor, Lenox and Tilden
Foundations

THOMAS DONEY (active 1844–52)

The Jolly Flat-Boat Men, 1847, after a
painting by George Caleb Bingham
Mezzotint
Image: 18¾ × 24 inches (47.6 × 61 cm)
Paper: 25¾ × 30¾ inches (65.4 × 78.1 cm)
Print Collection, The New York Public
Library, Astor, Lenox and Tilden
Foundations

AMOS DOOLITTLE (1754–1832)

A View of the Town of Concord, 1775
Engraving with hand-coloring
13¹³⁄₁₆ × 17¹¹⁄₁₆ inches (35.1 × 44.9 cm)
Print Collection, The New York Public
Library, Astor, Lenox and Tilden
Foundations

ASHER BROWN DURAND (1796–1886)

Ariadne, State VIII (final state), 1835,
after a painting by John Vanderlyn
Engraving
Image: 14⅛ × 17⅝ inches (35.9 × 44.8 cm)
Paper: 17¾ × 20⅞ inches (45.1 × 53 cm)

Print Collection, The New York Public
Library, Astor, Lenox and Tilden
Foundations

State I, 1835
Etching
Image: 14⅛ × 17⅝ inches (35.9 ×
44.8 cm)
Paper: 17¾ × 20⅞ inches (45.1 × 53
cm)
Print Collection, The New York
Public Library, Astor, Lenox
and Tilden Foundations

State III, 1835
Engraving and etching
Image: 14⅛ × 17⅝ inches (35.9 ×
44.8 cm)
Paper: 17¾ × 20⅞ inches (45.1 × 53
cm)
Print Collection, The New York
Public Library, Astor, Lenox
and Tilden Foundations

LYONEL FEININGER (1871–1956)

Daasdorf, 1918
Woodcut
Image: 13¹⁄₁₆ × 17⅝ inches (33.2 × 44.8
cm)
Paper: 18⅛ × 22⅛ inches (46 × 56.2 cm)
Whitney Museum of American Art,
New York; Purchase 72.5

JOHN FOSTER (1648–1681)

Mr. Richard Mather, 1670
Woodcut
6 × 5 inches (15.2 × 12.7 cm)
American Antiquarian Society, Worces-
ter, Massachusetts

WILLIAM GROPPER (1897–1977)

Sweatshop, 1934, from *The American
Scene – Series 2*
Lithograph
Image: 9½ × 11¹⁵⁄₁₆ inches (24.1 × 30.3
cm)
Paper: 11⁷⁄₁₆ × 15⅞ inches (29.1 × 40.3
cm)
Whitney Museum of American Art,
New York; Purchase 34.37c

CHILDE HASSAM (1859–1935)

Fifth Ave., Noon, State II (final state),
1916

Etching
9¹⁵⁄₁₆ × 7½ inches (25.2 × 19 cm)
Hirschl & Adler Galleries, New York

 State I, 1916
 Etching
 9¹⁵⁄₁₆ × 7³⁄₁₆ inches (25.2 × 18.3 cm)
 Hirschl & Adler Galleries, New
 York

STANLEY WILLIAM HAYTER (b. 1903)

Masques, 1937
Etching
4¼ × 7¾ inches (10.8 × 19.7 cm)
Philadelphia Museum of Art; Gift of
R. Sturgis Ingersoll

WINSLOW HOMER (1836–1910)

*The Army of the Potomac—A Sharp-
Shooter on Picket Duty*, 1862
Wood engraving
9 × 13¾ inches (22.9 × 34.9 cm)
Whitney Museum of American Art,
New York; Purchase

EDWARD HOPPER (1882–1967)

East Side Interior, State V (final state),
1922
Etching
8 × 10 inches (20.3 × 25.4 cm)
Print Collection, The New York Public
Library, Astor, Lenox and Tilden
Foundations

 Study for *East Side Interior*, 1922
 Conté and charcoal
 8¹⁵⁄₁₆ × 11½ inches (22.7 × 29.2 cm)
 Whitney Museum of American
 Art, New York; Bequest of Jo-
 sephine N. Hopper 70.342

 State I, 1922
 Etching
 7¹⁵⁄₁₆ × 9¹⁵⁄₁₆ inches (20.2 × 25.2
 cm)
 Philadelphia Museum of Art;
 Thomas Skelton Harrison Fund

 State III, 1922
 Etching
 7¹⁵⁄₁₆ × 9¹⁵⁄₁₆ inches (20.2 × 25.2
 cm)
 Philadelphia Museum of Art;
 Thomas Skelton Harrison Fund

THOMAS JOHNSTON (c. 1708–1767)

*A Prospective Plan of the Battle Fought
Near Lake George on the 8th of Sep-
tember 1755*, 1755
Engraving with hand-coloring
13¹¹⁄₁₆ × 17½ inches (34.8 × 44.5 cm)
I. N. Phelps Stokes Collection, The
New York Public Library, Astor,
Lenox and Tilden Foundations

ROCKWELL KENT (1882–1971)

Forest Pool, 1927
Wood engraving
5½ × 8¹⁄₁₆ inches (14 × 20.5 cm)
Print Collection, The New York
Public Library, Astor, Lenox and
Tilden Foundations

 Study for *Forest Pool*, 1927
 Pencil
 5½ × 7⅞ inches (14 × 20 cm)
 Rockwell Kent Collection, Rare
 Book and Manuscript Library,
 Columbia University, New York

FRANZ KLINE (1910–1962)

Untitled, illustration for "Poem" by
Frank O'Hara, from *21 Etchings
and Poems*, 1960
Etching with aquatint
Image: 8¼ × 14½ inches (21 × 36.8 cm)
Paper: 16¾ × 20 inches (42.5 × 50.8 cm)
Print Collection, The New York Pub-
lic Library, Astor, Lenox and
Tilden Foundations

MARTIN LEWIS (1882–1962)

Passing Freight, 1934
Etching
9 × 14⅜ inches (22.9 × 36.5 cm)
Collection of Paul McCarron

LOUIS LOZOWICK (1892–1973)

New York, 1925
Lithograph
Image: 11⁹⁄₁₆ × 9 inches (29.4 × 22.9 cm)
Paper: 15³⁄₁₆ × 11⁷⁄₁₆ inches (38.6 × 29.1
cm)
Whitney Museum of American Art,
New York; John I. H. Baur Pur-
chase Fund 77.12

 Study for *New York*, 1923
 Pencil
 12¾ × 9¹⁵⁄₁₆ inches (32.4 × 25.2 cm)

Whitney Museum of American
Art, New York; Richard and
Dorothy Rogers Fund 77.15

JOHN MARIN (1870–1953)

Notre-Dame, Paris, State V (final state),
1908
Etching
12⅞ × 10¾ inches (32.7 × 27.3 cm)
The Metropolitan Museum of Art, New
York; Alfred Stieglitz Collection

 State I, 1908
 Etching
 12⅞ × 10¾ inches (32.7 × 27.3 cm)
 The Metropolitan Museum of Art,
 New York; Alfred Stieglitz Col-
 lection

 State III, 1908
 Etching with pencil
 12⅞ × 10¾ inches (32.7 × 27.3 cm)
 The Metropolitan Museum of Art,
 New York; Alfred Stieglitz Col-
 lection

Woolworth Building (The Dance), State
II (final state) 1913
Etching with drypoint
12⅞ × 10⁷⁄₁₆ inches (32.7 × 26.5 cm)
The Metropolitan Museum of Art, New
York; Alfred Stieglitz Collection

 State I, 1913
 Etching
 12⅞ × 10⁷⁄₁₆ inches (32.7 × 26.5 cm)
 The Metropolitan Museum of Art,
 New York; Alfred Stieglitz Col-
 lection

REGINALD MARSH (1898–1954)

Irving Place Burlesk, State VIII (final
state), 1930
Etching and engraving
10 × 12 inches (25.4 × 30.5 cm)
Print Collection, The New York Public
Library, Astor, Lenox and Tilden
Foundations

 Study for *Irving Place Burlesk*, 1930
 Pencil
 10 × 12 inches (25.4 × 30.5 cm)
 Philadelphia Museum of Art; Gift
 of the artist

 State I, 1930
 Etching

10 × 12 inches (25.4 × 30.5 cm)
William Benton Museum of Art,
University of Connecticut,
Storrs; Anonymous gift

State III, 1930
Etching
10 × 12 inches (25.4 × 30.5 cm)
William Benton Museum of Art,
University of Connecticut,
Storrs; Anonymous gift

State VI, 1930
Etching
10 × 12 inches (25.4 × 30.5 cm)
William Benton Museum of Art,
University of Connecticut,
Storrs; Anonymous gift

JONATHAN MULLIKEN (1746–1782)

The Bloody Massacre, 1770
Engraving
7⅞ × 8½ inches (20 × 21.6 cm)
American Antiquarian Society, Worces-
ter, Massachusetts

CHARLES WILLSON PEALE (1741–1827)

*His Excellency George Washington,
Esquire*, State I, 1780
Mezzotint
13¾ × 9⅞ inches (34.9 × 25.1 cm)
The Metropolitan Museum of Art, New
York; Bequest of Charles Allen
Munn

HENRY PELHAM (1749–1806)

*The Fruits of Arbitrary Power, or the
Bloody Massacre*, 1770
Engraving with hand-coloring
9¼ × 8¾ inches (23.5 × 22.2 cm)
American Antiquarian Society, Worces-
ter, Massachusetts

PETER PELHAM (1697–1751)

Cottonus Matherus, 1728
Mezzotint
13¹¹⁄₁₆ × 9⅞ inches (34.8 × 25.1 cm)
The Metropolitan Museum of Art, New
York; Bequest of Charles Allen
Munn

JOSEPH PENNELL (1860–1926)

The Woolworth Building, 1915

Etching
11½ × 7¼ inches (29.2 × 18.4 cm)
Associated American Artists, Inc., New
York

PAUL REVERE (1735–1818)

The Bloody Massacre, State II (final
state), 1770
Engraving with hand-coloring
10¼ × 9⅛ inches (26 × 23.2 cm)
The Metropolitan Museum of Art, New
York; Gift of Mrs. Russell Sage

CAPTAIN A. J. RUSSELL (1830–1902)

*Stone Wall, Rear of Fredericksburg,
with Rebel Dead*, 1863
Photograph
Image: 9⅝ × 13¹⁄₁₆ inches (24.4 × 33.2 cm)
Paper: 13 × 16¾ inches (33 × 42.5 cm)
Daniel Wolf, Inc., New York

SAMUEL SEYMOUR (1796–1823)

*The City of New York in the State of
New York, North America*, State III
(final state), 1803, after painting by
William Birch
Engraving
18⅝ × 23¾ inches (47.3 × 60.3 cm)
The New-York Historical Society

State I, 1803
Engraving with hand-coloring
18⅝ × 23¾ inches (47.3 × 60.3 cm)
Historical Society of Pennsyl-
vania, Philadelphia

BEN SHAHN (1898–1969)

Seward Park, 1936
Lithograph
Image: 11¾ × 17¾ inches (29.8 × 45.1 cm)
Paper: 15¾ × 22¾ (40 × 57.8 cm)
New Jersey State Museum, Trenton; Gift
of Dorothy and Sydney Spivack

WILLIAM SHARP (1803–1875)

Opening Flower, from *Victoria Regia,
or, The Great Water Lily of America*,
1854
Chromolithograph
15 × 21 inches (38.1 × 53.3 cm)
The American Stanhope Hotel, New
York

JOHN SLOAN (1871–1951)

*The Copyist at the Metropolitan Mu-
seum*, State VIII (final state), 1908
Etching
7⁵⁄₁₆ × 8¹³⁄₁₆ inches (18.6 × 22.4 cm)
Whitney Museum of American Art,
New York; Gift of Gertrude Van-
derbilt Whitney 31.694i

State I, 1908
Etching
7½ × 9 inches (19.1 × 22.9 cm)
Philadelphia Museum of Art; Pur-
chased, Katharine Levin Farrell
Fund and Lessing J. Rosenwald
gift

State II, 1908
Etching
7½ × 9 inches (19.1 × 22.9 cm)
Philadelphia Museum of Art; Pur-
chased, Katharine Levin Farrell
Fund and Lessing J. Rosenwald
gift

JAMES MCNEILL WHISTLER (1834–1903)

Nocturne, State III, 1879
Etching with drypoint
8⅛ × 11¾ inches (20.6 × 29.8 cm)
The Metropolitan Museum of Art, New
York; Harris Brisbane Dick Fund

Nocturne, State III, 1879
Etching with drypoint
8⅛ × 11¾ inches (20.6 × 29.8 cm)
The Metropolitan Museum of Art,
New York; Gift of Felix M. War-
burg and his family

Nocturne, Cancelled State, 1879
Etching with drypoint
7¹⁵⁄₁₆ × 11½ inches (20.2 × 29.2 cm)
The Metropolitan Museum of Art,
New York; Harris Brisbane Dick
Fund

Under Old Battersea Bridge, State III
(final state), 1879
Etching
8⁷⁄₁₆ × 5⅜ inches (21.4 × 13.7 cm)
Hunterian Art Gallery, University of
Glasgow, Scotland

State I, 1879
Etching
8⁷⁄₁₆ × 5⅜ inches (21.4 × 13.7 cm)
S. P. Avery Collection, The New

York Public Library, Astor,
Lenox and Tilden Foundations

The Doorway, State VII (final state),
1880
Etching with drypoint
11½ × 8 inches (29.2 × 20.3 cm)
The Brooklyn Museum, New York;
Gift of Mrs. Charles Pratt

State III, 1880
Etching
11½ × 8 inches (29.2 × 20.3 cm)
S. P. Avery Collection, The New
York Public Library, Astor,
Lenox and Tilden Foundations

GRANT WOOD (1891–1942)

March, 1941
Lithograph
8⅞ × 11¾ inches (22.5 × 29.8 cm)
Associated American Artists, Inc.,
New York

Study for *March*, 1941
Charcoal and chalk
9 × 12 inches (22.9 × 30.5 cm)
Davenport Art Gallery, Davenport,
Iowa; Gift of Nan Wood Graham

American Prints 1960–1981

CHUCK CLOSE (b. 1940)

Keith, 1972
Mezzotint
44½ × 34¹⁵⁄₁₆ inches (113 × 88.7 cm)
Edition: 10
Printed by Kathan Brown
Published by Crown Point Press,
Oakland, California
The Museum of Modern Art, New
York; John B. Turner Fund

Trial Proof, 1972
Mezzotint
44½ × 35⅛ inches (113 × 89.2 cm)
Australian National Gallery,
Canberra

Trial Proof, 1972
Mezzotint
44½ × 35⅛ inches (113 × 89.2 cm)
Australian National Gallery,
Canberra

Trial Proof, 1972
Mezzotint
44½ × 35⅛ inches (113 × 89.2 cm)
Australian National Gallery,
Canberra

Trial Proof, 1972
Mezzotint
44½ × 35⅛ inches (113 × 89.2 cm)
Australian National Gallery,
Canberra

Trial Proof, 1972
Mezzotint
44½ × 35⅛ inches (113 × 89.2 cm)
Australian National Gallery,
Canberra

Keith, 1972
Collage of trial proofs
24 × 32 inches (61 × 81.3 cm)
Pace Editions, Inc., New York

JIM DINE (b. 1935)

Five Paintbrushes (first state), 1972
Etching
Image: 23½ × 35½ inches (59.7 × 90.2
cm)
Paper: 30 × 40 inches (76.2 × 101.6 cm)
Edition: 75

Printed by Maurice Payne
Published by Petersburg Press Ltd.,
London
Collection of Mr. and Mrs. Robert
Benton

Five Paintbrushes (second state), 1973
Etching
Image: 23½ × 31¾ inches (59.7 × 80.6
cm)
Paper: 30 × 37 inches (76.2 × 94 cm)
Edition: 20
Printed by Allan Uglow and Winston
Roeth
Published by Petersburg Press Ltd.,
London
Collection of John and Linda Talleur

Five Paintbrushes (third state), 1973
Etching with drypoint
Image: 20½ × 27¼ inches (52.1 × 69.2
cm)
Paper: 30 × 35½ inches (76.2 × 90.2 cm)
Edition: 28
Printed by Allan Uglow and Winston
Roeth
Published by Petersburg Press Ltd.,
London
Collection of Mr. and Mrs. Robert
Kaplus

Five Paintbrushes (fourth state), 1973
Etching with drypoint and soft-ground
Image: 14 × 27¼ inches (35.6 × 69.2 cm)
Paper: 30 × 35½ inches (76.2 × 90.2 cm)
Edition: 15
Printed by Allan Uglow and Winston
Roeth
Published by Petersburg Press Ltd.,
London
Pace Editions, Inc., New York

Five Paintbrushes (fifth state), 1973
Etching with drypoint and soft-ground
Image: 14 × 27¼ inches (35.6 × 69.2 cm)
Paper: 30 × 35½ inches (76.2 × 90.2 cm)
Edition: 15
Printed by Allan Uglow and Winston
Roeth
Published by Petersburg Press Ltd.,
London
Collection of Werner Kramarsky

Strelitzia, 1980
Etching (unique image)
35 × 24 inches (88.9 × 61 cm)
Printed by Jeffrey Berman
Collection of the artist

Strelitzia, 1980

Etching with monotype (unique image)
35 × 24 inches (88.9 × 61 cm)
Printed by Jeffrey Berman
Collection of the artist

Strelitzia, 1980
Etching with acrylic (unique image)
35 × 24 inches (88.9 × 61 cm)
Printed by Jeffrey Berman
Collection of the artist

A Well-Painted Strelitzia, 1980
Etching
35½ × 24 inches (90.2 × 61 cm)
Edition: 33
Printed by Jeffrey Berman
Published by Pace Editions, Inc., New
 York
Pace Editions, Inc., New York

Strelitzia with Monotype, 1980
Etching with monotype
35½ × 24 inches (90.2 × 61 cm)
Edition: 17
Printed by Jeffrey Berman
Published by Pace Editions, Inc., New
 York
Pace Editions, Inc., New York

White Strelitzia, 1980
Etching
44¼ × 30 inches (112.4 × 76.2 cm)
Edition: 18
Printed by Jeffrey Berman
Published by Pace Editions, Inc., New
 York
Pace Editions, Inc., New York

Green Strelitzia, 1980
Etching
40¾ × 28 inches (103.5 × 71.1 cm)
Edition: 10
Printed by Jeffrey Berman
Published by Pace Editions, Inc., New
 York
Pace Editions, Inc., New York

Green Gold Strelitzia, 1980
Etching
40¾ × 28 inches (103.5 × 71.1 cm)
Edition: 3
Printed by Jeffrey Berman
Published by Pace Editions, Inc., New
 York
Pace Editions, Inc., New York

SAM FRANCIS (b. 1923)

Lover Loved Loved Lover, 1960

Lithograph
25 × 35½ inches (63.5 × 90.2 cm)
Edition: 18
Printed by Emil Matthieu
Published by Kornfeld, Bern,
 Switzerland
Collection of the artist

Serpent on the Stone, 1960
Lithograph
25 × 35½ inches (63.5 × 90.2 cm)
Edition: 20
Printed by Emil Matthieu
Published by Kornfeld, Bern,
 Switzerland
Collection of the artist

Untitled (Metal Field), 1972
Lithograph
35¼ × 24 inches (89.5 × 61 cm)
Edition: 17
Printed by Hitoshi Takatsuki, Keith
 Kirts, Susan Titelman, and Keiko
 Yoshimura
Published by the Litho Shop, Inc.,
 Santa Monica, California
Collection of the artist

 Trial Proof, 1972
 Lithograph
 35¼ × 24 inches (89.5 × 61 cm)
 Collection of the artist

 Trial Proof, 1972
 Lithograph
 35¼ × 24 inches (89.5 × 61 cm)
 Collection of the artist

 Trial Proof, 1972
 Lithograph
 35¼ × 24 inches (89.5 × 61 cm)
 Collection of the artist

HELEN FRANKENTHALER (b. 1928)

Yellow Span, 1968
Aquatint
Image: 14 × 18¾ inches (35.6 × 47.6 cm)
Paper: 20 × 26¼ inches (50.8 × 66.7 cm)
Edition: 75
Printed by Donn Steward
Published by Universal Limited Art
 Editions, West Islip, New York
Collection of the artist

 Trial Proof, 1968
 Aquatint
 Image: 14 × 18¾ inches (35.6 × 47.6
 cm)

Paper: 20 × 25¼ inches (50.8 × 64.1
 cm)
Collection of the artist

 Trial Proof, 1968
 Aquatint
 Image: 14 × 18½ inches (35.6 × 47
 cm)
 Paper: 20 × 25 inches (50.8 × 63.5
 cm)
 Collection of the artist

 Trial Proof, 1968
 Aquatint
 Image: 14 × 18¾ inches (35.6 × 47.6
 cm)
 Paper: 20 × 25½ inches (50.8 × 64.8
 cm)
 Collection of the artist

 Trial Proof, 1968
 Aquatint
 Image: 14 × 18¾ inches (35.6 × 47.6
 cm)
 Paper: 19¾ × 25¼ inches (50.2 ×
 64.1 cm)
 Collection of the artist

Savage Breeze, 1974
Woodcut
31½ × 27 inches (80 × 68.6 cm)
Edition: 31
Printed by Bill Goldston and Juda
 Rosenberg
Published by Universal Limited Art
 Editions, West Islip, New York
Collection of the artist

 Trial Proof, 1974
 Woodcut
 31¾ × 27½ inches (80.6 × 69.9 cm)
 Collection of the artist

 Trial Proof, 1974
 Woodcut with collage
 31¾ × 26½ inches (80.6 × 67.3 cm)
 Collection of the artist

 Trial Proof, 1974
 Woodcut
 31½ × 26½ inches (80 × 67.3 cm)
 Collection of the artist

 Working Proof, 1974
 Woodcut with crayon, ink, and
 collage
 31¾ × 27 inches (80.6 × 68.6 cm)
 Collection of the artist

Cameo, 1980

Woodcut
42 × 32 inches (106.7 × 81.3 cm)
Edition: 51
Printed by Kenneth Tyler, Roger Camp-
bell, and Lee Funderburger
Published by Tyler Graphics Ltd.,
Bedford, New York
Tyler Graphics Ltd., Bedford, New York

Working Proof, 1980
Woodcut with pastel
41½ × 31¾ inches (105.4 × 80.6 cm)
Collection of the artist

Trial Proof, 1980
Woodcut
42 × 31¾ inches (106.7 × 80.6 cm)
Collection of the artist

Trial Proof, 1980
Woodcut
41½ × 31¾ inches (105.4 × 80.6 cm)
Collection of the artist

JASPER JOHNS (b. 1930)

Light Bulb, 1976
Lithograph
17 × 14 inches (43.2 × 35.6 cm)
Edition: 48
Printed by Bill Goldston and James V.
Smith
Published by Universal Limited Art
Editions, West Islip, New York
Private collection

Working Proof, 1976
Lithograph with crayon
11¼ × 17⅜ inches (28.6 × 44.1 cm)
Collection of the artist

Working Proof, 1976
Lithograph with chalk
17⅛ × 13⅞ inches (43.5 × 35.2 cm)
Collection of the artist

Working Proof, 1976
Lithograph with tusche
10⅝ × 13⅛ inches (27 × 33.3 cm)
Collection of the artist

Working Proof, 1976
Lithograph with tusche and crayon
11½ × 13¼ inches (29.2 × 33.7 cm)
Collection of the artist

Savarin, 1977
Lithograph
45 × 35 inches (114.3 × 88.9 cm)

Edition: 50
Printed by Bill Goldston and James V.
Smith
Published by Universal Limited Art
Editions, West Islip, New York
The Museum of Modern Art, New York;
Gift of Celeste Bartos

Trial Proof, 1977
Lithograph
48 × 32 inches (121.9 × 81.3 cm)
Collection of the artist

Working Proof, 1977
Lithograph with crayon and ink
48 × 32 inches (121.9 × 81.3 cm)
Collection of the artist

Working Proof, 1977
Lithograph with crayon
48 × 32 inches (121.9 × 81.3 cm)
Collection of the artist

Working Proof, 1977
Lithograph with crayon, pencil,
and ink
48 × 32 inches (121.9 × 81.3 cm)
Collection of the artist

Untitled, 1977
Lithograph
27½ × 40 inches (69.9 × 101.6 cm)
Edition: 53
Printed by James V. Smith
Published by Universal Limited Art
Editions, West Islip, New York
Whitney Museum of American Art,
New York; Gift of the artist 77.122

Working Proof, 1977
Lithograph with chalk
32 × 22⅞ inches (81.3 × 58.1 cm)
Collection of the artist

Working Proof, 1977
Lithograph with pencil, chalk,
and collage
24¾ × 35¾ inches (62.9 × 90.8 cm)
Collection of the artist

Trial Proof, 1977
Lithograph
26¼ × 37½ inches (66.7 × 95.3 cm)
Collection of the artist

Trial Proof, 1977
Lithograph
30 × 42 inches (76.2 × 106.7 cm)
Collection of the artist

Working Proof, 1977
Lithograph with pencil, chalk,
and ink
30 × 37½ inches (76.2 × 95.3 cm)
Collection of the artist

Savarin 5 (Corpse and Mirror), 1978
Lithograph
25 × 20 inches (63.5 × 50.8 cm)
Edition: 42
Printed by James V. Smith and
Thomas Cox
Published by Universal Limited Art
Editions, West Islip, New York
The Museum of Modern Art, New
York; Gift of Celeste Bartos

Working Proof, 1978
Lithograph with ink and pencil
29⅞ × 22⅛ inches (75.9 × 56.2 cm)
Collection of the artist

Savarin Monotype, 1978
Monotype from lithographic plate
26 × 20 inches (66 × 50.8 cm)
Printed by Bill Goldston
Published by Universal Limited Art
Editions, West Islip, New York
Collection of the artist

Cancellation of *Savarin Monotype*, 1978
Monotype from lithographic plate
26 × 20 inches (66 × 50.8 cm)
Collection of the artist

VINCENT LONGO (b. 1923)

Screen, 1967
Etching
17⁹⁄₁₆ × 22 inches (44.6 × 55.9 cm)
Edition: 25
Printed by Emiliano Sorini
Published by the artist
Collection of the artist

State I, 1967
Etching
17¹³⁄₁₆ × 18 inches (45.2 × 45.7 cm)
Collection of the artist

State II, 1967
Etching
19⅞ × 17 inches (50.5 × 43.2 cm)
Collection of the artist

Passing Through, State I, 1976–77
Woodcut
36 × 24 inches (91.4 × 61 cm)
Printed by the artist
Collection of the artist

Passing Through, State IV, 1976–77
Woodcut
36 × 24 inches (91.4 × 61 cm)
Printed by the artist
Collection of the artist

Passing Through, State VII, 1981
Woodcut
36 × 24 inches (91.4 × 61 cm)
Edition: 10
Printed and published by the artist
Collection of the artist

Cutting Close, State I, 1981
Woodcut (unique image)
31 × 23 inches (78.7 × 58.4 cm)
Printed by the artist
Collection of the artist

Cutting Close, State IV, 1981
Woodcut
31 × 23 inches (78.7 × 58.4 cm)
Edition: 17
Printed and published by the artist
Collection of the artist

Cutting Close, State VI, 1981
Woodcut
31 × 23 inches (78.7 × 58.4 cm)
Edition: 3
Printed and published by the artist
Collection of the artist

MICHAEL MAZUR (b. 1935)

Net #1, 1976
Etching with aquatint
18⅞ × 33 inches (47.9 × 83.8 cm)
Edition: 20
Printed by the artist
Collection of the artist

Trial Proof, 1976
Etching with aquatint, soft-ground,
scraping, and drypoint
21 × 32⅜ inches (53.3 × 82.2 cm)
Collection of the artist

Trial Proof, 1976
Etching with aquatint, soft-ground,
scraping, and drypoint
21¼ × 32½ inches (54 × 82.6 cm)
Collection of the artist

Trial Proof, 1976
Etching with aquatint
18¾ × 32½ inches (47.6 × 82.6 cm)
Collection of the artist

Net #2, 1976
Etching with aquatint
18⅞ × 32½ inches (47.9 × 82.6 cm)
Edition: 20
Printed by the artist
Collection of the artist

Working Proof, 1976
Etching with aquatint, chalk, and
erasure
18½ × 32½ inches (47 × 82.6 cm)
Collection of the artist

Working Proof, 1976
Etching with aquatint and char-
coal
18¾ × 32⅝ inches (47.6 × 82.9 cm)
Collection of the artist

Net #3, Working Proof, 1976
Etching with aquatint, pastel, and
erasure
18½ × 32¾ inches (47 × 83.2 cm)
Collection of the artist

ROBERT MOTHERWELL (b. 1915)

A la Pintura, 1972 (book of aquatints
illustrating Rafael Alberti's cycle of
poems *A la Pintura*)
25½ × 38 inches (64.8 × 96.5 cm)
Edition: 40
Printed by Donn Steward and Juda
Rosenberg
Published by Universal Limited Art
Editions, West Islip, New York
(Not in exhibition)

Study for *"White" 1-2*, 1968
Black crayon
10½ × 19 inches (26.7 × 48.3 cm)
The Art Institute of Chicago

"White" 1-2, Trial Proof, 1971
Etching with sugar-lift and aqua-
tint
25⅛ × 38¾ inches (63.8 × 98.4 cm)
The Art Institute of Chicago

"White" 1-2, Trial Proof, 1971
Etching with sugar-lift and aqua-
tint
12⅜ × 23¾ inches (31.4 × 60.3 cm)
The Art Institute of Chicago

"White" 1-2, Trial Proof, 1971
Etching with sugar-lift and aqua-
tint
25⅛ × 38¾ inches (63.8 × 98.4 cm)

The Art Institute of Chicago

Study for *"Red" 4-7*, 1969
Acrylic and crayon with dummy
type
24 × 36 inches (61 × 91.4 cm)
The Art Institute of Chicago

"Red" 4-7, Trial Proof, 1969
Etching with sugar-lift and aqua-
tint
25 × 38½ inches (63.5 × 97.8 cm)
The Art Institute of Chicago

Study for *"Black" 4*, 1969
Collage
24⅛ × 36 inches (61.3 × 91.4 cm)
The Art Institute of Chicago

"Black" 4, Trial Proof, 1969
Etching with aquatint
25¼ × 38 inches (64.1 × 96.5 cm)
The Art Institute of Chicago

Monster, 1974–75
Lithograph
41 × 31 inches (104.1 × 78.7 cm)
Edition: 26
Printed by Kenneth Tyler
Published by Tyler Graphics Ltd.,
Bedford, New York
Tyler Graphics Ltd., Bedford, New York

Working Proof (signed "Trial
Proof"), 1974–76
Lithograph with gouache
41 × 31 inches (104.1 × 78.7 cm)
Tyler Graphics Ltd., Bedford, New
York

St. Michael III, 1975–79
Lithograph and screenprint
41½ × 31½ inches (105.4 × 80 cm)
Edition: 90
Printed by Kenneth Tyler and Kim
Halliday
Published by Tyler Graphics Ltd.,
Bedford, New York
Tyler Graphics Ltd., Bedford, New York

CLAES OLDENBURG (b. 1929)

Double Screwarch Bridge, State I, 1980
Etching
Image: 24 × 51 inches (61 × 129.5 cm)
Paper: 31½ × 58 inches (80 × 147.3 cm)
Edition: 15
Printed by Pat Branstead

Published by Multiples, Inc., New
York
Multiples, Inc., New York

Double Screwarch Bridge, State II, 1980
Etching with aquatint
Image: 24 × 51 inches (61 × 129.5 cm)
Paper: 31½ × 58 inches (80 × 147.3 cm)
Edition: 35
Printed by Pat Branstead and Sally
Sturman
Published by Multiples, Inc., New
York
Multiples, Inc., New York

Working Proof, 1980
Etching with watercolor
Image: 24 × 51 inches (61 × 129.5
cm)
Paper: 31½ × 58 inches (80 × 147.3
cm)
Collection of the artist

Working Proof, 1980
Etching with aquatint, pencil, and
erasure
Image: 24 × 51 inches (61 × 129.5
cm)
Paper: 31½ × 58 inches (80 × 147.3
cm)
Collection of the artist

Double Screwarch Bridge, State III, 1981
Etching with aquatint and monotype
Image: 24 × 51 inches (61 × 129.5 cm)
Paper: 31½ × 58 inches (80 × 147.3 cm)
Edition: 25
Printed by Pat Branstead and Yong
Soon Min
Published by Multiples, Inc., New
York
Multiples, Inc., New York

Trial Proof, 1981
Etching with aquatint and mono-
type
Image: 24 × 51 inches (61 × 129.5
cm)
Paper: 31½ × 58 inches (80 × 147.3
cm)
Collection of the artist

Trial Proof, 1981
Etching with aquatint and mono-
type
Image: 24 × 51 inches (61 × 129.5
cm)
Paper: 31½ × 58 inches (80 × 147.3
cm)

Collection of the artist

Trial Proof, 1981
Etching with aquatint and mono-
type
Image: 24 × 51 inches (61 × 129.5
cm)
Paper: 31½ × 58 inches (80 × 147.3
cm)
Collection of the artist

NATHAN OLIVEIRA (b. 1928)

Woman's Face, 1966
Lithograph
21 × 17 inches (53.3 × 43.2 cm)
Edition: 20
Printed by Joseph Zirker
Published by the artist and Felix Landau
Collection of the artist

Woman's Face, State II, 1966
Lithograph
21¼ × 17⅛ inches (54 × 43.5 cm)
Edition: 20
Printed by Joseph Zirker
Published by the artist and Felix Landau
Collection of the artist

Woman's Face with Grey Oval, 1966
Lithograph with gouache (unique
image)
21 × 17 inches (53.3 × 43.2 cm)
Printed by Joseph Zirker
Collection of the artist

Man, 1971
Lithograph
30⅛ × 22⅜ inches (76.5 × 56.8 cm)
Edition: 14
Printed by Kenjilo Nanao
Published by the artist
Collection of the artist

Man, 1971
Lithograph
30⅛ × 22⅜ inches (76.5 × 56.8 cm)
Edition: 15
Printed by Kenjilo Nanao
Published by the artist
Collection of the artist

Man, 1971
Lithograph (unique image)
30⅛ × 22⅜ inches (76.5 × 56.8 cm)
Printed by Kenjilo Nanao
Collection of the artist

Archive Site, 1979

Etching with aquatint
Image: 11½ × 14¾ inches (29.2 × 37.5
cm)
Paper: 22¼ × 31⅛ inches (56.5 × 79.1
cm)
Edition: 50
Printed by Lee Altman and Katherine
L. Bradner
Published by 3 EP Press Ltd., Palo
Alto, California
Collection of the artist

Working Proof, 1979
Etching with aquatint, pencil,
ink, chalk, and gouache
Image: 11½ × 14⅝ inches (29.2 ×
37.1 cm)
Paper: 22 × 29¾ inches (55.9 × 75.6
cm)
Collection of the artist

Working Proof, 1979
Etching with aquatint, pencil,
ink, chalk, and gouache
Image: 11½ × 14⅝ inches (29.2 ×
37.1 cm)
Paper: 20¼ × 26⅛ inches (51.4 ×
66.4 cm)
Collection of the artist

Working Proof, 1979
Etching with aquatint, pencil,
ink, chalk, and collage
Image: 11½ × 14¾ inches (29.2 ×
37.5 cm)
Paper: 22¼ × 31⅛ inches (56.5 ×
79.1 cm)
Collection of the artist

Working Proof, 1979
Etching with aquatint and pastel
Image: 11½ × 14¾ inches (29.2 ×
37.5 cm)
Paper: 22¼ × 31⅛ inches (56.5 ×
79.1 cm)
Collection of the artist

Working Proof, 1979
Etching with aquatint and ink
Image: 11½ × 14¾ inches (29.2 ×
37.5 cm)
Paper: 22¼ × 31⅛ inches (56.5 ×
79.1 cm)
Collection of the artist

Working Proof, 1979
Etching with aquatint and chalk
Image: 11½ × 14¾ inches (29.2 ×
37.5 cm)

Paper: 22¼ × 31⅛ inches (56.5 × 79.1 cm)
Collection of the artist

Working Proof, 1979
Etching with aquatint, water-color, gouache, and ink
Image: 11½ × 14¾ inches (29.2 × 37.5 cm)
Paper: 22¼ × 31⅛ inches (56.5 × 79.1 cm)
Collection of the artist

PHILIP PEARLSTEIN (b. 1924)

Model in Green Kimono, 1979
Etching with aquatint
40⅜ × 27¼ inches (102.5 × 69.2 cm)
Edition: 41
Printed by Orlando Candeso
Published by 724 Prints, Inc., New York
Collection of the artist

Trial Proof, 1979
Etching
42½ × 31⅜ inches (108 × 79.7 cm)
Collection of the artist

Trial Proof, 1979
Etching with aquatint and pencil notations
40¼ × 29¼ inches (102.2 × 74.3 cm)
Collection of the artist

Trial Proof, 1979
Etching with aquatint
40¼ × 29⅜ inches (102.2 × 74.6 cm)
Collection of the artist

Trial Proof, 1979
Etching with aquatint
40⅛ × 26⅝ inches (101.9 × 67.6 cm)
Collection of the artist

Trial Proof, 1979
Etching with aquatint and pencil notations
40½ × 30¼ inches (102.9 × 76.8 cm)
Collection of the artist

Stonehenge, 1979
Etching with aquatint
Image: 23⅝ × 33¾ inches (60 × 85.7 cm)

Paper: 30½ × 39¼ inches (77.5 × 99.7 cm)
Edition: 50
Printed by Orlando Condeso
Published by M.E.P. Editions, New York
Collection of the artist

Trial Proof, 1979
Etching
Image: 23⅞ × 33⅝ inches (60.6 × 85.4 cm)
Paper: 26 × 39 inches (66 × 99.1 cm)
Collection of the artist

Trial Proof, 1979
Etching with aquatint
Image: 23¹⁵⁄₁₆ × 33½ inches (60.8 × 85.1 cm)
Paper: 30¼ × 39⅛ inches (76.8 × 99.4 cm)
Collection of the artist

Trial Proof, 1979
Etching with aquatint
Image: 23¹⁵⁄₁₆ × 33½ inches (60.8 × 85.1 cm)
Paper: 28⅞ × 39 inches (73.3 × 99.1 cm)
Collection of the artist

Trial Proof, 1979
Etching with aquatint
Image: 23⅝ × 33⅝ inches (60 × 85.4 cm)
Paper: 29¹⁄₁₆ × 39¼ inches (73.8 × 99.4 cm)
Collection of the artist

LARRY RIVERS (b. 1923)

15 Years, 1965
Lithograph
22½ × 31½ inches (57.1 × 80 cm)
Edition: 35
Printed by Bob Blackburn
Published by Universal Limited Art Editions, West Islip, New York
Collection of Mr. and Mrs. Peter A. Ralston

Working Proof, 1965 (signed 1976)
Lithograph with pastel and collage
22¾ × 31½ inches (57.8 × 80 cm)
The Art Institute of Chicago

Working Proof, 1965 (signed 1976)
Lithograph with crayon
22¼ × 31¼ inches (56.5 × 79.4 cm)

The Art Institute of Chicago

Working Proof, 1965 (signed 1976)
Lithograph with gouache, collage, and pencil
23 × 31¾ inches (58.4 × 80.6 cm)
The Art Institute of Chicago

15 Years (poster), 1965–66
Lithograph
35 × 23 inches (88.9 × 58.4 cm)
Unlimited edition
Proofed by Bob Blackburn
Published by Universal Limited Art Editions, West Islip, New York
(Not in exhibition)

Working Proof, 1965–66 (signed 1976)
Lithograph with collage and charcoal
32 × 22 inches (81.3 × 55.9 cm)
The Art Institute of Chicago

Working Proof, 1965–66 (signed 1976)
Lithograph with collage, acrylic, and pencil
33¼ × 21½ inches (84.5 × 54.6 cm)
The Art Institute of Chicago

Working Proof, 1965–66 (signed 1976)
Lithograph with crayon and collage
35 × 23 inches (88.9 × 58.4 cm)
The Art Institute of Chicago

Diane Raised I, 1970
Lithograph
22 × 30 inches (55.9 × 76.2 cm)
Edition: 20
Printed by Frank Akers
Published by Universal Limited Art Editions, West Islip, New York
Paine Webber, Inc., New York

Working Proof, 1970
Lithograph with collage and charcoal
21¾ × 29¾ inches (55.2 × 75.6 cm)
The Art Institute of Chicago

Diane Raised II, Working Proof, 1970–71
Lithograph with pastel
22½ × 29½ inches (57.2 × 74.9 cm)
The Art Institute of Chicago

Diana with Poem, 1970–74
Three-dimensional lithograph with

poem by Kenneth Koch
Open: 24½ × 57 inches (62.2 × 144.8 cm)
Closed: 24½ × 28 inches (62.2 × 71.1 cm)
Edition: 19
Printed by Frank Akers
Published by Universal Limited Art
 Editions, West Islip, New York
Neuberger Museum, State University
 of New York, College at Purchase

Working Proof, 1970
Lithograph with cutout
21 × 29¾ inches (53.3 × 75.6 cm)
The Art Institute of Chicago

Working Proof, 1970–74
Lithograph with pencil on two
 sheets of frosted mylar
21¼ × 27 inches (54 × 68.6 cm)
The Art Institute of Chicago

JAMES ROSENQUIST (b. 1933)

Circles of Confusion I, 1965–66
Lithograph
38½ × 28 inches (97.8 × 71.1 cm)
Edition: 12
Printed by Donn Steward
Published by Universal Limited Art
 Editions, West Islip, New York
The Museum of Modern Art, New
 York; Gift of the Celeste and
 Armand Bartos Foundation

Working Proof, 1965
Lithograph with pencil and crayon
29⅝ × 20½ inches (75.2 × 52.1 cm)
The Art Institute of Chicago

Working Proof, 1965
Lithograph with pencil
22⅛ × 30⅛ inches (56.2 × 76.5 cm)
The Art Institute of Chicago

Working Proof, 1966
Lithograph with collage
41¼ × 29½ inches (104.8 × 74.9 cm)
The Art Institute of Chicago

Working Proof, 1966
Lithograph with conté
40¼ × 26 inches (102.2 × 66 cm)
The Art Institute of Chicago

Working Proof, 1966
Lithograph with gouache and
 pencil
40⅛ × 28 inches (101.9 × 71.1 cm)
The Art Institute of Chicago

Working Proof, 1966
Lithograph with crayon
40 × 28 inches (101.6 × 71.1 cm)
The Art Institute of Chicago

Off the Continental Divide, 1973
Lithograph
42 × 78 inches (106.7 × 198.1 cm)
Edition: 48
Printed by James V. Smith
Published by Universal Limited Art
 Editions, West Islip, New York
The Museum of Modern Art, New
 York; Gift of Celeste Bartos

Study for *Off the Continental
 Divide*, 1973
India ink, crayon, chalk, conté,
 and pencil
42 × 78 inches (106.7 × 198.1 cm)
The Art Institute of Chicago

FRANK STELLA (b. 1936)

*Polar Co-ordinates for Ronnie Peter-
 son Variant IIIA*, 1978–80
Lithograph and screenprint
38½ × 38 inches (97.8 × 96.5 cm)
Edition: 32
Printed by John Hutcheson, Norman
 Lassiter, Bruce Porter, and Jim Welty
Published by Petersburg Press, Inc.,
 New York
Petersburg Press, Inc., New York

Working Proof, 1978–80
Lithograph and screenprint with
 hand-painting
38½ × 38 inches (97.8 × 96.5 cm)
Collection of the artist

Trial Proof, 1978–80
Lithograph and screenprint
38½ × 38 inches (97.8 × 96.5 cm)
Collection of the artist

Working Proof, 1978–80
Lithograph and screenprint with
 hand-painting
38½ × 38 inches (97.8 × 96.5 cm)
Collection of the artist

*Polar Co-ordinates for Ronnie Peterson
 III*, 1979–80
Lithograph and screenprint
38½ × 38 inches (97.8 × 96.5 cm)
Edition: 100
Printed by John Hutcheson, Norman
 Lassiter, Bruce Porter, and Jim Welty

Published by Petersburg Press, Inc.,
New York
(Not in exhibition)

Working Proof, 1979–80
Lithograph and screenprint with
 hand-painting
38½ × 38 inches (97.8 × 96.5 cm)
Collection of the artist

Trial Proof, 1979–80
Lithograph and screenprint
38½ × 38 inches (97.8 × 96.5 cm)
Collection of the artist

Working Proof, 1979–80
Lithograph and screenprint with
 hand-painting
38½ × 38 inches (97.8 × 96.5 cm)
Collection of the artist